Best
Erotic
Fantasy

Best
Erotic
Fantasy
& Science fiction

Edited By
Cecilia Tan
and
Bethany Zaiatz

CIRCLET PRESS, INC.
CAMBRIDGE, MA

Best Erotic Fantasy and Science Fiction

Printed in the United States
ISBN-13 978-885865-61-8

"The Heart of The Storm" by Connie Wilkins
Originally published in *Time Well Bent*, Lethe Press 2009

"Taste" by Jean Roberta
Originally published in *Obsession*, Eternal Press 2009

"A Feast of Cousins" by Beth Bernobich
Originally published in *Helix SF*, July 2006; reprinted in *The Mammoth Book of Lesbian Erotica*, Running Press 2007

"Caught" by Paige E. Roberts
Originally published in *Bosslady*, Erotictales Publications 2006

First Edition

Circlet Press is distributed in the USA and Canada by SCB Distributors.
Circlet Press is distributed in Australia by Bulldog Books.
Available from many other fine wholesalers and retailers.

For a catalog, information about our other imprints, review copies, and other information, please write to:

Circlet Press, Inc.
39 Hurlbut Ave.
Cambridge, MA 02138

www.circlet.com

Best Erotic Fantasy
& Science Fiction

contents

Introduction

We live in an age when the ways we can feed our imaginations are myriad. Our fantasies can take flight not only as we read books, or watch actors play them out upon stage or screen, but through role playing on the Internet (or in the bedroom), interactive gaming, and much more. "Let's pretend" is no longer an activity we leave behind in childhood, as the fanciful and fantastic only grows in popularity in our multimedia world.

Of course, Circlet Press's thread of the media tapestry weaving through your imaginations is the erotic thread. If people have imagined a way to eroticize something magical or futuristic or unreal, chances are we have done an anthology specializing in it. Fairies, vampires, cyberpunks, werewolves, angels, space aliens, elves, time-travelers, superheroes, and many other beings have stalked, pranced, shimmied, licked, kissed, and come in our stories.

But I never stop seeking something more. It's never been enough for us to merely have a story where a human being has great sex with a vampire/alien/fairy/you-name-it. The whole purpose of Circlet Press, since our first publications in 1992, has been to use erotica as

a way to break open the strictures and formulas of the sf/fantasy genre, while simultaneously breaking open the formulas of erotica by using science fiction and fantasy. Genres are like comfort food. We think we know what to expect from them, and we want our expectations met. But Circlet's fusion of erotica with sf/f is like fusion cuisine. We take the familiar and deliver a satisfying meal, and yet we excite and stimulate with something new created from the combination.

In Best Erotic Fantasy, we hunted down the stories we felt gave us the best kick of all three flavors we sought, erotica, sf/f, and the new thing that they become when you mix the ingredients together. From a pool of several hundred applicants from all over the English-speaking world, we narrowed our search to the 16 you see here.

In keeping with the theme that keeps coming back, of the old and the new, the comfortable and the exciting, this will also be Circlet's first book with simultaneous ebook and print book release. Our publishing program over the past two years has moved overwhelmingly to the digital side, but for these, the best of the best, we are publishing in both traditional bookstore release and in ebook. Traditional bookstore manufacturing and distribution is expensive, and we are grateful to the many individuals in the Circlet 100 who contributed to the effort. (They are thanked by name in the acknowledgements section at the end of the book.)

There are many ways to feed your imagination and let your fantasies soar. I do hope you enjoy these stories whether you devour them on creamy paper wrapped in slick paperback lamination, or through words scrolling down some electronic device, or—who knows?—some heretofore yet to be invented way of enjoying fiction... or perhaps an even older method, enticingly narrated by the voice of a lover each night before bed.

Cecilia Tan
Cambridge, Massachusetts

Vaster Than Empires

Allison Lonsdale

The installation was called Viriditas, after Hildegarde of Bingen's writings on the divinity immanent in green things. It was a church as much as it was anything else. Synthetic voices whispered Dylan Thomas' "The force that through the green fuse drives the flower" while flowers made of nanofabric opened and closed like sea anemones, like hungry mouths, breathing out molecules that sang of fear and longing when they hit the olfactory bulb, the oldest part of the brain. The Tree of the Knowledge of Good and Evil bloomed with scarlet orchids, followed by fruit in the shape of beating human hearts.

The infrastructure was built on military/law enforcement wares, very expensive when new and very cheap once obsolete. I was running this off a massive lie detector. Each person inside my little world was monitored: breathing, heart rate, pupil dilation, and skin temperature. Based on their reactions, I controlled lighting, air temperature, sound, scent, and the motion of the flexible structures.

If I coded, I could have written the whole thing in sensory markup and had it compiled into a VR. But it's illegal to do olfactory stim in

virtual reality, because of how strongly that part of the brain reacts to direct input. It's perfectly legit for me to release pheromones into the air through one of my creations, though. Every olfactory chemical in my projects is legal.

They shouldn't be. In the hands of a competent artist, those molecules are dangerous. I have made sociopaths weep with compassion. I have made rational, efficient, gray-suited managers fall helplessly in love with a color of light. Once I even got someone with Asperger's Syndrome to understand the concept of "spontaneous empathy", though she said she couldn't hold it in her mind after she left the gallery.

Once I killed a man.

⤶

Only a few people are allowed into one of my projects at a time. I can only manage so much, monitoring them through the interface. And after a few weeks working an installation, the people start to blur together, much as I love their reactions. This one made me sit up and pay attention, though. His body temperature was a big dark blot on my input: he was cold. I checked his breathing (fast and shallow) and pulse (too damn rapid). He was in the Field of Lilies, near the entrance; I couldn't figure out his reaction. Medical issues? A phobia? Who would keep a phobia in this day and age—and why walk into a gallery of what they fear? That would be about the only explanation for his responses.

The pupil monitor made it clear to me. Very dilated. I flicked back to the body temp. Yes. One pocket of fever heat on a body that was otherwise doing a classic fight-or-flight.

His cock. He was so aroused it was probably physically painful— and he was scared shitless.

Discretion may be the better part of valor, but I am a reaction slut. I had to see the look on his face. I flicked to straight visuals.

He was not handsome, but if a generation of cheap cosmetic surgery has taught us anything, it is that the packaging is only

marginally relevant. And in the backlash against lovely, bland uniformity, many people are now wearing the faces and bodies that the genetic lottery gave them, flaws and all. I was looking at one. Unless his surgeon had a particularly quirky and minimalist esthetic sense.

Pale skin, dark brown hair worn long and tied back. Clean-shaven. Tall oval face. Thin nose too long, gray eyes too bulbous. No cheekbones to speak of. Lips whose shape would never be compared to anything luscious. So why was I getting wet?

Because beauty is surfaces, beauty is art. People are what's under the surface. And there were huge and terrible things under his surface, angels of the vast abyss doing battle. I saw the ripples of their combat across his face. Forgetting that he was being monitored, he did nothing to conceal the signs. Longing and fear were trying to rip him apart, and he was four rooms away from the pheromone spray that should have triggered those feelings. This was all his own.

I wanted to reach out and comfort him. I wanted to amplify those emotions until they tore him apart, just to see what shining thing rose from his bloody husk. I wanted to taste his sweat.

I checked the memory left on the system. There was enough. I had it record him in 3-d for the rest of his trip through the installation. I locked the main doors, not letting anyone else enter. When the guests ahead of him left, he was alone in here with me and my beautiful machines. He was mine.

As he moved through Viriditas, his reactions got more powerful. I raised the temperature to comfort his cold skin, cut back on the awe-inducing subsonics, mixed home-safe-comfort molecules in with the other pheromones. He calmed, but not much. He was visibly trembling as he approached the Tree, and watching it made my nipples go hard. I had the visuals zoom in on his face. I did not quite believe what he did next. He took one of the scarlet, face-sized orchids between his hands and buried his face in it. He was kissing it, as though it were a woman. Then he backed away, sweating, and wiped his face on his sleeve. He looked as though something inside him had broken and he was drowning. I had already made my decision, and now I recorded and modified sound files and moved

robotics-control sequences into my system's main memory. He almost staggered as he entered the Rose Cathedral.

The wall of roses unfolded. Inside them were the faces of angels: modeled from averages of as many human faces as possible, they possessed unearthly beauty and symmetry. They opened their luminous eyes—all made of synthetic jewels, and none of them in the colors of human eyes—and sang the Duruflé arrangement of "Ubi Caritas". I had given them the voices of castrati, the power and richness of full-grown male lungs and throats fuelling the high voices of boys. He was transfixed. I let them complete the vocal piece, down to the final "Amen", and then I made all of their eyes fix upon him, and dilated their pupils. His own dilated in response. In chorus, they told him:

"Rappacini, Rappacini, Rappacini,
desires your company
at the Rose of Monday."

Then their faces settled into the repose of sleep, and the giant petals slowly folded back into buds, concealing them. His heart was racing, his pupils were still wide and dark, and his ragged breathing told me everything that I wanted to know.

↩

Back when I was a struggling aesthetic engineer trying to build a reputation, and he was a sensory coder working for a game design company, and we still used the names we were born with, Rex Monday and I were lovers. Together we tried Fuse, a cutting-edge (for its day) VR. Fuse was one of the short-lived genres of augmented VRs, meaning that you took a measured dose of a custom alkaloid before you plugged in, and the sensory input was designed to heterodyne with the drug's effect. Fuse was supposed to dissolve ego-boundaries, and it did a good job. Augmented VRs were later outlawed due to the number of people they put into psychiatric hospitals. Rex and I spent time in padded rooms, and neither of us can remember much of it. But when we came out, I had absorbed

the artistic sensibilities of a brilliant sensory coder, and he had acquired my intuitive knack for manipulating an audience's emotions with memes on multiple levels. We reinvented ourselves, and took on the names under which we would both do our best work.

I became Rappaccini, after Hawthorne's story. Not Rappaccini's daughter, the passive vessel of her father's destructive brilliance, but the old doctor himself, shaper of beauty and death. Because what have so many people worshipped, and killed for, and died for, but one who hung on a Tree, who died and went into the ground like a dry bulb and came back again like the narcissi pushing up through the earth in spring? Jesus, Osiris, Adonis, John Barleycorn—there's a rich memetic language of beautiful sacrifices who are linked to the green heart of the world. Crowned in lilies or lotuses, hyacinths or hops, these beautypainlovedeath memes play deep chords on the place inside us that can be molecularly mapped, transmitter by receptor, but cannot be compassed or comprehended by reason. Which is why I am a designer of interactive aesthetic environments instead of a scientist.

My old lover had also absorbed my fondness for dead languages; Rex Mundi, the king of the world, was an old name for Satan, used by the sort of Christians who believed that the kingdom of God was entirely separate from earthly experience. Who remembers that now? Those who recognize the joke at all think it points up the irony of VR fans that start to feel that simulated sensory input is the real world, and that the shadowy place where their bodies eat and shit and sleep is somehow false.

In the process of reinventing himself, he built the Rose of Monday, another Latin pun. It was a shrine to me, and to the shared universe we had created inside the Fuse construct. Hosted on an off-shore server, it used sensory coding illegal in the US. After all, what is the point of a garden in which the flowers have no scent?

⌇

I came home from the gallery with a data spike full of recorded images in my sweaty fist. Normally I go straight to the shower after a shift at the gallery, but I skipped it, feeding the spike into my home system and then throwing myself on the bed and plugging the connector into the socket behind my ear. I dropped out of my body into my office. The key to Rosa Mundi was in a bud vase on my desk; code sent periodically from its home server altered its composition. Today it was made of steel, but its petals turned to glass at their outer edges. I lifted it from the vase, brushed it with my lips, and felt the shimmer of connection begin. Once, I would have had my home system enabled for illegal olfactory codes just so I could smell it, because the Rosa Mundi keys change scent as well as appearance. But experience with my own art had made me wary of pheromones. When I visit Rosa Mundi, I have my wares disable olfactory input. I miss a great deal of the beauty there, yes, but in Rex's domain I have to be careful. The construct was built, in large part, as a map of the inside of my head—as it was fifteen years ago. I never enter it without taking a firm grip on my sense of self.

I appeared in the antechamber, its floor tiled in a compass rose of precious stones, its walls the wings of angels with each feather a petal. I was wearing the masque Rex had designed for me, a pre-Raphaelite painting made grass-green flesh, with flowering vines for hair and a gown of leaves. Into the still, hushed air of the chamber (I still find it eerie how subtly the sensory textures of that place are coded), I said the words to summon him: "Sic transit gloria."

Rex manifested in his classic masque, with top hat and tails, little horns, genteel white gloves, and polished hooves. His face was that of an archangel as Tamara de Lempicka might have painted it—if she'd been shooting up Yoshitaka Amano's RNA.

I explained my situation, and he was very pleased for me. He is generally of the opinion that I spend too much time hunched over an array of components, and should get out of the studio, have a massage, do some drugs, and fuck something. "A prey animal worthy of your refined tastes?" he said cheerfully. "Felicitations!"

"You know that I disapprove of that term, my friend." One thing I had absorbed from him in Fuse was the tendency to divide the world into predators and prey animals. This bothered me, and I had gone to great trouble to eradicate it in myself.

He sighed. "Then shall we call him—an herbivore? Surely that would be appropriate!"

"As you wish. I've invited him here. I want to make sure he's on the guest list." I sang a certain note that transferred a file from my home system, and the sound coalesced into an image I had recorded in the gallery.

Rex's laughter told me that the man used his real face online, as I had hoped. "A member of long standing, dear. And the scion of a wealthy, if tedious, family. In fact, he's a bit rich for your blood. It has never been your style to seek patronage."

"His finances are not relevant. He understands my work."

"Considering the amount of time he spends worshipping it here, I should think so. In fact, if he were a trifle less controlled, you'd have a stalker."

"And you didn't think of warning me because…"

"…you are a big girl and can take care of yourself. Besides, he's harmless. None of the wares here have picked up danger signs from him. He's courteous, well-behaved, respectful of others, and absolutely smitten with your work."

"I think you're jealous."

"Of course I am." Rex flashed me a mathematically perfect smile. "He sees how much of my talent is really yours, but he doesn't acknowledge how much of your talent is really mine."

⌐

My wares alerted me when my invitation was accepted, some hours later. He was waiting for me in the Hall of Contrasts. Replications of Georgia O'Keeffe's vivid and monumental vulva-flowers alternated with enlarged images of Robert Mapplethorpe's clinically precise black and white photographs of plant genitalia.

He heard the rustling of my masque's leafy dress and turned to face me. He wore a dark, archaic suit, perhaps nineteenth-century.

"How have I offended you?" he asked contrition loud in his body language.

"You have not."

"Then why—I don't understand."

"I know what you are," I said, watching fear and desire war on his face again. "I know what you are, and I invited you here. Do the math."

Something tense drained out of him. He looked like a bud tentatively opening. "Oh," he said, blinking in surprise.

"Rex tells me that you have spent a lot of time here, looking at images of my work and what inspired it. And he tells me you are rich, easily rich enough to buy a ticket to the most expensive aesthetic engineering installations. Why did it take you so long to attend one of my gallery shows?"

"Working up the nerve, I suppose," he said softly. "Trying to get the self-control."

"Afraid you might do something like, oh, try to make love to one of the orchids?"

He froze, looking at me with the eyes of a rabbit in truck headlights—but a sentient rabbit, quite aware that it was about to die.

"Do I look like I'm offended?" I said. "It's quite plain that you're wired." I used the street term for a VR addict, but I meant it in another sense. "With bonsai wire," I added. "I am fascinated."

"I am...flattered. I think."

His reactions had been reading close to fully human, meaning that he had his expression transfer fully enabled. Time to fire a dart and see what it hit.

"Look at me," I said. I spoke a Word, which emerged into the presumably fragrant air of Rosa Mundi with the sound of silk tearing. After an argument about appearance versus reality years ago, Rex had coded this for me, a variant on the unmasque command.

The botanical body stiffened, greens turned to browns, silken leaves harshed to flaking paper. The skin cracked, split, peeled away

in fragments, vanished. Under it, the bare skin of my own body was revealed: not a masque, but a face, scanned and coded to match me flaw for flaw. I wore a short dress of white linen. I watched him watch me, saw my harsh unbeauty reflected in his eyes. My hair cut close to my skull, just a coating of black texture. The heavy lips, the broad nose, the round face. The thick legs, the flat breasts. My wares and I watched him closely. He was reacting—but not with revulsion. His own choice, then, to wear what he was born with. Not just a distaste for medical nano, but values like my own: the container is not as important as the contents.

"My name," I told him, offering a much more profound nakedness, "is Catherine Sorayama."

"I would unmasque for you, Catherine," he said, "but I am wearing my face. My name is Gavin Revell." He reached towards me, a wreath of leopard-spotted orchids unfolding out of nothing in his hands. A lovely piece of code, that, and I wished for a moment that I could smell it. He crowned me; I caught one of his hands after they released the crown and I planted a kiss in his palm. He froze again, but it was something very different from a rabbit in headlights that looked out of his eyes at me now.

Hours later, still in Rosa Mundi, we sat on the grassy hillside of A Green Thought In A Green Shade, surrounded by poppies and linaria blossoms, and we spoke about art and desire. I pressed him to explain himself, because I liked to know how a beautiful device worked.

"It began at my grandmother's funeral," he said. "I was ten. I had never seen so many flowers in one place, and I had just been learning in life sciences that they were the private parts of plants."

"Private? They are flamboyantly public." I chuckled.

"My family were not exactly comfortable with the fact that they lived in bodies made of meat, if you know what I mean. I didn't know any words more explicit than 'private parts' until I was older."

"I do understand. Go on."

"I realized that right there at this very serious funeral, there were private parts all around the coffin. It was almost like bundles of little

naked ladies. It was very hard for me not to laugh. And then I started thinking, it really was like naked ladies, and the flowers suddenly seemed a lot more interesting. My data access was heavily restrained, so I had never seen a naked lady, except for pictures of Greek statues, which were not very exciting. But I figured that if these were the same organs for the plants, they had to have something in common. So I looked at them and tried to figure out if the place between a woman's legs looked like a flower, and which flower it looked like. And all the while the priest was saying serious words about God and death and eternal life, and these flowers—well, it had been drizzling. They were wet."

"Oh my."

"I had masturbated before, not that I knew the name for it—but that night I had my first orgasm. And it never occurred to anyone to restrict my data access to botanical images. I realized I could look at all the pornography I wanted without ever getting caught."

"But you got caught."

He looked at me obliquely, and was silent.

"In the gallery, you were frightened. Guilty. Someone, sometime, must have caught you."

"What kind of wares do you have running in there?"

"Oh-ho, yet another person who doesn't read the informed consent release before signing. I was monitoring your heart rate, pupil dilation, all kinds of stuff. You were so hot you damn near came in your pants; you were also terrified."

He sighed. "I was caught doing things with flowers. Several times. If they had believed in personality reprogramming, they probably would have had it done while I was still a minor."

"If you were truly unhappy, you could have had it done yourself since. Fetishes are pretty easy to undo. Expensive yes; difficult no."

He rested his head on my shoulder, making a small tremor of delight run through me. "But if they took it away from me, could I still perceive beauty the way I do now? I don't want to change if it means giving up this." He reached up and ran his fingers along the crown of orchids, now sitting at a rakish angle on my head. "Risking

the loss of this beauty in order to become 'normal'—from my point of view, that is insane."

<p align="center">↝</p>

Curiously enough, in meatspace he lived not far from me—at least, not far by maglev train. The next conversation was in my studio, and led to my bedroom. And there I discovered that longing does not conquer all; that Gavin, much as he adored my work, much as he desired to touch what was behind my eyes, was impotent with my fleshy, furry, warm mammalian body. I suggested drugs; he refused. He could not say it to me in so many words, but the implication was that if I were going to accept him, I would accept him as he was.

I am a resourceful woman.

The fashion designer who created this dress for me had been to one of my installations and then ripped me off mercilessly, getting her work on the cover of Vogue. Imitation being the sincerest form of flattery, I chose not to sue. Especially as I was able to talk passionately about intellectual property rights with her when someone ripped off her work, and the resulting case of lingering guilt was good for many, many favors.

The outline was reminiscent of Dior gowns from the 1940s, but the crisp linearity had been transmuted to organic curves. It was rendered in what the couture houses call "fleur-de-soie," a mostly-water nanofabric that duPont sells as petallica™. The conceit of this gown was that it was made from huge white rose petals. Each of my breasts was cupped by one; the rest of the bodice was the sleek curves of several almost imperceptibly overlapping. The skirt was made of petals at an even larger scale, a single one covering me from waist to floor. Seven of them overlapped, arching and flaring out from my waist like some wedding-gown confection. There were matching gloves, each formed in a single piece and covering me to the shoulder. Though the dress practically begged me to, I made no efforts with cosmetics; I, who can tinker with robotics control modules for

ten hours without thought of food or sleep, have never developed the patience for face paint.

When Gavin arrived his face took on the intense purity of sunlight seen through the edge of a petal, and he actually threw me onto the bed and landed on top of me. I forget, sometimes, that I am a small woman. Being reminded of it this way was unexpectedly exciting.

As my body temperature increased, the petals of my dress went scarlet at the edges. That strain of roses is called fire-and-ice. He crushed me in his arms, buried his face between my petal-covered breasts, rubbed his whole body against me through the cool almost-living texture of the dress. He let go of me long enough to shed his clothes, and as he returned to my embrace I reached down and wrapped one petal-gloved hand around his swollen cock.

His penis was so smooth, so sleekly lined, that the first time I had seen it, I had thought for a moment he was uncut, and I was seeing the line of glans muted by foreskin. But it was simply of an unusual shape. Its linear grace was lovely as a stamen, and with its heat muted by the nanofabric of my glove, it felt almost botanical in my grip. As I pressed it in my hand, a drop of clear fluid welled up, like nectar from the base of a honeysuckle blossom, and dripped onto the dress. I felt my clitoris swell in response.

Then he fell upon me, and rapidly reached climax pressing against the enormous rose within which my fleshy, furry, warm mammalian body trembled with unfulfilled desire. When I asked him to give me something, anything, to help me get where he had just gone, he was guilty, sorry, and unable—or unwilling—to cooperate.

⌒

I am a very resourceful woman.

There was a late twencen singer whose stage shows were so elaborate that they damn near qualified as aesthetic engineering. They demanded entirely new tools, such as the headset mike. These tools went on to spread throughout the industry and become common-

place. There are some parallels between us, and I find it amusing that her name was Bush.

The nano fabrication house that does my flowers is about ten times bigger than it used to be, thanks to the designer who ripped me off and the designers who ripped her off. Huge flowers made of petallica™ that can open and close on demand have become very trendy, showing up on everything from furniture to hats (and driving poor Gavin nearly out of his skull with frustrated desire, as he told me). So the company was happy to discuss a custom order with me, even if the specifications were, as their head designer put it, "fucking insane." They tried to charge me an obscene amount. Appropriately, I paid it entirely by licensing them the rights for the porno market.

The basic wiring had been easy; sensory interfaces got perfected years ago, opening the door to whole new fields of fetishes.(One of my hardware consultants has a meter-square clitoral interface covered with sapphire film, and she plugs into this while her lover drips molten copper on it. My personal life is so boring.)

The tricky part was working that technology into a flower.

The next time Gavin came to visit me, he was obviously guilty for not being able to meet my needs. He had brought an expensive peace offering: a massive nanofabric iris whose petals displayed constantly swirling Mandelbrot sets, one color being chased down the fractal arcs by another. I was impressed. I hadn't seen anything like this before, and I know the industry well. Evidently I wasn't the only one who had connections in a fabrication house.

I told him I had a flower for him, too, and led him into the bedroom. At first he didn't understand, looking blankly at the big red-and-gold orchid that rested between two pillows. Then I showed him the cables that led from it to my home VR system. He breathed gently, "Oh my."

"Happy birthday," I said, grinning.

"It isn't my birthday."

"It's somebody's birthday," I said. "Let's go to bed."

I stripped down and lay beside him. I could feel his thigh against mine until I plugged in the cable. Then I was in a soft dark place, deliciously cool, and all I could feel was the dim kinesthetic feedback of an alien shape—until Gavin bent his head to kiss the orchid's uppermost petal. That kiss hit my sensorium with the deep sweet ache of a perfect violin note.

When it comes to being licked between the legs, I want that tongue right on my clit. I have no patience for partners who take their time around the lips, or try to penetrate me with their tongue. I want them to cut to the chase and stay there. So when I had this interface designed, I set the parameters so that its input would all register as direct clitoral stimulation.

My clitoris was an orchid ten inches across, and the man burying his face in it had been fantasizing about this since before his voice changed.

My pleasure was at the center of his universe, and his hunger was at the center of mine. Not since Fuse had I felt this close to anyone. Gavin licked the inner hollows of the orchid with a clumsy urgency that betrayed his lack of experience with partner-sex, but it was all intense and I could use all of it to get me where I needed to go. It was when he got his hands slick with saliva and began stroking them over the petals that I felt the momentum really start to build. I realized that even though I could no longer feel the bed under my body or hear my breath rasping in my throat, I was still having visible, audible reactions, rocking my hips and groaning as he sucked on the central structures of the flower. So he was learning as he went, listening to my gasps and whimpers from beside him as he fed me sensation through the interface.

With this sort of VR play you lose your sense of time. When you've done a sensorium block, which is the standard setting on a genital sensory interface, you can't hear your breathing or heartbeat. Without those markers—and under the intensity of the direct-brain stimulation—time stretches out like bubble gum. I hit that brilliant clear place right before orgasm, where the nerves sing with a light the color of volcano hearts, and it went on and on and on. He had

found some pattern, a rhythmic sucking of the central petal and both hands spread flat rubbing the outer petals that just held me stuck there on the edge for longer than I thought I could stand. Right when I figured my body had forgotten how to breathe and I was going to pass out (which might have been true, because I was getting some visual interference, and it was those little sparkly things that either mean "you're about to pass out" or "you really need to clean your interface plugs"), I went over the edge.

Once when I was a kid, I went on one of those amusement park rides where they drop you several stories and then the rails curve and level out, and gravity catches you and inertia slows you down, while your stomach is still up at the top of the ride and your inner ears are calling you bad, bad words.

This was like going on that ride backwards.

The sensation shot me in a sweeping arc that accelerated straight up. As the spasms wracked me, each one raised my velocity. I was coming so hard that gravity inverted and I was being pulled upwards, until I broke through a membrane of physics equations that might have been the sound barrier.

On the other side, the rest of the climax was waiting for me. It hadn't signed any arms treaty I'd ever heard of. It had nukes.

I have always had "boy orgasms". They have an obvious beginning, middle, and end, and I usually get one per session of lovemaking. They just leave my clit so tender I can't stand more contact. Somehow, this wasn't a problem with the interface. I was having my first multiple orgasm. Or rather, it was having me. I felt like a kitten picked up and shaken in the mouth of a Rottweiler, or a lost kite being thrown around in high-altitude turbulence. Gavin was translating all of his years of frustration and desire into a secret language of slick heat and pressure and merciless wet friction, and it was shuddering in implacable waves up my spine, hammering against the shore of my gray matter with exquisite force.

And then something went very, very wrong.

There was a terrible shriek across my nerves like liquid oxygen hitting an open flame. It was not pain or pleasure as I knew them,

but it was deeper than anything I had ever tasted and I thought it was going to kill me. I heard alien colors shattering in my spinal fluid. I was being forced down through a hollow chill that felt like the smell of burnt metal. Something very bright burst inside my skull and pulled me inside-out through my cunt into a dark pressure. I was on the ocean floor. I couldn't breathe.

I came up from the dark place. Old VR-user's instincts had saved me; while my sensorium was going haywire, I had gotten a hand to my interface socket and yanked the cord out.

Everything hurt. My eyes wouldn't focus. I tried to think. Something had gone wrong with the interface. It could be something in the software…

or it could be something in the hardware…

I rolled over to look at Gavin, fighting a sudden wave of nausea. The room was spinning. I got my eyes focused enough to look at him, and I almost fell back into the dark place.

"No," I said, horrified. He had torn the orchid-interface apart with his teeth. Its complex, delicate structures were oozing out onto the sheets. He had swallowed some of it.

"Rappacini," he said. His face was magnolia-blossom white.

"I'll call an ambulance," I said. "You'll be all right." I already knew I was lying; he would never be all right, even if they could save him. He had ingested industrial compounds that were never meant to meet human tissues directly. How could I have been so stupid as to have that interface made? But how could I have imagined that he would do this—?

He knew he was dying. He shook his head slowly. "This," he said with some difficulty, "is what I want."

It took all the strength I had to reach out and touch his face. "I," he said very slowly, "love." And that was all he said.

I called for an emergency medical team. When they arrived, Gavin was already dead and beyond resuscitation—but I needed them. By then I was having my third seizure.

⏝

A lawyer from his family visited me in the hospital. I thought that I would be charged with his murder. I was wrong. When his family found out that he destroyed an experimental sensory interface by trying to eat it, and inflicted permanent neurological damage on a well-connected aesthetic engineer in the process, they began to be nervous about lawsuits. After all, they had known for years that there was something not quite right about their son, and some courts might be willing to hold them responsible. So they sent their lawyer to offer a generous out-of-court settlement, more than enough to cover my medical expenses.

In addition to the settlement offer, the lawyer gave me a small package. "This was found among his belongings," he said, "marked with your name. So far as we are able to determine, it was meant as a gift for you. The family would like you to have it."

Inside the box was a golden bee, precise in every detail, obviously the work of a nanofactory guided by exceptionally good design. There was no maker's mark; it's possible Gavin did it himself. There are things about him that I will never know.

When I picked it up, the warmth of my fingers triggered some mechanism that made its filigree wings begin to move. They fluttered into a blur; unable to lift its weight, of course, but lovely all the same. I set it on my breast, where it clung to the hospital gown, its compound eyes glittering like the granulation of ancient Etruscan goldwork. Suddenly I was able to weep; it went on for some time, until the electrical storm cut loose through my skull again and the careful hospital clothing stiffened to restrain my thrashing body.

His family made it clear that I was neither expected nor welcome at his funeral. I did not attend, not out of respect for their wishes, but because the painful irony of seeing him lying in state surrounded by the flowers he loved would have been too much.

Much later, with a medications pump installed at the base of my skull, I visited the cemetery alone. I carried thousands of dollars of custom tech in the pockets of my trenchcoat. Their settlement had been quite generous. I hoped that, when they learned of what I was about to do, they would not consider it vandalism and try to undo it.

Who was I trying to fool? They would never know. They would never come to visit his grave. Their not-quite-right son had embarrassed them for the last time, and they had no interest in seeing him again. They had planted him, like a bulb, and forgotten him.

But the bulbs of autumn rise up again in the spring.

I unrolled the thick adhesive sheet and spread it across the face of his headstone. His name and the dates were erased, tiny machines moving the granite one molecule at a time to fill in the engraver's strokes. The new channels were cut and filled with a metallic ceramic fused to the stone. The sheet told me it was done by turning black. I peeled it from the marker. A golden bee glittered in the afternoon sun, its filigree wings drawn with botanical precision. Above it, the quote from Marvell: "My vegetable love should grow / Vaster than empires and more slow." Below, the line Shakespeare wrote for Ariel in The Tempest: "Where the bee sucks, there suck I."

I planted the slender violet spike in front of the gravestone, driving it home with the heel of my boot. Under the grass, its mechanisms spread out into a mycelial mat, then reached for the surface. Hyacinths, the flower of the slain Adonis, began to push up through the earth. Drought would not wither them; frost would not kill them. They would bloom even in the snow.

⤳

The installation is called Apis.

It contains hundreds of images, arranged as though viewed with compound eyes, in shapes that echo the rose windows of a cathedral. Each is a photograph of a golden bee perched on a flower, printed on a translucent sheet and mounted in a screen in front of an array of precision-controlled light sources. The rose windows shade from one color at the center to another at the edge, and wherever that shading requires a certain shade of red-pink, the photographs are of my spread cunt, with the golden bee perched on one lip. So far, not a single reviewer has noticed. Philistines.

I had a fuzzy-logic AI developed to run the installation, controlling the lights and music and scents based on input from the lie-detector system. If I ride the interface too long, the seizures come, so I do not ride it any more. That is my penance. And I am glad to give it up, really; the possibility, the temptation of another one like him is too much. He understood the sheer raw beauty of the generative force, the gaping maw of need, the awesome multiplicity of the deepest drive. And I am as hungry for someone who understands that as he was for a way to consummate his longing. It is my penance for killing him that I will not permit myself that satisfaction again.

There are many satisfactions I do not permit myself. Orgasm triggers my seizures. Certain procedures might correct this, but the neurosurgeons tell me that I could lose a lot of memories, and possibly the parts of me that make my art. I am not willing to pay that price.

I live a monastic life after a fashion, married to my work, or rather to the inward and spiritual grace of which my work is the outward and visible sign. And if there is anyone to intercede on my behalf with the bright vast merciless Source of that grace, it is he whose image adorns a new chapel in the Rose of Monday; the only person I have ever known who surrendered himself to the riptide of Beauty without hesitation.

Fulgurite

Vylar Kaftan

July 11

I will be struck by lightning on July 13. I know this because I saw a unicorn in the desert sky earlier tonight. Its cockroach body and feathered wings cast shadows on the ground. Lightning forked from its horn, like decisions in my life. Decision to move to Phoenix: fork. Decision to finish my degree: fork. Decision to date Maddoc: fork. All the lives I rejected flash across the sky and are gone, except the one that will strike me. In two days, on a Thursday. Thursday the Thirteenth.

I saw the unicorn only briefly before it vanished. Maddoc doubts me, as we sit on the floor and eat Chinese takeout. "You said it had wings?"

"Dove wings, gray and feathered. And a cockroach body."

Maddoc sets down his chopsticks. "What?"

"Blood-red. The size of a bus."

"So it's a cockroach-dove thing?"

"With hooves. On hairy roach legs."

"What makes you think it's a unicorn?"

"It has a horn," I say, pushing my plate aside. "That makes it a unicorn." I go to the window and stare at the sky. It smells like a storm. Clouds stack on top of each other in thick blankets. Lightning flashes in the west. It fires an electrical impulse into my body, and I push the window open. I'm on the fourth floor. "Hello!" I call out the window, leaning forward into the hundred-degree heat. The blast of hot air buoys me up like boiling water, burning me but supporting me, and I'm sure I can fly away if I just let go.

Maddoc hauls me back in the window. "Are you crazy? Get back in here. You'll fall and kill yourself." It's like Maddoc, to make sure everyone and everything is safe.

I lean against the wall. I savor the storm front of heat that rolls over my naked arms and legs, invading the thin fabric of my sundress. "Kiss me," I say. "Kiss me as if you'd seen it too. As if it were real." I don't tell him that it is real, that I will be struck by lightning in two days. I love Maddoc, but he can't always keep me safe.

Maddoc obeys. He pushes his open mouth against mine. Our tongues fight wetly, writhing in the caves of our throats. His fingers twist my hair into knots and my nails rut into his back. He pulls away suddenly and fumbles at my dress. He tugs the strap off my shoulder with one hand as the other dives to my bare breast beneath. Heat rises where he touches me.

I roll onto the floor and pull him with me. Maddoc lands on top of me, smelling of arousal. His hips meet mine, chaperoned by two layers of fabric. If we were not clothed, we would be fucking. The hardness inside his gym shorts wants entrance. I push him off me, and he slides to the floor like a discarded silk dress.

He wipes his mouth and looks at me. "I wish you'd let me."

"It'll hurt."

"I love you. I'll be careful," he says gently, touching my arm.

I stand and adjust the straps of my dress. "I'm a virgin. It's going to hurt no matter what. I've heard it feels like being murdered."

"I promise I'll be careful. My first was a virgin too. She said it didn't hurt so much."

"How would she know? What could she compare it to?"

He sighs. "I respect your choice. I'm serious. I love you more than anyone I've ever met, and I'll wait as long as you like."

"I want it to be special. I'll do it when I'm ready. And I know when that will be," I say.

"When's that?"

I stare out the window. "Two days."

He stands behind me and strokes my shoulders. The room is hot, like a unicorn's breath. In two days I will be struck by lightning: fork. I will give Maddoc this gift because I love him: fork. I will let him inside me. I take his hand and squeeze it. The heat reminds me that this is my choice.

JULY 12

I'm sitting in my summer geology seminar at Arizona State University, and it's hot in here. I'm sticking to my seat and thinking about unicorns. I could capture the unicorn. If I sat in the woods and played a lute, the unicorn would rest its head in my lap. There aren't any woods near Phoenix, so a mountain will have to do. I know which one to use. I'm not thinking about lightning, though I should be. I'm also not thinking about the index cards that I shuffle in front of me, or the boy up front who's giving his presentation.

"Lightning," he says, and I look up at him. He's rocking back and forth on his feet like a bad slow dance in middle school. He speaks quickly. "Lightning is another unusual method through which rock can be transformed. When lightning strikes certain types of rock or sand, electricity transforms the strike area into a narrow tube of glass. This substance is called fulgurite."

I look out the window again. The sky has darkened in the last five minutes. The gray clouds in the west have turned to charcoal, an angry grade-school scribble of lines on faded paper. I don't see the unicorn, but I know it's waiting behind the storm. It drinks lightning and rolls in thunder, its cockroach body wallowing in energy like filth. I will be struck by lightning, and transformed to glass: exposed and breakable.

I remember my recurring dream, where my body is transparent except for the street map of veins. My red heart pulses in the center of my chest, vulnerable and naked for everyone to see. I'm nailed to a mountain by my hands and feet. Then invisible forces stretch my body and yank me into the sky. I'm still nailed to the ground but I stretch like clear rubber, unable to fly and unable to rest. I've had this same dream since I was thirteen. I wonder if the dream is about fulgurite. Maybe instead of bending, I will break like glass.

Now it's my turn to speak. I stand and walk to the front of the classroom. If I'm to be transformed to fulgurite, then I must be stone at this moment. I am bloodstone, with dark red veins through a muddy greenish rock. My veins pulse through my core. As I face the class, I'm not afraid, but the words of an old drama coach are still habit. The audience is naked before me.

I do not know what I speak about. I read the index cards mechanically, but keep glancing at the naked restless bodies before me. Nipple eyes watch me—alert male ones and softer, thoughtful female ones. There's a pierced punk girl in the front row, and she watches me with a slitted metal gaze on small bright breasts. All the belly buttons are small o's of surprise, startled to be looking at each other, seeing the other faces for the first time. Pink faces, brown, peach, amber—the chins obscured behind desks, the full expressions masked.

Class ends as I'm speaking. The faces rise in unison, revealing their true mouths hidden in dark curly beards. The women are mysterious in their closed-mouth shyness, but the men wag their tongues everywhere. I grab my bookbag before I'm crushed in a mass of bodies, a bloodstone wrapped in skin, a rock buried in flesh.

The halls smell of sweat and sex as the body-faces press forward. The eyes of the women and the tongues of the men jiggle as they walk. Here I see a female face touching a male face—eyes pressed together briefly, then separated. A male face sticks out his tongue at a pretty female as he passes, then he quickly turns away from her. I'm bumped on the sides by leering faces, grinning, mocking the veins in my body—mocking my heart. I wish they would stop touching

me, but there are too many people everywhere. I'm a rocky island in a sea of flesh.

I run out the front door of the building and throw my books to the ground. "I am not afraid!" I scream at the sky. Lightning flashes. The unicorn heard me and doesn't believe me.

JULY 13

Maddoc and I are walking up A Mountain. It's the one with the large white A for Arizona on the side, where teenagers go to make out. It's just before sunset, and still over a hundred degrees as we hike up the trail. The storm's humidity makes sweat pool beneath my breasts. Lightning crackles overhead.

"Shouldn't we go up here another night?" asks Maddoc.

"No. I want this to be special." I'm trying to remember that this is my choice. It feels more like fate. I am destined for pain, with this body I was born into, where I must allow Maddoc inside me.

He glances at the sky. "I've got condoms, just so you know."

I don't respond. The unicorn is circling the mountain, its thick roach body and feathered wings silhouetted on the clouds. It watches us walk up the hill, tilting its horn at me like a rapier. The wind picks up. It's not raining, not yet. Arizona storms are like storms nowhere else. Here we have desert monsoons—strong enough to knock down fences, or flood a street in two minutes. My skirt billows away from my body and into Maddoc's legs, tangling him as he walks. I'm wearing only the thin white dress and sandals. Maddoc wears his favorite red shirt and shorts, and cologne that isn't his usual.

We pass couples walking down the trail, holding hands. Maddoc's hand snakes into my own. I look ahead to the radio tower on the mountaintop, blinking red and erect against the sunset. The top of my dress is sticky and clings to my breasts like plastic wrap. I pull the fabric away from my skin, wondering when I changed back to flesh. It must have happened when Maddoc touched me. I wonder if I have caught fleshiness from him, like leprosy.

The last few feet of the mountain are steep. I hike up them carefully, with Maddoc behind me. I know he can see up my skirt. I struggle to the top and look up at the radio tower. A strong wind blows, knocking me back a step and scattering a family of owls from the tower. Lightning forks in the sky, none of it towards me, not yet. The unicorn circles overhead. It lands on the radio tower. Sparks fly from the tangled metal where the creature touches down. Everything is aligned, like iron filings to a magnet. I turn to face Maddoc. "Here," I say. "This is where I want us to be."

The wind blows his hair as he holds me in his arms. "You're so wild," he says, his fingers seeking my hair. "I can't understand it. There's something incredible about you."

"Kiss me," I say. Before he can respond, I stand on tiptoe and plant my mouth on his. Maddoc kisses me fiercely. I dig my fingers into his clothes. The buttons pop off his shirt as I tear it away. I let the shirt fly, and the wind carries it partway down the mountain before it catches on a rock. Maddoc doesn't seem to notice. He's unbuttoning my dress clumsily, his tongue still locked with mine. I tear off my dress too. The flimsy fabric gives before the buttons do, and the dress shreds under my fingers.

I hear a shriek, and I turn my head. Behind me, the unicorn has thrown its head back and screamed. I spin around to face it, dragging Maddoc with me. I'm naked except for my sandals. Maddoc's body shields me as I scream back. "I'm ready. I want you."

The unicorn snorts. Lightning crackles off its horn. Maddoc moans and bites my neck lightly. I claw into his back and pull him to the ground on top of me. Electricity rages through me. Maddoc fumbles at his shorts. I spread my arms and legs like a starfish. The unicorn swoops down and nails me to the ground with its hooves, stomping on my hands and feet. Each touch is a shock. Every sense is alive. Today I will be struck by lightning.

I arch my back. I wonder what happens if a unicorn lays its head in a maiden's lap, but misses her lap and instead it... but there's no time to figure that out. I stretch towards the sky: my face in the clouds, my hands and feet on the ground, my limbs like mile-long

parachute strings. The unicorn circles me, its wings flapping a storm wind in my eyes. Lightning crackles around me, forking with choices. The unicorn lands on a storm cloud near my feet. I lift my head to see it, smelling ozone in the air.

The unicorn scrapes its hooves against the cloud and lowers its horn. Up close, I can see the horn is the color of blood—grooved, with tiny sparks flickering against it. I stare at the beast, my arms and legs straining with agony. Unable to fly, unable to rest.

"I know what you want," I whisper. "I want it too. This is my choice."

The unicorn plunges toward me like a charging bull. Lightning strikes me. My whole body bursts with energy. I howl as power flows through me, through my infinitely long arms and legs, through my hands and feet into the rock below me. The radio tower explodes in shards of metal. I look downwards. The mountain is shaking. A snowflake of glass appears beneath me and spreads like frost across a window. The red stone of the mountain blurs to glass, revealing the heart of the giant rock. The transparent mountain shatters. Shards of glass fly like bullets away from the sound. I fall towards the explosion and close my eyes. I am flying and resting, both at once.

When I open my eyes, Maddoc is stroking my cheek. "Oh God," he whispers, "Oh, God." It's raining on us. He kisses me and moves wet hair out of my eyes.

"Did I bleed?" I whisper.

"Not much." He kisses me. "Did it hurt?"

"Not much." Not like I had feared. I look at his face, his naked body next to mine. He looks so vulnerable. I glance down between his legs, where his penis rests limply on his scrotum. Such a delicate thing, so strange but no longer foreign to me. I touch it lightly, and he shivers.

"I love you so much," he says. "Thank you. Thank you."

I kiss him gently, on the lips. The unicorn is gone.

Now I Live on the Street of Women
Jason Rubis

The oil must be running low. It's been dark almost an hour, but Rii hasn't lit the lamp yet. I wait until she walks past me, chewing her thumb and talking to herself. I say, "*Maihta*"—Light—and make the little tongue-on-tooth noise that means what you've said is a question. I have to do it again, louder, and then finally she notices me.

She giggles. She always giggles, just like she always talks to herself when Benta's not around. She starts teasing me, tells me I'm afraid. Oo-ohh, Baby. Afraid of dark. It's meant to stir me up, embarrass me, get me yelling. I never yell anymore. How can I be embarrassed about anything now?

But the dark does make me nervous, I've got to admit. The city is dangerous now, especially now, and there's nothing to stop anyone—looters or crazies—from coming into the alley and offing both of us. Even if the old lady were back, so what? She couldn't do anything more than Rii could—or me. My first week here, I used to drive myself crazy thinking up ways the two of them could secure this place better, or make weapons. Things a soldier would think of. I tried to tell them, they just laughed at me.

Maybe they're right. Not much point in worrying about those things now, I guess. And besides, now I've got Rii's attention. That means I've got other things to worry about.

She sinks down next to me and pulls her blouse open. I can hear the cloth tear a little as she pulls (old, cheap cloth), I can hear her breathing and whispering. I say, "*Ahn, ahnu se.*" No. Please don't do it. But I know she will, I'm not saying it very loudly. Conserving strength.

I think Rii was probably fat once. If she was, she isn't now. Now she's a stick-doll dressed in rags, but when I shut my eyes and think of her, I see a much heavier girl, with huge spreading tits and stumping legs like stone pillars and greedy eyes. She's greedy, alright. She eats whatever Benta gives her out of the day's take and licks her fingers after. If she had the chance, I think she'd eat and eat until she could barely move. She'd become this big mountain of fat and flesh, like one of the goddesses in Chtai legends, waiting for heroes to climb her and fuck her.

She bends her body over me in a half-circle, so her palms are braced on the ground beside my head and her breasts are in my face. She scrapes a stiff nipple over my lips and I open my mouth to take it. Why not? Why shouldn't I take it? If I don't, she'll be angry.

"You like," she says, kind of breathing the words out. Sounds somehow accusing: "*You like....*"

Her breast is probably the only fat part of her body. It smells and tastes the way a breast gets when you don't wash it for days and weeks, but I'm used to that. I'd hate to tell you what I smell like.

Her nipple is maxum sensitive. It has this little oily taste I've gotten to almost like. And I know how Rii likes it licked. Suck it. Pull it with your teeth. Whimper a little while you pull. That really gets her crazy.

Rii gasps and calls me Baby (again). Tells me I like (again), and also that I good. I good Baby. I don't want to, but now I'm in the rhythm. Now I gasp too, and cry a little. It gets hard to think. Rii is bumping her ass in the air and her nipple is a hard spiky little peg rolling on my tongue. I give her a bite—I try not to do it too hard,

but it's hard to judge now—and she makes a kind of short scream that gets swallowed halfway through. She pulls herself off me suddenly and sits there. I can hear her rubbing herself and going whisper-whisper-whisper.

Things could go in one of two ways now. I could be fucked, or tortured first and then fucked.

Rii cuddles her body next to mine, slides her hand over my naked belly and nuzzles my ear, whispering still, but this time to me. I get a little scared suddenly because she's talking dirty. Which means she's still excited. Which means I'll be tortured first.

She tells me about my big cock, about how it gets wet at the tip when I'm hard (for some reason, Chtai women think this is crazy-sexy), about my balls and how hairy they are, about my asshole and how she'll roll me over and put things in it. She tells me about all the other things she can do to me, and will do.

Then I start crying, which isn't good. The crying's only started in the last month, it makes me sick when I do it. Not for why you think, either. Some people—civils—think a soldier crying is like a dog talking, but plenty of oldboys will tell you different.

I think the crying's partly whatever's left of the meds churning around in me, getting in a last couple of licks before my body finally flushes the last of them out. That's what I hate. Anybody would hate being at the mercy of their blood like that, making them feel crazy for no good reason.

I just get scared of Rii all of a sudden, of everything she's saying, and I think about where I am and what happened to get me here and then the tears start coming for real.

Rii pouts and rubs away my tears and scolds me like a mother. It's almost funny the way she does it, so I laugh, and Rii laughs, and tickles me and bites at my neck and belly until I scream laughing and I don't even notice her climbing on me, getting hold of my dick and putting it where it'll do the most good. She starts fucking me then.

And I'm hard for it. Even with paving under my back, cold and gritty through my blanket. Even with the wind through the alley

and all the smells and all my muscles aching, I'm a porno-man with a massive tireless super-dick for my lady. I know that's the meds too.

Benta lets me come, usually, when she fucks me. Not Rii—being younger, she's probably afraid I'll put a baby in her. And Benta takes her time. When Rii finally gets down to it, she doesn't ride me more than a minute or two. And she always gets on me the same way, always turns her face to the wall, or anyway over her shoulder. She won't look at me when she mounts me or when she rides me. Not sure why, maybe it's another Chtai custom I never heard of.

After she comes (loudly) she'll go to the basin in the corner and wash herself. Maybe spare me one last smile. She'll leave me pulsing, with aching balls. She'll splash some water on me, wash her juices off, to keep Benta from smelling her on me and pitching hell, but she'll do it so it teases, and she won't jack me after. That's another thing. She never jacks me.

I used to beg her.

$$\backsim$$

Benta found me in Golondi Square, a day after the big battle turned sour. I suppose I might as well say three days after the war itself was lost. No sense pretending other, because it was lost. Is lost. We've lost. If we hadn't, I wouldn't be where I am now. I'd be recuping in a medtech or already walking again, resting on the Parity's credit in a good pleasure-place on Reimi, with tall, sweet-smelling women giving me what a hero deserves. I guess Reimi is Chtai-held now. Little dark men selling noodles in the shadow of the Mellastyn monument. The little women with their bright parasols crowding Endace Way, chattering.

Or maybe not. Maybe it's even worse. Maybe there were more bombs, maybe the war's done damage to both sides. I think about that sometimes, like maybe that's the reason I've seen so few people—and no men at all—since that day.

The battle... I remember running with the others, pounding over the Square towards the Councilhouse stairs. The shouting, I

remember we were all shouting, screaming. Waving our rifles. I was excited, we all were, and I don't mean just whiffed-up but fucking fuck-anything horny. Hot in the loin department and break-a-board-with-it stiff. We told ourselves it was because we were doing it, we were taking the fucking *Councilhouse*, we were going to break the Chtai seat of power right in half.

That whole scene seems very strange to me now. Long ago and far away. For a long time after I remembered it in pieces, and sometimes I'd lose a piece for months and get another in its place before I lost that one. That's the meds again. Hell, it was all the meds, including our battle-horniness. We were all pumped full before tearing out. Not quite legal, even given that we were soldiers in the Parity's service. Their use was supposed to be limited, strictly monitored. But we didn't even think about questioning the docs when they shot us up.

We had just reached the stairs—that's when the light hit. A searing blast of it that seemed to swallow everything and then—not the thunder I might have expected, but silence. A maxum huge silence that seemed to do some swallowing of its own. I remember thinking—right as I hit the ground—that I'd gone deaf and blind. Then I had what would be my last thought for a long time, about rumors I'd heard in the ship coming over. How sooner or later one of the Chtai anarch factions would get hold of a Void bomb, and if they did....

I woke up eventually. I tried to roll over, and I couldn't. I couldn't move at all, and the position I'd landed in kept me from seeing anything but the sky. Black boiling clouds, edged with green fire. A few darting fliers. All I could hear was screaming, a lot of gunplay somewhere, and eventually nothing but silence. I lay there watching the sky get dark.

I figured out what had happened to me, kind of. I was broken. The docs had given me a whopping dose of regeneratives on top of everything else, enough to fight off the worst of my injuries and keep me alive. Maybe they interacted with the other meds in a funny way. Maybe it was something else, but either way I was paralyzed

without losing feeling. And I could feel, alright. No major pain, but little feelings that were just as bad, almost. I felt the itch of insects crawling over my face, of blood drying on my chest. Stones digging into my back. I would lie on the Square like a broken doll until I was rescued or until I died. Maybe before either thing happened I'd get to feel street-dogs eating my fingers.

I cursed for a long time, yelled for help, raved when I knew it wasn't coming, and then finally shut up. Fell asleep. Woke and watched the sky turn bright again.

Then a face, rising over mine like a second sun.

A Chtai face: dark-skinned, three blue dots tattooed over the squinting eyes, noisily chewing something it suddenly swallowed, like I might jump up and try to pry it out of her mouth. Benta.

That was my first look at her.

I call her the old lady sometimes, but you know, she really isn't. She's older than me, but not by too much, I could see that even that morning. But years of poverty had worn her out, and it was pretty clear she'd never had de Leon treatments. So compared to a Parity woman, she looked ancient. There was actually grey in her hair, something I'd heard about, but never seen before. She was skinny, mean-looking. I knew she was a looter, one of the Chtai who'd been made homeless by the war, turned out into the streets to survive as best they could. Now that the fighting was over, the vibrations from the bomb settled, she had come out—probably with a lot of others—to get what she could.

She said something to me. It took me a while to recognize the Chtai word for "live" and the questioning tooth-click. I guess she wasn't altogether certain, and I couldn't really blame her.

I couldn't nod and at that point I couldn't speak. But I managed to blink and she seemed satisfied by that; she grunted. She looked at me for a long time. Then she grabbed my crotch.

The way she did it was so straightforward it was almost funny. She kneaded and prodded at me, looking skeptical. After a while she seemed to lose patience—she tore my fly open and dug my cock

out. I gasped—more from the shock of cold air than from anything like embarrassment.

She considered my meat for a while, actually turning it this way and that so she could look at it from different angles. Then she spat in her hand and started rubbing me. I stayed soft, flopping around in her fingers. It was too cold in the Square, after all, and this funny little woman wasn't exactly porno-sexy. But then Benta reached back with her free hand and touched my cheek, the kind of thing a nurse or mother would do. "Chuu-uuh," she whispered, or something like it. If it was a word, I didn't recognize it. Probably just a meaningless piece of baby-talk. Something in me responded to it, though. I guess. I gasped again, and twitched very slightly. And for some reason, I got hard.

Thinking back on it, that hard-on probably saved my life. No question, it proved my value loud and clear. Without it, I probably would have been left to die out there in the Square. As it was, Benta grinned—first down at my hard cock, then at me. A big happy grin.

And then she got up and walked away. A second later I couldn't see her anymore.

I almost called after her. I didn't want to be left alone, I knew damn well she was my only hope for survival. But she came back before too long, unrolling a stinking blanket on the stones beside me, grunting and hissing as she pushed me onto it. More hissing as she took hold of the upper corners and pulled. I watched the sky shake and jerk as I was dragged.

I was taken down side-streets, past wreckage and a lot of corpses. Benta had to stop now and then and push me back onto the blanket—I would roll off if she didn't. Finally—it might have been hours later—we came to a narrow alley wedged between two crumbling, abandoned buildings. The place was littered with broken pottery, torn-up seating-cushions, a few ration-packs. Everything was scattered, most of it in bad shape, but you could see it all added up to someone's clumsy attempt to make a home. A tapestry had been strung up between the two opposing walls to make a kind of roof.

A girl was sitting hunched in the shadows, watching as Benta pulled me in. That was Rii. She looked scared—when she saw me her eyes got big and she jumped up.

I've never found out what these two are to each other. I guessed for a while that Rii was Benta's daughter, but their faces don't look much alike. Daughter-in-law, maybe, the husband dead in the war. Or maybe the two of them just took up together once the war started. Pooling their scraps, looking out for each other.

The old lady scolded her and finally, not looking happy at all, Rii came over to help. I listened to them. I had been taught Chtai Basic via subliminals during my initial training, but real people speaking a language don't talk the way they do in subs. The conversation was fast, hard to follow. Rii wanted to know who I was. Benta told her I was a soldier. Parity. The war. Was she stupid?

I knew the girl wasn't asking about who I was, but why Benta had brought me here. Didn't matter. A demonstration was coming.

Benta stripped off her dress, flung it aside, stepped out of her shoes. She was naked underneath, her thighs neither as skinny or as heavy as they could have been. The hair where her legs met was dark and—I was surprised by this—carefully shaped, not all shaggy the way I would have expected a street-woman's pubes to be. She must have plucked it. Her breasts were small and high, with hard brown nipples. Her feet stank of her rotting shoes, but they were small and neat—pretty little feet, actually.

Benta moved in a circle around me, scratching herself here and there. I had the idea she was showing herself to me, letting me get a good look at her. Then she got down and began working my cock with her hand again. That grin came back. She licked her lips and rolled her shoulders, making like a porno-girl.

I can't say I was surprised. And I got hard again, of course. I didn't expect to, but somehow I did. Benta said something over her shoulder to Rii and Rii giggled loudly, covering her face with both hands. Then Benta got on me and took my cock and guided it inside her. I tried to tell her no, don't, I don't want it. Don't want a dirty

Chtai streetwoman fucking me was what I meant, but I couldn't even get the no out.

She was tighter than I expected. And though I fought it all the way it felt good, as good as any fuck in a high-class brothel. I felt the muscles in my thighs tighten as they tried to thrust. Nothing doing. It's a whole different feel when you can't push your dick. The cunt seems wetter, somehow. The whole thing moves more slowly, that's the thing. It made me crazy that first time, thinking about how I wanted to roll us over and really drive into her. I was breathing explosively, gulping air and blowing it hard out of my nose.

Benta took her time. When she came, it was with a delicate, weirdly ladylike little quiver. She licked her lips like she'd just been fed something sweet.

She kissed me, after. Among themselves, Chtai don't kiss a lot. But the whores and streetwomen who might need to turn a few tricks have somehow gotten an exaggerated idea of the importance of lip-sucking in the Parity. Benta kissed me all over my cheeks, smacking and gasping.

"Ben-ta," she told me, and touched her forehead-tattoo so I'd know she was telling me her name. "Ben-ta-a-a kei... lu a-a wau? Nai-i ke." I'm Benta, who are you? You're a beautiful baby. Drawing the words out, slurring them, the way Chtai girls talk in pornos; apparently Chtai men think that's cute. I was being laughed at, teased.

She made Rii come over and kiss me, then. Come and kiss our baby, he is so beautiful.

It struck me then that Chtai do kiss their children.

Rii's kiss was a tiny little press of lips to my cheek that was strangely sexy. "Baby," she said, staring down at me. Soon her smile grew wider.

⌒

Benta finally does come back, nearly an hour after Rii fucked me. She snarls at Rii to put the lamp on, and when Rii tries to tell her there's almost no oil left she snarls some more. A moment later

there's light, enough to see Benta. The cloth sack she uses when she's out scavenging is empty, and I almost groan out loud. An empty sack means no dinner, for any of us.

But Benta's not alone tonight, the lamp shows that too. Tonight she has a guest. A woman, of course. I wonder, not for the first time, if maybe there just aren't any more men. Maybe they were all killed in the war. Maybe something in the war—some weapon much worse than a Void bomb—killed them all, all except me. It's a nightmare thought that—right now—makes nightmare sense. I think of all the worlds in the Parity, hundreds of planets and cultures. Not just Cthai-held, but held by Chtai streetwomen, all of them looking just like Benta and Rii, sitting with folded arms on mounds of rubble, picking at their toes and bitching at each other.

Benta's friend has short hair, dyed red. A whore. You saw a lot of that just before the war, supposedly the idea was to imitate Roxi Jandel, who was big in pornos back then. Of course porno-girls come and go like rainstorms, but once the war hit, the Golon whores had other things to worry about than keeping up with the latest Parity hairstyles. This woman has a little party dress now gone mostly to rags, and an old shoulder-bag that she keeps clutched to her side, like someone might run in from the street and snatch it from her.

Rii seems to recognize the woman. Goes right to her, squealing, and gets hugged. But Red doesn't really seem interested in the reunion. It's me she's interested in. As soon as she can she tears herself away from Rii and kneels down beside me, cooing. I jitter my eyelids at her. She strokes my cheek and her fingers trail down to my chest, work over the muscles there. Then down, over my belly and to my warm, half-hard cock.

Oohs and aaahs. Piercing giggles. By now Benta is at her side, whispering to her. Red whispers back, but her eyes never leave my face, even when the whispers get a little agitated. Even when they're almost shouting at each other, and Rii sits back on her heels, nervously gnawing a thumb, Red keeps staring at me.

Benta grabs my cock and keeps saying hard, he's always hard. And there's another word I can make out... *kuomoi*, that's it. A word that best I can remember means a little bit of fat on a piece of cooked meat: tasty, that's what it means.

Finally Red breaks our gaze. Stares at Benta for a little, then takes something wrapped in dirty paper from her bag, hands it to her.

Benta unwraps it and I can see it's a pistol. Standard military issue, blow-your-nuts-off light-blaster. Impossible to say how many charges there are left in it, or if there are any. Red probably got it off a dead soldier—maybe Chtai, maybe Parity, it wouldn't have mattered to her.

Benta takes the gun and turns it over, frowning as she inspects it. She looks unimpressed, but you'd know looking at her that a master bargainer was at work. Even if the pistol is broken, it's maxum valuable; just the sight of anything like a weapon will scare hell out of other street-scavengers. Finally Benta sets it on a pile of other junk, nods, and chases Rii over to make tea. That's how Chtai doing business seal a deal: they drink tea together.

I realize I've just been sold. Rented out, rather. As neatly as that.

Red gets right to work. She makes it clear she's going to enjoy herself. She starts with all the tricks she would normally use on her customers, but now they're all for her pleasure. She strips for me, rubs her breasts, blows me kisses. Her body is bony and she smells, but she isn't all that bad. Not at all. Her eyes are big and dark, outlined with dark stuff that's probably not makeup, but ashes saved from her cookfire and mixed with oil. She has four blue dots tattooed on her forehead, and the little triangle that's given to Chtai girl-children who show signs of growing up to be really graceful and pretty. When she smiles at me it's with a funny little twisting of her lip that makes her look almost cute, like a kid up to mischief.

She prods at my belly, tickling me, asking me if I don't want to move. If I'm not going to get up and kiss her. She keeps saying, Are you going to get up? No? Lazy! Lazy boy! I don't tell her that I can't get up, any more than I can fly. I know I'll start bawling if I do.

I smile at her instead, big and sunny. I want her to like me. If she likes me, she might let me come. If she likes me, Benta will be happy with me, and Benta happy is a fuck of a lot better than Benta pissed. I get light-headed thinking how I want Red to like me.

But it becomes clear that Red isn't interested in fucking. Instead—after she's managed to get me good and hard with her little show, she starts playing for real.

She takes something out of her bag, a tiny case of polished wood. She opens it and shows me what's inside. When I realize what red is showing me, I almost start crying for real.

There's a whole Chtai subculture that revolves around the *hzei-pahlo*—the delighting needles. They're really old, something invented centuries ago. There are whole long series of historical pornos about certain old Chtai noblewomen—"needle queens"—who specialized in sex-tortures with the *hzei-pahlo*. Some Chtai men are obsessed with them. I heard once about one high-ranking Pyandesh commander who gave a world to his favorite needle-queen. A whole damned planet.

The set of needles Red show me are obviously antique, but they probably still work just fine. They look ordinary, but they're charged with currents of energy that work on the nerves in funny ways. They can create any kind of sensation you might want your victim to feel—not necessarily pain. Supposedly some of the cruelest and most accomplished needle-queens drove men crazy with what felt like never-ending blow-jobs.

Red isn't a skilled needle-queen by any means. Maybe she wants to become one and needs someone to practice on. Maybe someone—another soldier would be my guess—did something to her once and she's been waiting for some kind of revenge ever since. Maybe she's just a little crazy. I think that's probably it, actually.

She makes me scream and laugh and cry. By now the last of the oil's gone and the alley is dark. There's a shape over in the distance that I know is Benta—sitting slurping tea and watching. Another shape is Rii, watching every movement of Red's hand putting the needles in my balls, the bottoms of my feet, around my nipples. The

needles are fine like hairs, and flexible enough so there's no risk of them breaking inside me. Rii whispers over and over to herself. I can tell she's taking notes.

⌒

After Red has finished with me, almost two hours later, she accepts a cup of tea. But she drinks it quickly and refuses—politely—Benta's offer of a refill. She wants to leave. It could be that she simply wants to make it back to her own territory before it gets too late, but she seems a little embarrassed, too. Before she leaves she glares at Benta and says something about "next time" and "remember you promised." Benta nods. I understand that the pistol must have paid for several sessions with me, to be enjoyed at Red's discretion.

The needles have left no marks and though I'm panting and sweating like I just ran a mile, I'm not in any kind of pain. Even though I'm not looking forward to Red's return, I feel this crazy almost-excitement, like I had just made it through a battle. Next time, I tell myself, I won't scream, even if she makes me come three times in a row again, squirting so hard that after I finish my balls feel like two crushed fruits.

But Benta is as happy as I had hoped she'd be. We have nothing but scraps for dinner tonight, but I get an extra biscuit shoved in my mouth, and as much tea as I want. Rii showers me with kisses while Benta sits and counts off names to her, giggling. Women's names. Kua. Deime. Geja. I don't know who these women are, but I can suspect. More customers—possibly other aspiring needle-queens. I have a feeling we're going to be having a lot of company over the next few weeks.

I'm cold. Rain is falling outside and sheets of it are blown inside on a cold breeze, splattering my naked skin. I complain loudly.

The women carefully pull me into the corner and Rii rolls out a special treasure: another blanket, torn and stinking, but heavy and

warm and more than big enough to cover all three of us. Soon we're rolled up tightly together, Rii's hand gently clasping my balls.

But I can't sleep. My kidneys ache from all the tea I've drunk and I have to wake Benta up, crying from shame. Benta scolds me for not telling her earlier, but she's not too angry. After all, as Rii sleepily reminds her, I can't help it.

Benta takes an old canteen and carefully positions my cockhead at the rim. I wait and then let go, listen to my water hissing against the metal. When I'm finished, Benta sets the canteen aside and wraps the three of us back up, gives me a kiss before she settles her cheek next to mine. It's wonderful to be so warm and safe.

Double Check

Pete Peters

The Queen's sealed order was carried by her personal page to the edge of the field. Under watchful eye the wax seal was breached, and the unfurled parchment passed to the gloved hand of a foot soldier. The soldier mouthed the words to himself, and cupped his hand to the ear of a signalman at his side. The signalman raised his drumstick and tapped a coded message to the assembled pieces. They'd stood in the fog at their appointed positions, their heads turned in his direction in anticipation of the order that ripped the morning air: Pawn to King Four.

Known as the King's Bishop's Gambit, the objective is to organize a powerful thrust along the King Bishop file. Any pieces ordered forward in this move would soon be encircled by opposing pieces. It's a reckless move, belying the cold calculations of the White Queen.

In his tethered ankles the pawn stepped mincingly to the square ahead. His oversized knee-high boots made sucking sounds in the mud. He was badly exposed, positioned between these two armies in the pre-dawn light. If he retreated to his side he would be beaten and would forever lose his rank as one of the Queen's favorite pieces.

However, if he followed the order the Black side would capture him and he would be taunted and brutalized in their rough hands. If his capture was well affected, and he lived, he would perhaps be feted at the table of the Black King. There was no point in questioning what to do. His forsaken fate was already determined by the will of his Queen and his ultimate desire to satisfy the hunger between her legs. He stood still in his newly assumed position, Pawn to King Four, and prayed for a merciful denouement.

The pieces on both sides awaited the Black Queen's response to King's Bishop's Gambit, none more so than the terrified white pawn. Through the morning mist the pawn could see the faint outline of the black pieces. The muck clawed to his boots as he leaned forward, his head cocked to one side, though he would not understand the opposing side's code.

The snap of the enemy snare came from somewhere in front. He grit his teeth and pinched his anus as if it would protect him from the implications of the sound which echoed off the castle walls behind him, where the White Queen surveyed the field from her private tower. The command was understood by the black pieces: Black Knight to King Five. The pawn's cock twitched and lengthened. He listened for a sign of what was to come. He tried to slow his breathing so he would not be detected. It was in vain.

The thump of horse hoofs pounding the ground sent tremors up his legs. The vibrations increased, lapping at his groin and vibrating along his feebly held steel. He had only a few seconds reprieve before a mounted black knight engulfed his horizon. He savored the terrifying moment as a searing white flash pierced his skull. He was felled with a blow to the head and lay bleeding. Before he could scream five foot soldiers pinned him to the ground, face down.

A tapered stone phallus with a lathed flange was slicked in warm oxen lard and inserted in his ass. A thin leather strap was wrapped through an incision in the base of the phallus. He was turned on his side. The two ends of the strap were pulled round each thigh to his front and tied many times around his crossed wrists, which were securely held by one of the foot soldiers. The final inches of each end

of the strap were looped round the base of his cock and tightened into a permanent knot. One of the soldiers stuffed a cloth gag in his mouth. Finally, he watched helplessly as his cock tip was painted with a horsehair brush dipped in diluted pine resin. Its radiating heat would keep his ember glowing for the inevitable pleasure of the Black Queen.

Wrapped in a Gordian knot of ingenious proportions, the pawn was left to squirm in the wet clay. Attempts to pull his arms forward to relieve the torque on his cock served only to further constrain his impeached anus. To relieve the pyramidal pressure of the phallus his one recourse was to pull back, causing his hardened cock to rear up in agony. The rising sun finally cleaved the morning mist, revealing to both sides the spectacle of the quivering pawn. Impressed by the drama of his capture, the Black Queen lowered her field glasses to her thigh and gasped. She would surely un-shutter her chastity belt to allow his unbowed thrusts in her salty pit.

This early sacrifice, and the pawn's brutal humiliation, set the tone for the day. The ensuing exchanges would be swift and merciless. The rules of engagement would be followed to the letter, as always. However, no rule could safeguard a prisoner once they were held in the labyrinthine chambers of the enemy castle.

As the pawn was carried roughshod over the field the white pieces imagined the torment he would endure in the days ahead, and speculated on the variety of attacks he would endure. Indeed, the black pieces would each have their turn. He would be held in multiple restricted positions. He'd be helpless against the multi-pronged tactical maneuvers the Black Queen urged her recruits to practice amply on freshly captured pieces. He was not aware, however, that his capture would be to his benefit.

This young pawn was a promising recruit. His own White King had witnessed his de-flowering. But his fine-hewn luster had worn thin with his Queen. He was in need of rough handling by seasoned hands if he were to attain his potential and fulfill the duties of a highly ranked piece in the royal chamber. The King, being of weak disposition, looked ashen as he watched his young pawn being

dragged away. The Queen prayed for the pawn. She prayed that his captors would avail themselves of his tender flesh, repeatedly. She prayed that they would prick his skin, and beat his thighs and ass with birch rods. She prayed they would mount well thought-out attacks on his square. She knew she would see him again, the fruit of a prisoner exchange, with newly learned tactics to service her and the King. There was however the possibility of disaster in playing this game.

Returning captured pieces to their rightful side carried a risk. While in the hands of the enemy a pawn might have turned. They would have been instilled by their captors with a distaste for their own King and Queen, and a wish to cause them more pain than pleasure. The turncoat pawn would conceal his secret until an opportune moment arose. In such a scenario the Queen might find herself the victim of one or more malevolent pawns. At the moment she becomes aware of her predicament it would already be too late to employ a tactical response. The depth of her moans and cries of despair would be evidence that a Queen was in the rare position of Double Check. It was an unlikely position, and one that each side relentlessly sought for the other.

On this morning the two Queens perused the battlefield through their field glasses and pondered their next move. They each caught a glimpse of the other from their opposing sides and exchanged a quick smile. They were locked in eternal combat, as they were on every other day. However, each was a master alchemist in the methods and modalities of eliciting pleasure. Their desire for further knowledge in this realm exceeded their desire to win in the battlefield. It was through the exchange of captured pieces that they were able to share their knowledge, as each captured piece bore a peculiar imprint of their captor's methods. Only through this connivance could they satisfy their deepest desires. For both Queens this would be another glorious day in their Kingdoms, followed by a deliciously sleepless evening.

Metamorphosis

Deb Atwood

Mystique had banned smoking years before, but still the lights shone dimly through particles that danced in the air around us, scenting the air with human sweat and arousal. My partner and I gyrated to the thumping low bass, holding the spot we had carved out among the other men in the overcrowded club. In the crush, we danced close enough that I breathed in the familiar scent of spice and musk from his skin.

He made me long for Jonathan.

It had been four years since I last danced. Four years of hard work, building my research and developing new technology. I built on my own groundbreaking cloning research, developing methods to use cloned cells to replace lost limbs, or force growth in infants who had never developed properly in utero. I worked long hours in the lab, and longer hours at home, on equipment borrowed and moved into my flat, hooked up to Jonathan's computer. Without him in my life, there was no one to remind me to pause and eat. I slept when I was tired, and ate when my stomach begged for mercy. I ran models overnight, not wasting one precious moment.

And after four years, the final calculations were complete. The serums were readied, the plans held carefully in electronic storage, waiting for me to push the button to begin. It would be my master-work.

And so I went to Mystique for a drink, and instead found myself on the dance floor with Peter, a young man so like Jonathan when we first met, fifteen years ago. The similarities between their features were jarringly perfect, aside from some small details, and height.

Jonathan was taller, at least an inch over six feet, close to my own height of six foot four, whereas Peter only came up to my chin. It was the legs that made up the difference; Jonathan had long legs, so our hips were of a like height, but Peter fit to me just a little low, so when I pulled him tight against me and ran my hands down his back I had to reach before I could settle comfortably at his waist, fingers slipping beneath the waistband of his slacks....

"You sure all you want to do is dance?"

He claimed my attention with his question and a soft knowing smile. I didn't release him, instead pressing a kiss to his forehead, feeling his dark locks against my cheek. Too dark, too rough.... Jonathan's hair was the color of milk chocolate, rich and thick, with a soft wave to it. This was more the shade of black coffee, and had a wiry curl. Still, he was warm against me, teasing me with curious hands across my back and buttocks, silently asking his question again while he waited for my response.

I chuckled, and used one finger to tip his chin, then lowered my lips to his. "No, that's not all I want to do. Is it that obvious?" I infused my tone with innocence, knowing that my arousal was more than evident as I held him tight against me. But this banter... even the sex that would follow... that wasn't what was important to me. I was aroused, yes. But not for this man.

I wanted Jonathan.

But it was Peter warm in my arms, his familiar scent all around me. Desire took me like a rush, and I said, "Come home with me."

He hesitated, for just a moment, then gave one swift nod, wiry curls brushing against my chin.

It was too soon for anything but sex, but maybe that was all I needed right then. This man, my bed. We hurried home.

We made it into my flat, no further than the living room, before he had my shirt open to kiss my chest. His skin seemed to glow, illuminated only by the streetlights outside my window, as we divested ourselves of clothing and settled on the couch.

He sat on my lap and I pulled him towards me, kissing him roughly, drinking in the taste of him; tequila had been Jonathan's favorite and the taste of it on Peter's lips was a potent aphrodisiac. My hands slid down his back, gripping his ass tightly in frustration when I found it too soon, his torso too short. He only moaned, taking it as encouragement.

He sought to distract me with his mouth and hands, sliding down my body, kneeling between my legs to take my cock into his mouth. He teased me at first, rolling his tongue around the head, then engulfed me completely and pulled with rough suction, seesawing back and forth in sensation. I closed my eyes, imagining rough skin beneath my hands instead of smooth, and seeking the mole at the base of his neck, just above his left shoulder, that wasn't there. I lost myself in the sensation of his mouth on my cock, and I used him to fuel my imagination with sensation. I let him try to be my Jonathan.

⟿

Peter liked to talk, as I discovered on our second date. We sat at one of the few tables in Mystique's dining room, his legs stretched out beneath the table until his toes touched mine. He had a tequila sunrise in one hand, and gestured with the other as he spoke, features moving in familiar animation. I smiled as he almost struck another patron in his enthusiasm; people had always needed to dodge Jonathan's lively conversational gestures.

He told jokes with an intensity that I craved to hear again, and I laughed at old favorites as if I had never heard them before, finding comfort in the familiar cadence of his voice.

We talked about everything except ourselves, until Peter began a game of give and take. His favorite food, then mine. His favorite movie—Creator, just like Jonathan—and I confessed it was a favorite of mine as well.

"So what do you do?" He leaned forward, elbows on the table, intent upon my response. "I know you work for the college, but what department?"

"Biology." His enthusiasm was infectious and I found myself smiling in return. Telling him of my research, and of the clinical trials we had just begun. Something in my words reminded him of a movie, and he was off again, chattering away with some story that held my interest not at all.

It was all foreplay, and I knew that he kept me entertained in hopes of bedding me again, and to be honest, I was tempted to dispense with the formalities and simply take him home, toss him onto the couch and rip off jeans which looked as if they had been painted on. Black jeans, too tight for public consumption. Wrong. They should be faded denim, made that way by years of comfortable use, not for a marketing ploy. Sneakers instead of heavy black combat boots. The devil is in the details, and the details were wrong, just wrong.

I realized that Peter waited patiently for an answer to something I hadn't even heard him ask. He swirled his goblet of red wine as he gazed over the rim at me and smiled. "The absent minded professor, aren't you? It's attractive... seeing you get all vague and gazing off into the distance like you're thinking amazing thoughts." He reached out, almost touching the gray at my temples as if to emphasize the image I presented, and then withdrew before his fingers stroked against skin. I tingled with his almost touch, hungered for more. It was a sweet gesture, and so familiar, with a brush of a touch against my cheek.

He wasn't quite right. But he would do. We could work things out, fix the things that were wrong.

His fingertips brushed my cheek again, then withdrew. "Were you thinking of him?" he asked quietly. Dark eyes searched mine, waiting for a response.

Jonathan. I still wasn't ready to talk about it, yet Peter waited, his expression filled with compassion. He reached out and touched my hand, stroking his thumb over the back of it in a gentle motion that brought back memories. Jonathan had done that to comfort me, knowing that simple touch said more than words ever could.

"Jonathan," I whispered. "His name was Jonathan."

"What happened?" Peter's voice was low and he leaned towards me. His foot had left mine and all pretense of seduction had fallen away. His youthful gaze was sweetly intent only upon my remembered pain.

"He's dead." I brought my other hand up, letting Peter cover both of my hands with his own. Still his thumbs stroked, and with my eyes closed I could let memory wash over me. "We had been partners for a decade when he was diagnosed with an inoperable cancer. He was gone in mere months."

"What was he like?"

I glanced up, meeting Peter's gaze. The pain of the past washed over me. "Jonathan was ten years younger than me. He was Italian, with a fiery enthusiasm and temper to match. Everything delighted him and he was determined to taste the entire world in his zest for life. He taught robotics at the college and we met when he came to me, looking for references regarding brain development. Before he died, he had developed a plan for his research, but he had not yet presented it for a formal program nor had he obtained a grant, so his dream died with him. Only his notes remain."

Dark eyes lit with sudden fire. "Robotics? I've been working on an artificial intelligence program for my thesis, and I was toying with taking it into the PhD program. If you still have his notes, I could..." His voice trailed off, fading into small nothing. "Oh. Right."

I withdrew, slipping my hands from his grasp. "Only Jonathan could continue his work." Pain tightened my throat, making it nearly impossible to force the words out. "Only Jonathan."

Peter stared at me, silent, eyes wide. Then he withdrew as well. He looked down and away for a moment, before coming back with a clear calm gaze. He no longer smiled, nor shadowed my pain. "I see."

There was silence then, and he stood, his fingertips settled lightly on the table. He tapped them, staring down at the space where they touched the wood in staccato tempo. "Perhaps," he began. He looked up, past me, at the wall behind my head, then off to one side. Then back to me. "Perhaps it would be best if we waited. Try again another time, when it isn't so painful."

I couldn't let him walk away. If he left, all was lost. Jonathan would be lost.

And even as I thought it, he turned his back on me and was gone.

ᔄ

I stared at the phone, uncertain. Lifted the receiver to hear the discordant buzz of dial tone, feel the cold plastic settle against my ear. I pressed buttons with one finger, checking each number in my planner first before I touched it. Seven digits, then it rang three times.

With a whirr-click, a machine picked up the line. Peter's voice, tinned by recording, floated down the ether to my ear. "Peter, Rafe and Shawn aren't here right now. Leave a message and one of us'll get back to you."

I hesitated. "Peter." I started to hang up the phone, then pulled it back to my ear. "I'm sorry. I'll make dinner tonight. If you're interested, be here by seven."

There was no rescinding the invitation once made. I settled the phone back on the hook and wondered if he would come. From the bedroom I heard the soft ding of Jonathan's computer signaling the end of its calculations. Everything was ready.

At seven o'clock on the nose, my doorbell rang. I opened the door and Peter entered, sniffing the air and sighing happily.

"You like garlic," he said, as he shrugged out of his long coat. "I'm glad to see it. I'm always disappointed when a spaghetti sauce shortchanges the garlic and basil."

Jonathan loved garlic, and I learned to love it too. "Of course." I took his jacket and tossed it over the railing. "Dinner's already on the table. I'm..." I hesitated, uncertain quite what to say or how to say it.

"I missed you."

I miss you too. I didn't say the words. Instead I took his hands and drew him close to me, wrapping my arms around him and pulling him tight against my hardening body. I let my kiss speak to my longing for who he could be, who he called to in my memories.

"I shouldn't have left," he whispered between kisses.

"I shouldn't have let you," I told him, caressing wiry curls. Soon, soon... "We'll talk more about Jonathan's research. I do have all his notes." My lips found the pulse point behind his ear, and I nipped his skin, felt him shiver against me. "Later..."

"Evan." Peter gasped my name, tugged at my shirt to pull it from the waistband of my slacks. I growled and captured his hands, pulling them roughly behind his back and holding him still while I plundered the soft skin of his neck and shoulder, kissing him until his stance softened and I had to hold him up when his legs would not.

"Have you ever been bound?" I murmured.

Slowly he nodded, eyes wide and trusting. His gaze followed me as I let him go and stepped away. "Is that what you want?"

"That and more," I told him. I caught his hand and led him with me to the bedroom.

He resisted, but it was only a token attempt; I could see it in his eyes. "What about dinner?"

"The salad's in the fridge, and the lid's on so the water won't boil over. We'll put the pasta in later. And spaghetti sauce only improves the longer it cooks." I pulled harder, and he tripped, falling against me. I wrapped my arms around to hold him hard, lifting him slightly. "I have brownies for dessert, if you're good," I whispered against the soft skin of his neck.

"I'll be good," he murmured back. "So good."

I twisted the dimmer for the light in my room, moving from bright glare to soft dusk. My one conceit, with a lover almost half my age, to use darkness to hide my greying hair and aging skin. We stripped in that near-dark, discarding clothes in hasty piles before we fell together onto the bed. I ran one hand down the side of his body, from chest to hip. "Do you trust me?" I asked.

He nodded once.

"Say it," I told him, eyes narrowing. My hand held still on his hip, fingers tight against him.

"I trust you." His voice was hoarse, eyes wide and watchful.

"Will you do whatever I wish?" I let my hand drift up to find one sensitive nipple and tweak it roughly.

He nodded again, rapidly. "Yes. I will do whatever you wish."

I slapped him on the hip. "Roll over, onto your stomach."

He did, knees coming up and in so that he half knelt there before me. I pushed his head down, placed his hands spread apart, fingertips close to the carved oak headboard. Ropes and leather cuffs hung from hooks on either side of the headboard, already cut to the proper length so that when I belted the cuffs about his wrists, he could no longer pull his hands back, nor together.

I positioned his hips next, lifting his ass high even as he stayed on his knees, spreading his legs apart. Then I bound him with cuffs that wrapped around both the tops of his calves and just above his knees, forcing his legs to remain bent. Ropes ran from the foot of the bed and from beneath, so he could pull neither forward, nor back, nor side to side. He would stay exactly where I set.

His breathing rasped loud in the quiet of my bedroom, quick and gasping for control. His cock raged hard even as I bound him to my whim. I laid one hand on the small of his back, felt his muscles jump beneath my touch. "Almost ready," I told him. "But first..." I drew a velvet mask from the nightstand drawer. I had commissioned it made for Jonathan, for the eve of our tenth anniversary. It fit snuggly around Peter's head, tight against his eyes, shutting out every hint of light and image.

"Evan," he moaned. He wavered, ass swaying before me, inviting me to touch him.

And I did. I knelt behind him, almost the perfect height for me to press against him. I scraped fingernails down his back and watched him writhe beneath my attentions. Felt him sigh when I reached beneath him to take his heavy length into my hand, stroking him until he tried to thrust against the restraints and push himself further, hard-

er into my hand. I slapped his ass for that, and he only whimpered and thrust again, filled with the impatience of youth.

I released him and curled over him instead, hugging him from behind, my arms wrapped around his chest, one hand settled against where his heart beat like a frantic caged bird denied its release.

It was time.

I whispered soothing words in his ear, soft silly sayings to soothe the hurt as I stepped away again, leaving him there on my bed, open and waiting. Wanting. He whimpered as I unlocked the castors on the computer cart, threw back the cloth that had hidden it from view, and rolled it close to the bed. A quick flick of a button and the machine awoke, ready and waiting for my instructions. I lifted long ropes of plastic tubing, hung them over the arm that stretched out from the desk, then found the needles at the ends. Ten of the tiny ones, barely an inch long and pale pale blue at the tips. Then thirteen of the larger ones, thick and red. Two green, for the spots at the base of his neck. I kissed each spot of skin, licked it and nipped it and soothed it with my tongue, before I let the needle bite deep. He whimpered with each, quivering beneath my touch with anticipation for the next; my lover nearly came from the kiss of the needle. I secured each with a bit of tape, until 25 strands hung from Peter's body, tethering him not only to the computer, but to a refrigerated instrument which would release perfect tiny droplets of information into Peter's bloodstream.

I looped them over the arm on the computer stand so that he could not feel the tethers, only felt the exquisite sharp pain as he moved and the needles moved with him, sending tiny shocks of pleasure through his body. He was ready. I stroked my cock with my hand, wanting him as much as he wanted me. So was I.

I clicked the mouse and the coordinated dance of program and biology began. Peter wriggled as chilled liquid pumped beneath his skin. I did not give him time to wonder at the strange sensation, distracting him with my hands parting his cheeks, thumbs pressing against his ass. "I am going to fuck you," I said quietly. "Tell me you want me."

"Evan," he groaned my name. "Don't toy with me now. Just do it."

"Tell me," I demanded. I reached for the tube of lubricant, spread it quickly before rising over him and pressing my cock into him.

"Fuck me," he said, then louder again, "Fuck me!"

And I did. I pushed into him as he clenched around me, muscles rippling in strange arrangement as his body danced to my design. I reached around him, caressing him into pleasure even as the shocks of pain and sudden change coursed through him. As I rocked forward, his hips met mine at the proper height, no longer too low. I sighed at the feel of him, reach up to brush my thumb over the mole on his left shoulder, just at the base of his neck. Yes, that was right. He felt right.

He shuddered beneath me, blood pulsing hard through his veins, so close to the edge of pleasure and pain. With one hand I reached forward to caress the soft chocolate locks that crowned his head. Wrapping my fingers in his hair, I gave a sharp tug, and he shuddered beneath me. So close. We were both so close.

I held him close with one arm about his belly, and with the other I stroked him, pulling hard with anxious thrusts. Faint beeps from the computer echoed my motion; the program was done. We could be done.

He cried out, a strangled sound of pleasure and pain, and thrust one more time. I felt him tighten beneath me, felt his muscles bunch; he gave a raw shout as he spilled onto the sheets, tightening around me until I pushed forward, pouring myself into him.

And in that moment I screamed his name.

Jonathan.

The Heart of the Storm

Connie Wilkins

The night sky arched into infinity. The stars in their distant, unfathomable intensity seemed more real to Rowan than the earth three thousand feet below. She swayed in the harness, heart pounding, lungs beginning to pump again now that the parachute had safely deployed. Elation coursed through mind and body like freedom, like power, like—like sex. Not that sex was anything but a faint memory these days.

Time, along with gravity, seemed to loosen its hold, and for a long moment she could imagine that the world she drifted toward was not the war-torn one she'd left.

Concentrate! Look down, check the terrain, anticipate your landing! Rowan wrenched her thoughts back to reality, but it was too dark below to make out many features on the ground. In the east, clouds edged with silver by the hidden moon towered in sublime indifference to the affairs of men.

She twisted slowly toward the southwest. There, along the Breton coast, dull flashes illuminated a smoky mist. Same old world, same war. The Allied bombers were making a run at the battleships and U-boats in St-Nazaire's harbor, a frequent enough assault that the

Germans might not suspect a diversion. Rowan wasn't the only agent being dropped over Brittany tonight. She breathed an uncharacteristc prayer for safe passage of the plane and soft landings for those who had jumped farther north.

Worry about your own landing! The breeze was freshening into a light wind. The terrain below blinked into visibility as the moon emerged from behind the clouds, illuminating Rowan's dangling form as well as the mushroom billow of the parachute.

Landmarks began to match the map in her head. Two streams converging at a certain angle; the spire of a distant, isolated church; a deserted road. The wind was taking her to the east, too fast! But better east than west, where the great marsh of Le Briere spread across 99,000 acres between the Vilaine estuary to the north and the mouth of the Loire to the south.

There should be a signal fire somewhere in the angle between the streams. No sign of it yet. She tugged on the lines, warping the shape of the 'chute, altering direction just slightly. Yes, there, a spark…gone…there again, a steady glow, not bright, but enough. They would have been watching and listening for the drop plane, and feeding the native peat into the fire in anticipation of her landing.

Or anticipation, at least, of someone's landing. They had not been informed that the explosives expert being sent from London was a woman.

Nature might not have suited Rowan for the roles of wife, mother, nurturer; but fate, she thought, had prepared her for a mission at least as vital. With a university degree in chemistry and post-graduate training as a pharmacist, she was well qualified to teach the resistance fighters of the Maquis how to make explosives with materials available at any apothecary. And, while she had been born in Cornwall, not France, her Breton grandmother had sent her to a convent school in Quimper in the vain hope of teaching her a proper level of feminine docility. Certainly she knew more about Brittany and the Bretons than someone from Paris or Marseilles.

It had not been easy to persuade the British SOE and de Gaulle's Comite National Francaise to let her volunteer for the Free French.

Obtaining additional training in demolitions had been even harder, but there had been no one better suited. She had worked tirelessly, persistant when necessary, steeling herself to feign docility when there was no other course, avoiding the least hint of scandal. The desires of the flesh had been reined in, painfully, by the fierce grip of her determination. What if she were a woman? All the better to deceive the Germans. If the men of the Maquis didn't like it—and, from her year at school in Brittany, she was sure they wouldn't—it was too late now.

Oh hell! Too late? Time and gravity reclaimed her suddenly, brutally. The ground hurtled upward. A gust of wind—the flash of upturned faces, and then pale mounds of haystacks looming beyond the circle of the fire's glow—Rowan drew up her legs, curled into a ball, and tried to propel herself toward the nearest stack by force of will.

The world, abruptly, was a maelstrom of choking dust and prickling straw. Her left ankle twisted beneath her. No time for pain! Reflexes from training kicked in. She freed her knife and slashed at the 'chute's lines. No point now in hauling at the mass of fabric to conceal it in the hay. If German voices approached, rather than Breton, there was nothing to be done but stand and face them. If I can stand at all!

At first there were no voices, only feet running through the stubble of the field. A flaring torch stopped a few feet away, its circle of light overlapping her. Rowan stood—yes, she could stand, just barely, painfully—and pulled the leather helmet from her head, brushing back a dark forelock as it fell across her brow. She could feel the eyes behind the light surveying her.

"Those London fools have sent us a woman!" The male voice was brusque with annoyance, but the words were unmistakably Breton.

So much for chopping my hair short! I knew I couldn't deceive them for long, but—not even for a moment? Relief overrode Rowan's irritation. She took a step away from the hay, staggered, and only just kept from falling.

"Hold up the torch, Joachim." This voice was authoritative, musical, and unmistakable female. Rowan, startled, staggered again, and

would have fallen if not for the quick support of a pair of strong, slender arms. The scent of a woman teased her nostrils. Long strands of flame-gold hair—or did they merely reflect the torchlight?—brushed against her face, their silken stroke sending shivers of delight throughout her body. She felt dizzy.

Am I hallucinating? Have I hit my head and don't remember it? Other arms moved her back to sit on the hay, and she felt a man's woolen shirt rough against her cheek. A low voice rumbled from his body into hers.

"Your ways won't work on a woman, Sylvie!"

The Brieron dialect would have been impenetrable to Rowan if Sister Amalie at the convent school had not been a native of the marshland. The language they had spoken together had had far less to do with words, though, than with touch, and Rowan had taught as much as she'd learned, which explained why she'd been made to leave after only one year. She doubted that Sister had ever taken her final vows.

"Oh, yes, my ways will work on this one." Sylvie's laugh was low and amused. "And if they did not, what of it? You are too suspicious of strangers, Joachim. There is no need to bind by charms those already bound by a common enemy."

Rowan looked up into eyes the deep brown of peat water, flecked with amber in the torchlight. She had understood enough to brace herself to be on guard. Breton folklore had been denounced at the convent school as mere peasant superstition, and Rowan had paid very little attention to such stories; still, hadn't there had been something about blonde fee women whose unearthly beauty ensnared mortal men? Only fairy tales, of course. But what strange folk had she landed among? If they themselves believed in charms, how was she to teach them the science of explosives?

There was nothing unearthly about the face laughing down at her, framed by bright waves of hair escaping from a loosely tied kerchief. Rowan's heart, or something not far from it, lurched at the sight of freckles sprinkled across a snub nose and a merry, curving mouth meant for joy. A queenly or angelic sort of beauty Rowan could have

easily withstood, but this... A tingle spread across her skin, then worked its way deeper, piercing layers of repression, stirring up barely-banked embers.

"Are you hurt?" Sylvie asked, in perfect cosmopolitan French, and then repeated the question in English. "Your ankle?" She knelt, throwing back the dark cloak covering her white skirt and simple smock, then ran her hands down Rowan's calf. Even through heavy leather flight trousers her touch burned like brandy, searing Rowan's leg all the way up to her crotch.

Sylvie gripped the injured ankle lightly, then released it. "Is this painful?"

"Only when you stop," Rowan thought dazedly, and then realized that she had spoken aloud, and in the Brieron dialect. Hadn't Sister Amalie used those very words once, when they were... Well. Now, like a randy dolt, she'd revealed what might have been a useful secret, along with something else that she knew already was no secret to this woman.

"Ah," Sylvie said, quirking an eyebrow. "Such pleasant surprises can be found in the oddest circumstances! But perhaps we shall keep some of this to ourselves." She made the merest gesture toward Joachim and a younger man who were busy hauling in the parachute. There would doubtless be some black-market dealer who would pay well for the silk fabric, with no questions asked.

"Of course, as you wish," Rowan answered in formal French, and then spoiled the effect by yelping as Sylvie's grip on her ankle tightened sharply, then eased. Rowan stepped reflexively backward. The ankle bore her weight now without the least complaint. Ripples of heat ran up her calf and pooled between her thighs, then dissipated as the imprint of Sylvie's fingers faded. Rowan very nearly whimpered with the sense of loss.

"Well," Joachim said crossly as he returned, "is she our bomb-maker, or is she not? And what are we to call her?"

"Could you speak more slowly? I'm not familiar with your dialect," Rowan lied cooly.

"Can you show us how make bombs?" he repeated impatiently in servicable French. "And what is your name?"

"Rowan," she said shortly. "And yes, if you can get me the materials I need, and follow my instructions to the letter, we will make explosive devices." She was suddenly very tired. "But not tonight."

"Of course not," Sylvie said firmly. "Jacques," she called to the younger man, who was hanging back, "slide the chaland into the water, please. We will meet you at the landing."

Jacques cast her a look of abject devotion, then hurried off into the darkness. "Come," Sylvie said, putting an arm around Rowan and urging her in the direction Jacques had taken. "We will soon be on the water, and then you may rest for a few hours until we are deeply and safely into the marsh."

The landing was merely a cleared space on the edge of a stream so narrow that the chaland, a flat-bottomed Brieron punt with its stern nearly as tapered as its prow, barely fit between the banks. The torches were extinguished, hissing, in the black water. "You will see well enough by moonlight once your eyes adjust," Sylvie assured her, brushing a finger light as a dragonfly's wing across her eyelids; and it was true, Rowan realized, as her night vision became clearer than she had ever noticed before.

Jacques poled the boat along the winding channel overhung by low trees. The two women sat pressed together toward the stern, sharing Sylvie's cloak, an arrangement that provided Rowan with more warmth than could be attributed to the woolen cloth alone. She wanted to relax into the moment, savor the feel of Sylvie's skin separated from her own by only a few layers of cloth, watch the play of moonlight over the ripples on the water and the curves of Sylvie's face. *If this be enchantment, which I do not believe, what of it? We all work for the same cause.*

But Joachim, sitting facing them, resumed his testy questioning. "How soon, then, Mlle. Rowan? How long must we wait?"

Rowan was too tired, or too distracted, to think clearly. Sylvie's feminine perfume seemed to evoke the spirit of some rare, night-blooming flower. "Soon enough," she told him, thinking that he

wanted details of the coming Allied invasion. "But they would scarcely tell me the time and place and then drop me so nearly into the lap of the enemy. We will have at least a month, I think, to prepare."

He shook his head vigorously and waved a dismissive hand. "No, no, how soon can you make the explosives?"

"As soon as I have the components. There must be apothecaries in some of the villages, and surely several if you go as far as St.-Nazaire or La Roche-Bernard. I will make a list, and you can gather the materials in amounts small enough to attract no attention."

Sylvie's hand had been resting lightly on Rowan's thigh. Now her grip tightened. "You know of the bridge at La Roche-Bernard?"

"I have heard of it," Rowan said, becoming more distracted by the moment. "The longest suspension bridge in the world, spanning the Vilaine Gorge. The town is far beneath, downstream along the river. I studied the maps in detail while I was in London."

"And do they know in London," Joachim said caustically, "that the Germans are stockpiling ammunition at their headquarters near the base of the bridge? And that they plan to begin transporting it in five days to the northern coast to fight off the expected invasion?"

"They know," Rowan said, although, in fact, she had not realized that the danger was quite so imminent. Five days! "So I am here, and we will be ready." *That great high bridge? And Maquis operatives to train who still believe in charms!*

"Yes, you are here," Sylvie said firmly, "at exactly the right time. And you will find that we have not been idle. There will be little or no chance for rest, though, in the days ahead, so we must take what we may now."

Rowan's mind was roiling. Rest seemed impossible. The stream merged with another, and then others, swelling into a small river, and the punt moved faster and more smoothly with the flow. Sylvie tucked the cloak closely around them, leaned her red-gold head against Rowan's dark hair, humming an almost inaudible tune; and suddenly, it seemed, Rowan was waking from a long, deep sleep.

Ripples of coral clouds streaked the brightening sky. Strong arms helped her from the boat. Not Joachim; the wide breast she leaned

against was unmistakably that of a woman. Through the mist of waking Rowan looked up into a face faintly lined by time and weather, topped by cropped steel-gray hair.

"Where..." but Rowan's voice felt rusty. She drew in a deep breath and recognized Sylvie's scent clinging strongly to the older woman, blending with notes of sun-warmed herbs. Had she been helped, too, from the boat? Or had they shared a deeper embrace? And whatever made her imagine such a thing, or care?

But she knew. Memories teased at her, of a discreet club in London where she had ventured once with a friend from University. Short-haired women in tweeds or loose trousers and waistcoats had come and gone with with pretty girls clinging to their arms. In the last two years she had not dared to return, in her struggle to remain above reproach, but only watched once or twice from a distance and then gone home with fuel enough for imagination so that by midnight her narrow bed was over-warm and her tangled sheets damp.

"You are on an island of safety," came the response, in a contralto voice edged with humor. Rowan, even through a haze of sleep and something close to jealousy, did not doubt that for an instant.

A girl of about nine or ten took Rowan's hand shyly and led her to a sprawling cottage with thatched roof and reed-strewn floors. She was shown a room where she could wash and tidy herself, and another where an assortment of shirts and trousers were laid out across a pallet stuffed with goose feathers. Rowan gratefully stripped off her flight suit and harness and found clothing that fit well enough. *At least I am tall enough for men's clothes!*

The child poked her head shyly around the edge of the door. "Corrie says to come and eat your breakfast. We are to have crepes today!"

"Is Sylvie there?"

"No, of course not!" It clearly seemed to her a foolish question. "Sylvie goes about her own business, and one must not ask!"

Oh? Well, I will ask, if the mission requires it!

Rowan followed the child out past a chicken coop into a tiny garden fenced by boards, their gently curving lines attesting to a former

existence as the sides of chalands. The gray-haired woman sitting at a wood-plank table must be Corrie. In this brighter light she did not appear so much old as poised comfortably between youth and age, dressed for practicality in the same sort of homespun shirt and trousers worn by Joachim. She looked up at Rowan, surveying her calmly for a moment as though to assess her now that the sunlight had strengthened, and then waved her to a bench.

I'll wager she knows everything there is to know about Sylvie, or is not afraid to ask!

The coffee was hot and strong, augmented by some herb Rowan did not recognize, but far more palatable than any she had tasted in London since rationing began. "No, thank you," she said when Corrie offered milk and honey. "This is too good to need sweetening."

Corrie nodded approval. "Here comes Claudette with our sweets, in any case, although you must try the honey sometime while you are with us. The wild bees of the Briere guard their gold well, but we still find it." The child set a tray of crepes on warm plates before them. Blackberry jam oozed from between the lightly browned layers. A dish of some darker strips with a slight resemblance to kippers was included, and when Corrie offered it, Rowan, feeling suddenly starved, decided not to ask, just eat.

"I should warn you that not everyone appreciates the virtues of smoked eel," Corrie said, a smile twitching at the corners of her wide mouth.

Rowan, feeling challenged, took a mouthful and chewed, undeterred by the crunching of small bones. The smoky tang made an odd but satisfying contrast to the sweet crepes. "You can't imagine what I've had to eat in London. This is a different world, in so many ways." She gestured across the table, then on toward the panorama of reeds and meadows and blue channels stretching languidly to the horizon, recalling the sense of being isolated from time, from reality, as she drifted downward under the parachute. The tranquillity of the marsh seemed unworldly, the only motion a rippling of water and faint quivering of rushes stirred by an otherwise imperceptible breeze. One could rest here forever... *Like the lotus-eaters of Lethe...*

The sudden honk of a goose broke the silence. On the far bank of the stream fluffy brown goslings scattered among the thickest reeds as two predatory herons soared overhead.

"Different from London, yes," Corrie said. "But we cannot escape the world even here." Her jaw seemed suddenly squarer and the lines beside her mouth no longer suggested smiles and hearty laughter. "The foot soldiers and tanks of the invaders will not penetrate here, but their planes still fly overhead. And while they could not starve us out, for the marshland supports its own, we are bound by ties of blood and friendship to all of Brittany. And all of France as well," she added as an afterthought.

Rowan's relief must have shown on her face. Corrie chuckled. "Did you think we had lured you into this watery maze to keep you from your mission?"

Something about the older woman inspired frankness. "I did feel some sense of being... lured. And Sylvie spoke of binding by charms." Rowan spoke lightly, but watched closely for Corrie's reaction.

"Did she? How careless of her! It's bad enough that the Germans think her a witch." Corrie seemed to be savoring some private joke. "Well, one who bears the name of the Rowan tree need fear no evil charms. And even if there are such things, they are clearly not sufficient to fight our battles for us. We need your bombs." She pushed back her chair and stood up. "Come along now, if you are quite finished, and I will show you what we have done to prepare. I'm afraid there will be little rest for any of us for many days and nights to come."

Rowan had known that Corrie was tall, but she was just beginning to appreciate her commanding presence. Sylvie was flame and grace and seduction; Corrie, she thought, was a weathered, sheltering rock who could transform into a raging lioness at need. *Where on earth is all that coming from? But oh, if I could only be singed by whatever sparks they may strike from each other!*

Corrie's broad form was well along a trail leading through a clump of alders by the time Rowan, ducking her face to hide its warm flush, caught up. The path led to a small cove on the far side of the island, nearly filled by a flat barge supporting a large tin-

roofed structure. Several chalands were squeezed in on either side, and men were unloading bundles onto the deck.

"Where better to assemble explosives than afloat in the heart of a marshland?" Corrie said cheerily. "And our factory is movable, as well, although not too quickly or far. We had to haul the barge here in segments." She trotted lightly up the plank. Rowan followed, feeling curious eyes surveying her.

Inside the building four women were opening feed sacks and splitting hay bales to reveal a wide assortment of pharmaceuticals, most containing acids and nitrates and chlorides in one combination or another. They clearly had at least a half-formed notion of what she would need. Shelves bearing more materials were built along two walls, while a large work table occupied the center, and pots and kettles of various types hung on racks next to a black iron stove. "There is plenty of peat for fuel," Corrie said, "but we have brought in coal, as well, in case hotter fires are needed."

"This will be excellent!" Rowan said, nodding in greeting toward the women. "I had expected to make do with far less. Given time, I could have made explosives with little more than droppings from the henyard. With what you have here, and whatever more you can get me quickly... Well, it will be a long four days, but we can do it, if you will follow my directions in every detail."

"Write me a list of whatever else you require, and we will send for it," Corrie said. "Do it quickly, though; a storm is on its way, but I think it can be held off until nightfall."

Be held off? Rowan knew by Corrie's sidelong glance that she was watching for a reaction. Let her wait. Rowan would do some watching of her own.

She made a quick survey of what was on hand, and jotted down a list of requirements, emphasizing especially the need for glass or ceramic containers. Then she turned to the instruction of her assistants. Their grasp of procedures was impressive; she had the notion that their experience went well beyond daily cooking chores when it came to measuring, mixing, testing, and isolating incompatible materials. One elderly woman in a starched white cap asked her what

words to say over a mixture, then laughed and shook her head after an admonitory look from Corrie.

By late afternoon more punts arrived with materials from Rowan's list. There were a few roads through the marshes, she was told, but the Germans had commandeered most vehicles, even horses and donkeys, so everything must be transported by bicycle from the more distant towns and villages to the landings where the boats waited.

Gray storm clouds were heaped on the western horizon, looming nearer as the day wore on. Corrie spent more and more time on the deck watching the sky. Finally she disappeared for so long that Rowan would have gone ashore to look for her, except that one of the women blocked her way, asking trivial questions that had been dealt with hours ago. Rowan suspected deliberate obstruction.

One more boat arrived, just past sunset, after most of the other punters had departed. In the distraction of unloading Rowan slipped away, intending to follow the path back to the house to look for Corrie on the pretext of asking whether dinner would be brought to those still working. When the track she took led instead slightly upward, she kept on, hoping for a wider view.

The sky grew suddenly much darker. Thunder rumbled in the distance. Rowan nearly turned back, but not far ahead she could see a gleam of light through willow branches. Hurrying on, almost certain Corrie would be there, she passed into the grove of trees and halted in surprise. A slender figure in white stood gazing into the rippling waters of a spring-fed pool. A small fire in a circle of rocks behind her illuminated the red-gold highlights in her hair.

"Sylvie?"

Without glancing up, Sylvie beckoned her forward. "Look," she said softly. Rowan gazed into the pool and saw, not a reflection of the willow branches arching above them, but a scene of dark towering clouds edged with vermilion, like embers from the fire of the departed sun.

Sylvie took Rowan's hand, turning toward her. The touch stirred Rowan's flesh, even as her mind whirled with the impossibility of what she had seen.

"Believe, or do not believe," Sylvie said gently. "It makes no difference. I cannot understand your magic of molecules and atoms, but I must still believe in its power, and make use of it."

"I thought Corrie would be here, holding back the storm," Rowan said, only now admitting this to herself, and refusing to examine the thought. Belief or its lack seemed irrelevant. Sylvie's closeness, the curve of her lips, the rise and fall of her breasts beneath her white gown, projected a magnetism owing nothing to the physics taught in schools.

"And so she was," Sylvie said, "but that is a wearing task, and she is not as young as she once was. I sent her to rest."

To rest? But Corrie isn't that old. And she said there would be little rest for any of us. Clearly Corrie too went about her own business, and one must not ask. Safer, of course, not to trust Rowan with secrets when she might yet be taken by the Germans; but still she felt a pang.

Sylvie's hand tightened on hers. "Are you disappointed to find me here instead?" The amusement in her smile told Rowan that she had no doubt as to the answer.

"No, of course not!" Rowan's hand was still in Sylvie's; she reached out boldly to take the other. Why not show some initiative? Shouldn't being charmed include some benefits? She gazed into Sylvie's amber-flecked eyes, aching to lean forward until her mouth was touching those full, tempting lips. Instead, she heard her own voice ask, as though from a great distance, "Are you and Corrie... close?"

Sylvie smiled again. "Oh yes. Very close."

"As close as this?" Now Rowan dared to put her arms around Sylvie, who did not resist but rather pressed her body closer into the embrace. Rowan touched her mouth gently to cheek and lips. Sylvie responded with an urgency that sparked a jolt of desire, and with mounting hunger Rowan kissed her all along the curve from chin to throat, and below, nudging downward the gathered neckline of her dress until the swell of round breasts showed pink puckered nipples, tender and firm, so sweet to the tongue...almost as sweet as the sound of Sylvie's breath quickening into sobs of pleasure.

Rowan's own breathing burst out into a sudden yelp as Sylvie clutched at her buttocks and forced her hips even closer, until thighs slid between thighs in an accelerating rhythm of thrust and parry. "Harder!" Sylvie gasped. "Quickly!" The very air sparked and tingled, charged with erotic energy. Heat flared in Rowan's depths, tension swelled, swelled, crested...they were riding the wave together...

A sudden crash of thunder drilled right through to their bones. "Quickly!" Sylvie shouted again, and with scarcely a pause for breath they were racing together down the hill, dodging great raindrops, until there were too many to evade. Sylvie's white dress glowed as though phosphorescent, leading Rowan safely through the growing dark.

They burst into the cottage with water streaming from their hair and clothing plastered to their bodies. Sylvie's lush curves glowed pink through fabric made translucent by the soaking, a temptation Rowan, still highly aroused, could never have resisted if the house had not been swarming with all those who had remained on the island.

Sylvie greeted everyone cheerfully, playing hostess once she had put on dry clothes. The women produced a meal in easy cooperation. Rowan answered questions about explosives and asked some of her own about the bridge at La Roche-Bernard, finding herself spending the rest of the evening bent over charts with Joachim as he drew diagrams detailing the bridge's construction and just how and where the Germans stored their munitions.

Corrie didn't reappear. Everyone went to bed early, wherever they could find a likely corner. The child Claudette and the oldest of the assisting women shared Rowan's goosefeather pallet, but she tossed and turned so, waking often from interrupted dreams of Sylvie in her arms—or, disturbingly, in Corrie's arms—that she moved finally to the reed-covered floor for the sake of her bed-mates.

There was little rest for anyone in the next three days. Rowan tried to be everywhere, overseeing the rough refinement of chemicals and the preparation of fuses, charting blast vectors and bridge stress points with Joachim and the other men who would be helping to

handle the final detonation, and emphasizing safety precautions over and over again.

Whenever her strength wavered, Corrie seemed to be beside her, smoothing misunderstandings, bringing order out of chaos, building confidence in those who needed it. She had a towering presence, at once commanding and kind, along with some further aura that made Rowan struggle to suppress a thrill of something between awe and longing. *Like a roedeer in the presence of a great elk! But I'm no bleating doe!* She mustered her own powers of science and of will, and maintained the authority that no one, least of all Corrie, seemed to question. *Dare I ask her to go with me to help when, inevitably, I move on to train Maquis groups in other areas? How immovably is Corrie bound to this place, by blood, by nurture, by... magic?*

Late every afternoon, just before sunset, Corrie disappeared into some private retreat. Sylvie would arrive in the early evening, often wearied by her own secret pursuits, but still managing to inject some degree of merriment into the brief time between work and what little sleep could be managed.

Rowan lay on her crowded pallet each night imagining Sylvie creeping at last into Corrie's bed, laying her bright head against the weary gray one and feeling those strong arms wrap around her, giving comfort, giving... but by then she would be asleep.

Corrie, Rowan suspected, was working on plans of her own. There had been mutterings about the certainty of reprisals for the bombing. The Germans were known to punish at random, with no regard to proof of guilt. Corrie had asked whether there would be unmistakable traces of fuses and their rough-made explosives after a successful detonation; Rowan had assured her that if the ammunition dump went up and the bridge came down, there would be no way to prove that God and all his Angels had not ignited the blast with their fiery trumpets, but the Germans would certainly have few doubts as to who was responsible.

"Would it be possible, however unlikely, for a lightning strike to do the job?"

Rowan stared, speechless. "If you can command the lightning," she said at last, "what need do you have of me?"

"What need? Let me think..." The first smile in two days softened Corrie's stern features. "No, I cannot command the lightning." She put a hand on Rowan's shoulder and gave it a brief squeeze that left a lingering heat. "That detail I must trust to you." And then she was off across the room to help a short woman lift down a canister from an upper shelf.

The band of saboteurs embarked in two chalands while the sky was still dark, the gently rippling channels lit only by the waning moon. Rowan did not question the feather-touch of Sylvie's hand across her eyelids, giving her the night-sight of an owl, nor did she hesitate to return the warm pressure of Sylvie's full lips on her own as they parted.

Corrie did not appear. *I can't believe she wouldn't come to see me off!* Some half-formed notion had begun to stir at the back of Rowan's mind, though she was not yet prepared to examine it closely.

By mid-morning Rowan rode in a farmer's cart filled with peat blocks and onions, pulled by a mule so old the Germans could think of no better use for him. Joachim and the others proceeded toward La Roche-Bernard at seemingly random intervals, on bicycles with panniers of garden produce. The concealed components for the explosives were divided into several sections. Only when all had met at a farmhouse, near the town but well off the main road, was Rowan ready to mix the components and bundle them into a long burlap sack well-wrapped with twine. Just past sunset she climbed into the cart again, holding the infernal bundle on her lap as though it were a suckling pig destined for a general's table.

A line of storm clouds had loomed in the west all day. Now, from the high bridge, they seemed to fill most of the sky. "We can't wait for full night," Rowan muttered to Joachim, and he nodded. They had planned to reconnoiter on the northern side, and then recross to the southern side after dark, but it could be pouring rain by then. *Is Corrie straining to hold back the storm? Or is it Sylvie's job by now?*

There was no other traffic, since most travelers knew enough to find shelter. Lightning flashed in the approaching clouds. Returning to the southern end of the bridge, the cart tipped suddenly, as though an axle had broken. While the farmer was unhitching the mule and leading it away, the twine-tied bundle slid between bridge and railing, to be lowered by rope down, down, far into the gorge, until it dangled just above a cluster of tin-roofed warehouses on the river's bank.

"Go!" Rowan ordered fiercely. "Get off the bridge, all of you!" No one dared challenge the blaze of command in her eyes. When all were clear, she struck a sulfur match, lit the long wire fuse, and watched to be sure the spark continued downward. Then, as thunder cracked and the first drops of rain began to fall, she leapt onto the waiting bicycle and pedaled for her life.

Ninety seconds and half a kilometer later, she huddled with the others behind a hillock, watching lightning slice across the clouds. Suddenly a flash brighter than any lightning bolt ripped the sky. The earth lurched beneath them, again and again, as pile after pile of munitions ignited, until a mighty creak and crash sounded through the smoke and rain and steam. The southern end of the bridge had split away from the land to crumble into the fiery gorge.

They tried to persuade her to stay through the night in a safe house at the edge of the marsh, but she would not be held.

"No," she told Joachim when he became too overbearing. "I will go back tonight. If no one can take me, I will pole the boat myself. How can I lose my way when such a powerful charm binds and draws me?" She stared him in the face until he had to look away, remembering his own words the night she had landed.

"Then I will take you," he muttered. "But," looking up again with the ghost of a smile, "the Corrigan never had need of any charm to bind you!"

The early sun sparkled on reeds and grasses still wet from the evening rain as they neared the island. Rowan sprang from the chaland when there were still two feet of water between prow and landing.

She barely paused at the cottage, where only a few were stirring. The path to the hilltop showed signs of passage since the rain; she had no doubt that Corrie knew she was coming, and the scent of strong coffee as she entered the willow grove made her even more certain. A glance showed a flask and two mugs and a napkin-covered basket set out on a flat stone beside the fire circle.

"We did it," she said simply, as the cloaked figure sitting against a willow trunk started to rise. "The bridge is down, the munitions are blown sky high, and in years to come there will be legends told of how lightning smote the invaders' stockpiled weapons."

"How does it feel to be a legend?" Hoarseness marred the attempted humor in Corrie's tone. Her amber-flecked eyes held a gleam of laughter, but her faced showed strain and her shoulders slumped with weariness as she stood. She had never seemed so...human.

"I'm still puzzling that out." Rowan went forward without hesitation and slipped her hands under the wool cloak, stretching her arms around Corrie's warm body. "Tell me how it works," she murmured, resting her head against the homespun shirt pulsing with the beat of the heart beneath. "Is it true that if a Corrigan's lover will still desire her in her daylight form, as well as in the seductive nighttime guise, they may live happily together?"

"So they say." Corrie's arms were around her now, but lightly, and her lips just brushed Rowan's dark cropped hair.

"But if I love you now, must I lose you?" Rowan moved her hands along Corrie's strong back and worked her mouth slowly across her shirtfront, making it clear that carnal love was definitely part of the package. Corrie stood quite still, barely breathing, although her heartbeat quickened. "Don't the legends say that the younger form becomes the true one, both night and day?" Rowan went on.

"Who would choose otherwise?" Corrie's tone was light, but Rowan sensed her tension.

"I would," she said firmly. "Sylvie is lovely, enchanting, and I would miss her, but if I had to choose, I would choose you." Her

hands lowered to grasp Corrie's wide hips and pull their bodies even closer together.

Corrie's arms tightened until Rowan could scarcely breathe. "Who believes the old legends? If there is love enough, I think, we can choose to be either, at will, though I have never seen it tested."

"You had better be right." Rowan felt her own heart pound and her blood race. "Because it's going to be tested now."

"Wait." But Corrie's moving hands didn't seem to be aware of her own instructions. "This is wartime. You know that once you've taught us to manage on our own, you must move on to other Maquis cells."

"Are you bound to this place? Could you come with me, to organize, teach, use your special skills, if they can be invoked elsewhere?"

"There are three more spring-fed pools across Brittany where the power is strong enough. But I could not stay away too long, while you..."

"There is nowhere I would rather be. Afterward, win or lose, we would come back to the heart of the Briere."

"If there is an afterward." But Corrie's mouth had moved to Rowan's cheek and was inching toward her lips.

"We had better not waste what time we have, then," Rowan said; and she didn't. There were no more words, only the fierce, sweet urgency of mouth on mouth, breast on breast, thighs rocking between thighs, hands thrusting hard and fast where the intensity of need demanded nothing softer. Questions would come, but for now they faded in the flare of desire. Only hunger needed answering..

The destruction of the bridge seemed to pale, for the moment, beside this

blaze of magic older and earthier than legend. An achingly short moment; there was still work to be done, and already little Claudette was calling from below; but when night came again, after more hours laboring side by side on the necessary contrivances of war, Rowan's dark head rested against Corrie's, still gray, on the goose-feather pillow while they found comfort and joy, if very little sleep, in each other's arms..

Alienated

Helen E. H. Madden

"I wonder if it's male or female."

Joe Rose studied the alien sitting at the end of the bar, trying to decide on an answer to his question. There were maybe a hundred different species that came through the Staten Island transshipping station where he worked, and Joe knew almost nothing about any of them. Sure, he could tell a Latian from a Grizzt, and he knew enough to never shake hands with a Raelian—if you did, you got a palm full of green goop—but he didn't know shit about the intimate details of their biology. All he knew was that he couldn't tell the guys from the girls just by looking at them, and this particular creature sitting at the bar was no exception. It had a lithe, fur-covered body that curved in all the right places and luminous grey eyes with long lashes set above high cheekbones. Joe could almost swear it was female, but there was something about the set of its shoulders and the way it cradled its beer that just screamed male.

"Man, I really wonder," he muttered again.

"So why don't you go ask it, Rosie boy?"

His drinking buddy, Hank Lawson, punched him on the shoulder and grinned. A few of the other guys around them laughed. Joe growled and hid behind his beer.

"No fucking way."

"Why not?" Hank urged. His rough face split into a leering grin. "If you're lucky and it's a girl, maybe she'll show you how they do it up there in outer space!"

Joe glanced back at the alien. He had to admit that would be pretty damned lucky. The thought of cuddling up to all that fur made his cock twitch, and he couldn't stop staring at the way her uniform hugged her body. Or was that his body? Christ, he wished he could figure it out.

"Forget it Hank, I'm not drunk enough to go ask."

"Come on, Rosie boy! You aren't scared of a little bitty alien are you?" Hank jeered. "Go ask it what it is, and then ask it for a fuck. I dare you!"

With a meaty hand he pushed Joe off the barstool. The rest of the guys cheered him on. Joe wanted to say no, but then Hank had said those three little words—"I dare you!"—and that was that. No way was he going to back down on a dare from Hank Lawson, especially not when the rest of the gang was watching. No fucking way.

So Joe picked his way through the mob at the bar, headed for the alien at the other end. Before he could reach her (him?), she turned and looked straight at him. The intensity of her gaze stripped away all his bravado and took his clothing with it. For an instant, Joe stood naked in the crowded bar, and the shock and embarrassment made him so hard he thought he'd come on the spot.

"Holy shit!" he muttered, unable to even move. Then the alien looked away. Freed from her paralyzing stare, Joe dropped his hands to cover himself only to discover he still wore his faded jeans and work shirt. He looked back at Hank, flustered. The big dockhand just grinned and flashed him a thumbs-up. The rest of the guys hooted and clapped as Joe squared his shoulders and went through with the dare.

"Hi," he said as he sidled up to the alien. "Care for some company?" She nodded and Joe slid onto the empty barstool next to her.

"Thanks," he said.

"You are welcome," she replied.

She had a nice voice, rich and melodic, one that sent shivers down his spine. It was a little too low for female, a little too high for male and the ambiguity had Joe squirming in his seat. Fuck, what if this thing was a guy after all and he pissed it off by asking about its sex?

"Come on, Rosie boy! You aren't scared of a little bitty alien are you?"

Scared? Him? Never. He stole a glance at the creature sitting next to him. She (he? it?) looked back expectantly, wide grey eyes mesmerizing him.

"Shall I pay for you?" she asked.

"Huh?"

She (Joe decided it had to be a she, because his cock sat up straight every time he looked at her) gestured to the empty mug gripped in his hand. "What do you wish to drink?"

"Oh!" He flushed as he tried to decide. "Beer, I guess. Lager."

The alien called to the bartender and tapped Joe's empty mug with a long finger that ended in a neat, tapered claw. Like a cat's claw, Joe thought as his drink was refilled. She looked just like a great big house cat in need of some serious heavy petting. Here pussy, pussy, pussy. Then he swallowed as he noticed how long the claw was and decided she reminded him more of a tiger.

The bartender wandered off and Joe peeked at the alien again. The neon lights of the bar poured over her cascade of shoulder-length braids and polished the short nap of auburn fur on her face and hands to a velvety sheen. Her uniform covered up the rest of her—a fitted blue jacket cropped at the waist, skintight white shirt, and gray leggings tucked into black boots with heavy tread. Geometric shapes embroidered the shoulders of her jacket, a sign of her rank he supposed, and a long line of swooping gold characters decorated her left lapel.

"Um, is that your name?" Joe asked, pointing to the script. His fingertip hovered over the spot where the characters curved over her rounded breast. That part of her definitely looked female. He wondered if it was covered with fur too.

"Kazen, Nashaetra clan, from Daesha. Navigator for the Torlance."

"Huh?"

"Kazen," she repeated slowly. "Nashaetra clan, from Daesha. Senior navigator for the Torlance."

"Oh, Kazen." Joe pressed his lips together and nodded. "From the Torlance? Nice ship. My crew just finished loading your cargo today. I'm Joe Rose, by the way."

His gaze flashed back to Hank and the guys sitting on the other side of the bar. The big dockhand laughed at him and waved. Then Kazen shifted in her seat, pulling a twenty credit note from her jacket pocket. Joe decided he'd better act fast if he was going to go through with this.

"Say, I was wondering..."

She stared at him again with those eyes and his earlier feeling of nakedness returned. Joe felt a thrill of embarrassment mingled with a little fear and excitement as he imagined her stripping off all his clothing right there in the bar, just so she could take a good long look at what he kept hidden underneath. Man, he'd undressed some women with his eyes before, but he could actually feel her hand slip between his legs to cradle his balls.

"What are you?" Joe blurted out. Then he winced. Christ, that wasn't exactly the smoothest pick-up line.

"Kazen," she answered. "Nashaetra clan, from Daesha—"

"No, no, I got your name. I meant, are you, you know, female?"

She stared, unblinking. His heart sunk a bit and his cock deflated. "Okay, are you male then?"

No answer but that startling gray gaze. Joe bit his lip.

"I just need to know, because there's something I wanted to—."

"Yes."

"Huh?"

He frowned. What the hell did yes mean? Yes, she was female? Or yes, she was male? Before he could ask, she stood up, dropped the twenty on the bar and then walked out.

"Go get her, Rosie boy!" he heard Hank shout. Joe grimaced, but his cock was straining against his fly again and Joe decided to follow where it pointed, out of the bar after Kazen.

He had to run to catch up. If she was female, she was pretty damned tall, taller even than him, with her long booted legs quickly carrying her down the block to a nearby hotel. Joe saw her disappear inside the building and he sprinted the last several yards, barely making it through the door in time to see her step onto the elevator.

"Hold it!"

He darted across the lobby, ignoring complaints from the desk clerk as he ran past. Just before the elevator doors slid shut, the alien reached out to hold them open.

"Thanks," he said, panting as he stepped into the car. The doors closed and Kazen pressed a button. The elevator began its slow, rumbling ascent.

"So, Kazen." Joe leaned back against the wall to catch his breath. "I didn't get your answer back there in the bar. Are you a guy or a girl?"

"Yes."

He clapped both hands to his head. "Okay, I don't understand that. Let's try this. Can you have sex with humans?"

"We are compatible."

Joe's cock jumped at that bit of news. "That's good! Would you, and I mean you personally, prefer to have sex with men or women?"

"Yes."

Did that mean she liked both? Joe shook his head, trying to figure it out.

Buttons lit up as the elevator continued upward. When it reached the fifteenth floor, the elevator rumbled to a halt and the doors slid open. Kazen stepped out and Joe quickly followed. "Perhaps I'm not making myself clear. Biologically speaking, are you male or female?"

The alien stopped in front of a door, room key in hand. "Daeshaen physiology is different from human physiology. This cycle, I produce

eggs as a human female would, but I would need to transfer them into a potential mate for insemination and gestation. Does that answer your question?"

"Not really." Joe scratched his head. "I think you said you make the eggs and put them inside someone else to have a baby."

She nodded. "Yes."

"But you said this cycle. What's a cycle? And what did you do last cycle if you didn't make eggs?"

"A cycle is a breeding period. It lasts approximately forty-two Earth months. During my previous cycle I could receive eggs from a mate, fertilize them, and carry them to full term to produce a child."

"Uh, with humans, it's the males that usually do the fertilizing and the women who carry the kids."

"So I have been instructed."

"But you're saying Daeshaen males carry the babies and the females do the fertilizing?"

"Not exactly. As I said, our physiology is different. We are not male and female as you would understand it."

Joe tried three times to open his mouth and utter an intelligent reply to that statement. In the end, the best he could come up with was, "Look, do you have a vagina or not?"

Kazen nodded. "I have genitalia similar to a vagina. You're interested in examining it?"

Joe blushed and laughed at the same time. "Well, yeah I guess so. In fact, I want to do more than just look, you know?" He leaned closer to her and traced the lapel of her jacket with a finger. "I'd like to..."

Ask her for a fuck! Hank's voice echoed inside his skull, making Joe flinch. Hell, that was crude. He had his foot in the door. He didn't want to screw things up now by being vulgar. He took a deep breath and opted for a more subtle approach.

"Kazen, I'd like us to be intimate. You know what that means?"

For the first time she smiled, and Joe's heart started to pound. "Yes, I understand intimacy. The question is, do you?"

"If I don't," he whispered, leaning closer, "I'd be happy to have you explain it to me."

He had to rise up on tiptoe to kiss her. Kazen parted her lips and let him explore her mouth with his tongue for a few moments. She tasted like cinnamon and fresh oranges, he thought. Then she pulled back and said, "I'll show you mine if you show me yours."

She sounded like a coy schoolgirl, but her face was dead serious. Joe wondered what she'd look like wearing that expression and nothing else and his cock started to throb.

"A little show and tell? That sounds good to me."

Kazen slipped the key into the lock and pushed the door open. Joe followed her in, blinking in the dim light of the room. It was a standard suite with a king-sized bed and two night tables, nothing out of the ordinary here. It seemed odd to him that he was about to have sex with an alien in a place so normal, but then Kazen seemed so strange that perhaps a mundane setting was best.

"Which of us is going first?" Joe asked as he followed her to the bed.

Kazen pushed him down onto the mattress and climbed on to straddle his hips. Her clawed fingers worked carefully, unbuttoning his shirt and stripping it away.

"Okay, I guess I'm first." His voice grew hoarse as he watched her reach for his belt. His fly was next, and it came open so fast Joe could have sworn it had undone itself. From beneath it swelled the bulge of his cock, imprisoned within the striped fabric of his boxers. A small wet spot already stained the elastic waistband. Kazen touched the wetness and sighed.

"You like that?" Joe breathed. He slipped his hands beneath her jacket, feeling for her breasts. "You like that I'm turned on?"

"Yes. The human sexual response is very intense, very pleasurable to share."

"Oh yeah? How many human sexual responses have you shared?" he asked, laughing.

Without waiting for an answer, Joe slid the jacket off her shoulders and began to tug at the skintight shirt she wore underneath. He peeled the garment away from her body and discovered the fur on Kazen's hands and face extended to the rest of her as well. Grinning,

he skimmed his fingertips up her stomach and around her breasts, enjoying the soft fuzzy feel as he drew smaller and smaller circles around her almost human nipples.

"You feel so good," he said, looking up into her huge gray eyes.

"You feel so good..." The words echoed back to him in a woman's voice, and all of a sudden Joe was on top, looking down at a brown-skinned girl with curly black hair. His hands reached down to cup her full breasts, gently squeezing the soft, buttery flesh.

His hands.

His hands were covered with auburn fur.

"What the hell!"

Joe sat up with a start, his heart racing. He looked at Kazen and she gazed back expectantly.

"What just happened? I saw a woman, and I think... I think I was you!" Joe blinked several times. "You made love to that woman."

Kazen nodded.

"And somehow you showed that to me? Christ, was that telepathy?"

"We call it intimacy," she answered. "A sharing of memory and experience."

She slipped a finger inside the waistband of his boxers and stroked the head of his cock. "You asked to be intimate. There are many, many experiences I could share, but I thought I should start with something familiar to you."

She found the slit of his cock head and pressed her fingertip against it, rubbing back and forth. Joe groaned and lay back on the bed. "In the bar," he gasped. "When you looked at me, I felt naked."

"That was... a challenge. To show you how exposed you would feel if you chose to be intimate with me."

"You knew what I wanted even before I walked up to you?"

"I felt your curiosity, very strong. I was glad when you answered the challenge. Curious lovers share the best experiences."

Joe shivered, suddenly understanding. "You show me yours, and I show you mine?"

"Exactly." She pulled down the waistband of his shorts to free his cock, and began rubbing the sweet spot just below the glans.

"You do this with everyone you fuck?"

Kazen nodded.

"Why?"

She paused. "Why does it matter to you if I am male or female? Humans call it sexual preference but we call it alienation. You cut yourself off from potential lovers for the most superficial reasons— gender, race, religion, age. Then you isolate yourselves even further by failing to connect with each other when you do celebrate intercourse. In fact, you do not celebrate it at all. You let your bodies perform the mechanics, but your minds never touch."

Joe shook his head. "Humans can't do what you just did. I can't put my thoughts into someone else's head. We just don't communicate like that."

"How do you know? Have you ever tried?"

He bit his lip. "I wouldn't even know how to begin."

Kazen leaned forward and kissed his neck. "You said if you did not understand intimacy, you would be happy to let me explain it to you."

Joe groaned. Her tongue flicked over his earlobe and her fingers went back to teasing his cock. "I did say that," he whispered. "But this... this sharing thing, I don't know."

"Do you want to leave then?"

"Yes. No. I don't know." He squirmed beneath her, trying to decide. "Can I see it first? I mean, I know this is gonna sound really superficial after everything you've just said, but can I see what you look like down there before we go any further?"

Kazen sat up and nodded gravely. "Of course."

She rolled off him and settled back on the bed. Joe reached over, released the straps on her boots and pulled them off. Hands trembling, he reached for her pants. They slid down her hips and legs like silk. Underneath, she wore nothing but fur. The auburn down of her belly faded to pale gold between her legs. At first, Joe saw nothing there but an uninterrupted surface of skin. Then like an orchid at

sunrise, everything blossomed. Four dark veined petals unfurled from the smooth exterior of Kazen's groin to reveal a crenellated bloom of moist flesh, tinted pale pink to dusky maroon. Its frilled edges pulsed and swelled, drawing his eyes down to its center where he spotted a small hard bud set above a narrow opening. Beneath that slit appeared a short fleshy stem that he could only describe as the stamen of a rare flower.

"You can touch it if you like," she said, spreading her legs a little wider.

Joe reached out a tentative hand and brushed the damp outer petals. They fluttered at his touch. Kazen moaned and he grinned like a kid on Christmas morning.

"It's sensitive?"

She nodded. "Just like the genitals of a human female."

"What about this?" His fingers grazed the bud. Kazen arched her back and gasped.

"That's very sensitive. As is this."

The stamen twitched and grew longer as he stared at it. Joe shook his head. "That's a lot more complex than what I've got. What do you do with it all?"

"Let me show you, if you really want to know."

Joe swallowed. If she showed him something, then he'd have to show her something. Did he really want to open up to an alien like that? He looked back down at the strange sensual flower burgeoning between her legs and reached out again to stroke it. Just before he touched it the outer petals wrapped around his fingers, pulling them all the way in. Shivering, Joe imagined what it would feel like to bury his cock inside those petals. What had Kazen said? Curious lovers shared the best experiences? He was certainly curious now.

"Okay. Show me."

Just like that he was Kazen again, this time kneeling between the legs of another Daeshaen, one named Seera with silvery blue fur that shimmered beneath the glow of two moons. Seera, so sweet and gentle, wanted to spend one last night making love before they shipped out on different vessels. Joe watched Kazen's hands reach out and

stroke the skin between Seera's legs until the outer petals of her sex opened up. Beneath the vision he saw his own hands following along, the memory of the blue Daeshaen superimposed over the real one lying on the bed before him. He continued to caress her undulating outer lips until both the remembered alien and the real one began to rock their hips and moan. Then Joe moved further inward, his fingers spiraling around the small bud of flesh he thought must be an alien clit. When he touched it, the bud released a pungent scent like ripe melon. Mouth watering, he leaned down to taste.

At the first lick, Kazen cried out and arched her back. Just like a human female would, Joe thought, and that sparked one of his memories. The blue Daeshaen faded and was replaced by Cheryl, his ex-girlfriend. Twenty-seven and still a virgin, she'd arched her back the same exact way the first time he went down on her. Then she grabbed him by the ears and pressed his face to her pussy, demanding more. Joe loved the way she tasted, like rosemary and olive oil. Just like mom's Italian cooking, he joked with her later—sharp, fragrant, and delicious.

But right now he tasted ripe fruit and he knew it was Kazen he was licking, not Cheryl. Cheryl left him two years ago because he wouldn't open up to her, she said. He shut her out, alienated her because he wasn't good at expressing his feelings, and even though he loved her so much it scared the shit out of him, he was still young enough to play the field and here she was asking him about marriage and kids and the future and why didn't he want to settle down and spend the rest of his life with her? It was the same damn argument over and over and over again until finally he told Cheryl she was suffocating him, so she said good-bye and faded away as a thick blue gelatinous mass took her place on the hotel room bed.

He became Kazen again, a Kazen that shook with fear as the gel overwhelmed him, smothered him and covered every inch of his body as it wended its way inside him. It filled every orifice he had—his mouth, his nose, even his genitals—sending him into a panic attack. I can't breathe! he thought, but in the back of his mind he knew he could. Oxygen passed through the viscous being that held

him, allowing him to respire without hindrance. His fear eased as he realized the gel wasn't suffocating him. It had simply submerged him inside itself to love him more completely. Within its fluid embrace, Joe felt endless ripples of electric current running over his body. His cock stiffened with each pulse, and the gel, sensing his excitement, wrapped more tightly around him, massaging and stimulating him until Joe thought he would pass out from sheer ecstasy. It was as if someone had taken his entire body inside their mouth to give him the ultimate blowjob.

Then he realized Kazen did have him in her mouth. Through the mirage of the gel he felt her lips glide over his cock. Gasping, Joe reached down to stroke her face. God he loved touching that velvet skin. It felt so smooth and soft, it reminded him of Hank Lawson's crew cut. Hank, the guy he played high school football with, the guy he went to college with, the guy who stumbled into his dorm room late one night while Joe was jerking off and said, "Here Rosie boy, let me show you how it's really done," and then he got down on his knees and started licking the head of Joe's leaking cock. He'd never felt anything so damned good as Hank's tongue running up and down the length of his dick, and when the big guy took the whole thing in his mouth, Joe thought he'd damn near explode. And he did, right inside Hank's mouth, but Hank just laughed as he swallowed and told Joe it was his turn and Joe said okay and he got down on the floor with Hank and went to work. Hank had a nice cock, longer than Kazen's stamen but that was changing because that little beauty just kept growing with every lick Joe gave it until it was just as long, though not as thick as Hank's cock, and then he was giving head to both Hank and Kazen and the sound of the two of them crying out his name as he sucked on them was like music to his ears. He and Hank made that music all night long, he recalled, but come morning they were both sober and the song was over and neither one of them could admit to what they'd done. The two best friends couldn't even talk to each other anymore so they went their separate ways, and Joe eventually dropped out of college his senior year and he didn't see Hank again until ten years later when he went to work at the Staten

Island transshipping port and by then they were okay, they could joke and drink but damn they never could look each other in the eye. They were alienated, cut off from each other by their stupid macho pride.

Pride, pride, stupid pride. It was stupid pride that got Kazen into trouble, claiming she could steer the Torlance even though she'd never set foot on a ship that big before. Well she'd steered it all right, steered it so close to Raelia's second sun that she'd scorched the hull and now the captain sat white-knuckled at his command post, too shaken to even swear at her and the senior navigator, Orxtl, scowled at her so hard that Kazen knew she was going to lose her license but a little while later old Orxtl pulled her into his quarters and teased her out of her uniform, laughing all the while because he'd done the same damn thing on his first flight out long cycles ago, except his captain actually shit his pants from fear. Kazen laughed too and then she sighed as Orxtl coaxed open her sex and played his long white fingers over her stamen cock until she was squealing with frustration and then the old man opened himself up and slipped her right inside his flowering pussy and rode her hard and fast until she came screaming inside him and afterward as she licked him clean he told her not to worry about what happened that morning because everybody made mistakes the first time around.

And there's always a first time for everything but you never know how it's going to work out. The first time Mrs. Minnever invited him into the house, Joe hadn't expected anything more than a glass of lemonade. She was a proper lady, a fine lady Mr. Minnever told him, and she didn't care for rude behavior which meant if Joe was going to cut their lawn this summer he'd best mind his manners. So Joe watched his language and said please and thank you to Mrs. Minnever, and every Saturday he mowed and edged three acres of Kentucky bluegrass all for the bargain price of fifty bucks a week. It wasn't much but when you were flat broke and headed off to college every little bit helped. Then one day Mrs. Minnever invited Joe into the house and told him she would pay a hundred bucks if he'd just take off his clothes and let her touch him. Mr. Minnever was out of town, he was always out of town, and Mrs. Minnever was so lonely.

Joe was a good boy, she knew that, a virgin she was willing to bet and when Joe blushed she laughed. Be a good boy for mama and take off your clothes, she said, and he did. Then Mrs. Minnever told him to undress her too, only he couldn't use his hands, he had to do everything with his mouth, and bit by bit he pulled off her clothes with his teeth to reveal that beautiful curvy body covered in auburn fur. Then Mrs. Minnever was pushing him back into a kitchen chair, placing his hands on her velvety breasts as she straddled his eager cock. Forty years old and still tight as a drum she bragged, and when the outer petals of her pussy reached down and grasped his cock and balls, he had to agree she was damn tight. She pulled him in deep into the flowery folds of her sex and rubbed her stamen against his prostate. I'm gonna come, I'm gonna come, he chanted over and over again, and Mrs. Minnever said there, there baby, come to mama, it's all right. When he was done she bent him over the kitchen table, pressed his face into its green formica surface, saying tit for tat, what's good for the goose is good for the gander, and he would have protested but the first dollop of lube had already hit him right between the ass cheeks and next thing he knew Mrs. Minnever, call her Barbara please, had two fingers inside him and it felt strange as hell but good too, and then she put something else in there, something long and hard that kept Joe rocking and moaning for all he was worth. And that, ladies and gentlemen, is how he lost two virginities in one day and made a hundred bucks in the bargain. In fact he made a lot of money that summer, and never regretted how he earned it until the rumors started. Barbara said he shouldn't care about what people said. She was leaving Mr. Minnever anyway and twenty-two years age difference wasn't that big a deal, not when two people really loved each other the way she and Joe did. But it mattered to Joe, it mattered a hell of a lot what folks said and even though he loved her he lied and said he only did it for the money. Then Barbara screamed at him and slapped him and said she hated him and they were alienated from each other because he was too fucking scared of what other people would think.

And on and on it went, from Joe to Kazen and back again, an endless stream of memories flowing back and forth, each one triggering another as they hurtled along. They were connected, with Joe on top plunging his cock into Kazen's beautiful alien pussy and her beneath with her long velvet legs around his waist and her stamen, her cock, sliding into his ass. Joe felt it stroking inside him and he laughed. What the hell did it matter if Kazen was male or female? She was in him and he was in her, and he couldn't tell anymore where one ended and the other began. Their desire had fused them together into a complete circuit of trust, intimacy and love. And Joe did love her, he really, really did. Then they both shuddered and the petals of Kazen's flowered sex convulsed around Joe's cock while her stamen thrust into him one last time. Joe cried out and shot his seed deep inside her as he flew through the last of their shared memories to land safely in her arms.

〜

He walked Kazen to the docks the next morning and kissed her gently before she boarded the Torlance. Joe was back to being Joe and Kazen was Kazen again. They were two separate beings just like before, but connected now in a way he'd never known was possible.

"I'll be back in three weeks," she told Joe.

"I know. I'll be waiting." He pulled her close again for another kiss. "Thanks for last night. It was amazing."

She ruffled his hair and smiled. "You are welcome. Now share it with someone else?"

"Okay."

He watched her board the giant freighter and then turned to walk away. Hank Lawson waited for him at the end of the dock, a look of astonishment plastered on his broad face.

"Hey Rosie boy, what the fuck happened last night? You never came back to the bar."

Joe nodded. "I spent the night with Kazen."

"Kazen, huh?" Hank scratched his close-cropped scalp and chuckled. "Well, well, well. I guess you got an answer to your question then. So what was it?"

"Hmmm?"

For the first time in years, Joe looked Hank in the eye. He gazed at his friend and called up the memory of a night they'd once shared a long time ago. The big dockhand blushed as though he knew what Joe was thinking, but he didn't look away.

"Hey, Earth to Joe? I said what was it? Spit it out. Was it male or female?"

"Yes," Joe answered finally, and he walked away grinning, knowing that Hank would follow.

Younger Than Springtime

Grant Carrington

He had tried to save himself.

"You've got to be less impulsive. You've got to think things through more carefully."

"Thanks. I'll think about it, old man."

A quarter was dropped in his hand and then he watched himself walk away. "Wait." He tried to follow himself but couldn't keep up and soon lost himself in the people on the sidewalk. Soon she would be laughing with himself about the encounter.

He looked down at the coin in his hand. It wasn't a quarter. It was a Susan B. Anthony dollar. He had never realized that.

"I bet you never even considered that he wouldn't listen to you."

The voice cut through him but when he turned around, she wasn't there. Instead an old woman was looking at him.

"It didn't work for me either," she said, "but I didn't really expect it to."

The familiar voice sent familiar emotions through him. "I never... I never thought that you would be here."

"Never crossed your mind, right? Still as impulsive as ever."

"No, not quite. It's hard to be impulsive when you've got a trick knee that could go on you at any moment without warning. But why are you here?"

"Perhaps I'm a little bit more impulsive than I used to be. I tried to tell myself not to be so anal retentive."

"I never called you that."

"But you thought it." Her smile was as quirky and comfortable as ever. "I didn't listen to me fifty years ago and I didn't listen to me now."

"You never told me that ..."

"It happened just after we met. I almost told you when you told me about ...that old man who had stopped you on the square but ..." She paused.

"You were too anal retentive." He tried to smile away the bite of the words. "But why are you here now? I mean, it was months ago when we ...they met."

"We can't return. I thought you knew that. We're here for the remainder of our lives."

"It just wasn't important. I didn't even think about it."

"Impulsive." She smiled again. "So, as long as I had to stay, I thought I'd come here and watch the encounter we had laughed so much about. That old man seemed to know so much about us. I didn't plan to say anything to you. That was... an impulse."

"So you're not as anal retentive as you used to be."

"And you're not as impulsive, perhaps. Age has a tendency to smooth things over, doesn't it?"

"Except for the pains." He sighed. "Do you have a place to stay?"

"I do. I've been here for several months. Do you?"

"No. I wasn't... I wasn't thinking."

She looked at him for a long moment. "Come along then. This time the treat's on me."

Her room was a simple one, just a few blocks away from the square. He couldn't help thinking that it was also just a few blocks away from where their younger selves lived. She sat down on the bed.

"I guess we sleep together again. There's no place else."

"That's all right. I can find a place of my own. I don't want to be any trouble."

"It's no trouble." She cupped his wrinkled face in her wrinkled hands.

↬

Her breasts now sagged with age but he could still see the firm full ones he had known when they were young. He touched them as though they were more precious than the rarest of gems. When they tired of talking about what had happened in the years since their parting, they finally went to bed, where they were surprised to find themselves capable, both emotionally and physically, of desires that they had thought were years behind them.

They made love with greater tenderness and more passion than their younger selves were doing at that very moment, fifty years in their past.

Make Work

Bryn Allen

Deep into summer, the sun was a gleaming hammer banging down on the black asphalt roads and concrete arroyos of LA, making it a bright sort of hell. Trapped in the sluggish circulation of the city's rush hour, that image did nothing to improve Sarah's edgy mood. Months of contemplation and counseling had caught her in a thin tissue of support and coaxed her out into the world again. Now that support was melting rapidly beneath the hot torch of August, and Sarah could feel all the anger that she had pressed down boiling up again, until it finally slipped free.

"Move that Gods cursed shit-heap!" The rusted Toyota that was blocking her attempts to shift over into the right lane finally seemed to listen, and slipped back a little. Sarah slammed down on the accelerator and forced her car to slalom forward into the tiny opening. From behind, brakes squealed and horns blared at her and the huge green Hummer that lunged into her space even as she was blowing out of it. Ignoring the noise, Sarah spun the car into a sharp right turn and barely managed to slide it into the entrance of the apartment complex that she was trying to reach.

In the lot and out of the car, Sarah stepped into the shimmering layer of heat that pooled above the asphalt and felt the gelid air pull the sweat out of her and into the dark wool suit she wore. "This is it," she muttered as she pulled out her heavy briefcase, trying to pretend that any of this mattered, that it wasn't just make work passed to her as a congratulatory sop for not having slugged anyone at the convent for over a month. "In and out and done." Striding towards the stairs, she unconsciously checked the feel of the holster strapped across her back. Make work or not, its presence reassured her. This Made worried her.

⌒

"Who is it?" came the voice from the far side of the door, a smooth baritone that barely cut through the white noise of traffic and air conditioning.

"Mr. Nu? I'm Sarah Volker, from the Mother's Church." She waved the vinyl case holding her ID and badge at the opaque glass eye set in the door. "It's time for your unannounced." The deadbolt popped like a shot, making her twitch, and then the door swung open on a room dark and warm as an oven.

"Come in, Sister Volker. Sorry about the place, but I wasn't expecting you. Of course." The man holding the door for her was young, Asian, beautiful. Dark hair and gleaming eyes, slim and muscular build, a face almost feminine in its smoothness but male in its hard angles, he was extraordinary even in a city where beauty was cheap. Sarah felt a stirring inside her, and it made her grit her teeth as she stepped in. She wanted to flee, or to smash her elbow into his welcoming smile, but instead she strode across his living room and dropped her case on his coffee table.

"I'm not a Sister, Mr. Nu, I... Our Father's balls!" As he shut the door, the stale heat of the place hit her, breaking her out of the spiel that she had been spouting all week. Terry was watching her, eyes shifting between her face and the dark case on his table, expression

faintly concerned, though it was unclear if that was for her or for what was coming.

"Usually I keep the air conditioning on, just in case someone comes by, but with the rolling black outs I haven't bothered." He walked to the thermostat on the wall and flicked it on. "I don't feel the heat."

"I guess not." She said it a little shortly, noticing that no sweat rose on his face or marked his clothes. Her suit, meanwhile, was rapidly becoming heavy with her body's desperate attempts to cool down.

"Why don't you take off your jacket and I'll get you something cold to drink? The air should kick in soon."

Sarah brushed back a damp lock of dark hair that had escaped her braid and thought about it. "Bottled water?" she asked, and he nodded. "Just bring me an unopened one then, please." He stared at her curiously for a moment, then turned and disappeared into his kitchen. Sara reached for her jacket, considered the hardware underneath for a moment and then shrugged. This wasn't a covert operation. She slid out of it, grateful that she had just a thin silk shell underneath and stepped closer to one of the rooms vents. The air coming out felt fractionally cooler, and she held her wrist to it as she watched Terry step back into the room with her drink. His movements were deft and silent, holding a fluid dark grace. Combine his motion with his looks, and he reminded her of a well crafted knife, pretty and dangerous. The feeling stirred in her again, stronger, and she pushed it away.

"This okay?" he asked, setting down a plastic water bottle next to her case. She watched his eyes flicker over her, face to breasts to hips and back to her eyes before even bothering to look at the weapons that nestled beneath her arms, the worn leather holsters that held her automatic beside her right breast and the blessed blade beside her left. She waited for a question, but he stayed silent.

Picking up the bottle and twisting the cap, Sarah felt the plastic pop reassuringly and took a drink. "Thank you. Well…" she tried to refocus on the speech she had begun, but the heat and his presence were throwing her. "Let's just get this over with, okay?" She took

another swig of water and then popped open the case, letting the dim light touch the dark leather and gleaming metal that coiled within. Her eyes watched him as he looked in, and she saw the flicker of anxious excitement that flashed across his face as the lid fell free. It brought her a brief flare of excitement, then an angry kind of shame.

"You're doing the full binding." Sarah pulled out one strap, felt its cold iron chains tap cool against her wrists, felt the silver runes stamped in the leather warm under fingers. Terry had smoothed his face, but there was emotion circulating there, a sort of dreadful interest that slipped out from under his mask. But no fear, or the dangerous tense eagerness that might signal trouble.

"It's what's specified in the Codex," she said, laying down the bindings. Her hands brought out the collar and his eyes dipped to it and then quickly back to her. "Do you have some sort of problem with it?"

"No," he protested, "No. It's just a little surprising. The others just usually contented themselves with a quick reading and some coffee. They were a little different than you. I think this embarrassed them."

Sarah shifted under the weight of the leather holster that was beginning to chafe with the dampness that had soaked into it from her skin and was tempted. She could follow their lead and leave him and this heat that much faster. There was almost no chance of harm. But her training wouldn't be so easily denied. "I think you're overdue then. Would you please…" she let it hang, but he knew what was required and began to pull off his shirt. She bent her head and fussed with the bindings, letting him undress on the edge of her vision. When he was done, she did her best to shove her mind into a state of detachment and looked up at him.

He was perfect of course, as only the Made could be. Faintly golden skin, unmarked by scar or blemish, lay smooth and hairless over muscles that rippled as he shifted his weight. Her eyes slid down to his groin, then jerked upwards to his face to find a faint, knowing smile. She wondered how well he could read the turmoil

of emotions in her, and the smile pissed her off. "Wrists out." He raised his arms, and she picked up the first restraint.

First right, then left, she moved quickly, uncomfortable with his closeness and angry at his body and her response to it. She yanked the straps tight, harder than she should, and she felt him stagger. He was lighter than he looked. "Sorry," she said quietly, but he just shook his head. She checked the straps, making sure that the leather kept the touch of the cold iron chains from his skin, then picked up the ankle cuffs and knelt down. A flare of warning went through her as she bent down to secure the restraints around his ankles, an uneasy acknowledgment that this was his best chance to fight her, and she welcomed the sensation as it took her away from the burning awareness of the closeness of his sex. Done, and she stepped back from him. The smile had faded into a frown as he bowed his head, hands flexing and muscles twitching nervously in his arms and legs as his attention drew inward.

"Now the collar," Sarah spoke quietly, reaching down and finding the piece of heavy leather and cold metal by touch, not taking her eyes from him. His concentration was drawing her, pulling at her from two directions. The old part of her, cold and dangerous, was made wary by it. The new part, hot and covetous, was inflamed. She stepped forward and wrapped the collar around his neck, fingers deftly flying over the buckles in a fit of tense excitement. Done, she reached up to touch the silver rune of command that gleamed on the front of the collar. She spoke, the Latin quick and light on her tongue, and like a cold current magic snapped out of the bonds. Terry shuddered at the touch, and for a second his form shimmered and blurred.

Nodding with satisfaction, Sarah reached back and found the water, raising it again and taking a drink. Nu had closed his eyes and was still, fighting the dictates of the magic and slowly losing. His shape blurred again, paled, and she set down the bottle. She didn't notice the heat anymore.

"Give me your name." Sarah's voice was quiet but stern, her best imitation of the nuns who had terrified her through her early training. Nu's face twitched and his tongue darted out, touching his lips.

"Terry Nu," he whispered.

"No." All week they had fought this, all the Made that Sarah had interviewed, no matter how docile they were otherwise. It was intrinsic to their makeup, branded on the spirits that animated them; they could no more surrender this piece of themselves easily than Sarah could have slit her wrists. Before, Sarah had simply sat back and waited, letting the bonds do their work. This time though, she couldn't. The passions and anger he stirred in her were too strong to let it go, and she reached out and pressed her fingers against the gleaming collar and ordered him again. "Give me the name your creator gave you."

He was curling in on himself while still standing, head lowering, hands fisting and pulling in, shaking his head with denial. Sarah clenched her hand around the collar and pushed her will into the rune below her palm, feeling it flare with the power she fed into it. "Name yourself to me. Now."

With a groaning sigh, his resistance dissolved, and his form with it. Flowing like wax, he slumped and changed beneath his dark bonds, his beauty replaced by another's. The woman now before Sarah was as perfect as he had been, with pale white skin and shining blonde hair, a body slim but rounded and ripe. The change finished, she shuddered and sighed and looked up at Sarah with eyes a wide, flawless blue, innocence threaded with want. Those eyes stared at Sarah with a rapt intensity that was all fear and desire. "Your name," whispered Sarah again, lost in the gaze of her captive.

"Teri Inhio. Mistress." A sharp stab of desire stabbed through Sarah's groin like a knife at the word, and she snatched her hand from the collar and spun away as her vision darkened with lust and despair.

⤵

"Is that all you need?" Sarah dropped the last binding into the case and shut it before turning toward the question. Terry had redressed while she packed, and was staring at her with curious eyes.

"Yes, that's it. You're clean." She plucked up her suit jacket and slid it on, pulling her damp braid out and resetting it over her back. "Thank you for your understanding."

"Of course."

Sarah shifted uncomfortably and then hefted up the case, fiercely ignoring the desperate echo of desire that still stirred in her. "Well then, I'll…"

"Ms. Volker, could I ask you about one thing though?"

She blinked, then straightened her shoulders and made herself look straight at him. "Of course. Is it about what happened with the…"

"No, I understand that. It always affects me that way. And usually my testers too." He grinned then politely ducked his head as Sarah felt her cheeks begin to flame. "I was just wondering if you would be working my case again."

"I don't expect to. I certainly hope not. I mean, I mean this is a temporary job for me. I may be leaving the church soon."

"Oh." He seemed a bit thrown by the answer, but knowing he was, Sarah thought it was probably more the torrent of emotions that had run through her during the response then the words themselves. He frowned, obviously thinking about leaving it there, but he continued. "Then, I was wondering if you might be interested in getting together some time. Dinner or something. If there would be no conflict of interest or anything."

Sarah stared at him, too dumfounded to really think it through. "You're asking me out?" she managed.

"Yes. On a date." He smiled, brilliant and beautiful.

Sarah opened her mouth, but whatever she was going to say was suddenly cut off by a sharp bark of laughter. Terry looked startled, then offended, and Sarah hastily shook her head. "It's not you, I'm just thinking about what the Mother Superior would say if… Fuck it. Serves her right if she doesn't like it. Why not?" A strange and

sickening thrill went through her at her assent, but some decent part of her still managed to slip forward. "I have to warn you though, right now I'm working through some things, some personal issues."

"Who isn't?" Terry's eyes flicked down to the case that Sarah held. "It shouldn't be boring at least. It's sudden, but what about next Friday?"

"I live in a convent," said Sarah. "Just tell me where."

ᔓ

The Mother Superior's office was dark wood, old books and heavy furniture, a dim cavern whose one window, with its green palm studded view of the convent gardens and the sea below them, was a bright incongruity. Seated before it, walled behind her massive desk, the dark robed figure of Mother Carol herself was simply a woman shaped hole in that light, the only clear thing about her the gleaming silver symbol of the Goddess she wore upon her breast. It was an office built to oppress, but Sarah had seen much worse and was used to it. Besides, she had no problem with being rude. "It's a shitty pile of make work."

"Made work, dear, not make work." The one problem with Carol having long ago given up on interacting with Sarah through her usual comfortable milieu of intimidation was that frequently she tried to use humor instead. Years of screaming threats at young nuns who were in the midst of training to battle the minions of hell was, however, poor preparation for levity. Sarah folded her arms and looked away from her nominal boss, refusing to deal with the pun, and Carol grunted and began tapping impatiently on her desk. "Look Sarah, you said you wanted something to do, so here it is. There are over fifty free Made in the LA area to keep track of. Making sure none of them have been turned is vital. A demon clothed in a body of thaumiplasm is a nightmare I don't need to have. Bloody shit should be illegal."

"The odds for that are firmly in the winning-the-lottery zone. A novice could do this work."

"One could. But if they happened to win this lottery, that novice would likely end up damned, and a third of this city with her."

"You don't think at least a third of this city isn't already damned?" muttered Sarah.

"Oh for the Gods' sakes Sarah, cut the crap already, please? We're all heartily sick of it. Look, I'm sorry it turned out that you're human after all, and that you can't spend all your time tearing the hearts out of demons anymore, really I am. You were very useful to the church, and much more pleasant to work with. But that's over. Try to move on, okay?"

Sarah gritted her teeth and stared at the rows of books on the shelves beside her. The words tore at her, but she had heard them all before. Why… began to echo through her again, but by now even she was sick of the complaint. "Fine. Fine. By the Gods, I hope I get to shoot one of them."

"That's my girl. I'll have their files sent along to you. Although…" Carol's voice trailed off, hesitant.

"What?" snapped Sarah. "I said I'd do them, I'll do them. Or is it too challenging now?"

"No, it's just that one of them was, well, made specifically for the sex trade."

"I thought most of them were."

"Many are. But those almost never break free of their spells and become autonomous. Only a handful of those made for sex have ever come under the auspices of the Codex."

"So what are you saying?" Sarah glared at the shadow sitting across from her. "I'm not some sort of sex fiend y'know. Or so I'm told."

"Of course you aren't dear. I just thought…"

"Send them all or don't send any." Sarah shifted in the heavy leather chair and rubbed a hand across her face. "I'll deal with it. And why the hell is it so hot in here today?"

"Is it? I hadn't noticed. Would you like something to drink?"

"Sure. Are we done?" For some reason Sarah was beginning to feel strangely nervous, the dark walls of the room seeming suddenly confining.

"Almost. I thought we could talk about this last Made. He calls himself Terry Nu." Behind Sarah the door clicked, and a young novice materialized by her chair, offering a plastic bottle of water to her on a heavy silver tray. Sarah stared at it for a moment, puzzled by it, then looked up at the novice, a beautiful young woman with long blond hair and a familiar face.

"Sarah?" Sarah tried to shake off the confusion that was gripping her and looked back across the desk. Carol had stood and was now a lean silhouette against the window. "He has some abilities you should know about. Are you still hot?" Sarah nodded, feeling the sweat now rolling down her body, soaking into clothes. "Child, please help Sarah get comfortable please."

The novice winked one brilliant blue eye at Sarah, than reached down to take her hands and pulled her to stand. Then she began to undo the buttons of Sarah's suit. "He's a shapeshifter for one," continued Carol. "His true form is actually female." The novice had slid off Sarah's suit jacket and silk shell, was now tugging down her slacks. Sarah held the back of her chair and stepped out of them and her shoes. "But he currently favors a male form, seems to date mostly gay men."

The novice had stood again and was staring at Sarah with a look of sweet intensity. Gliding forward, the front of her robes brushed against Sarah's breasts as her hands reached around and freed the tiny hooks of Sarah's bra. Slowly, she pulled it forward and off, her hands lightly brushing the sides of Sarah's breasts as she took it, sending a sudden electric quiver through Sarah's body. "He earns his living as a stunt double. With his body's resilience and his shape shifting, he's in high demand." The novice dropped the bra and reached out with her hand to trace the line of the leather holster that still rested against Sarah's skin. The touch was distracting; a blaze of fire, but Sarah fought it and shook her head no. The woman nodded, then ran her hands down Sarah's sides.

"And he's strongly empathic. He can easily read emotions, especially those dealing with sex." Under the novice's hands, Sarah's panties slid to the floor, leaving her naked except for her weapons. The Mother Superior had stepped around her desk and was leaning against it, her face a blur in the dark cowls of her robe. "Thank you, Teri. Are you feeling better now, Sarah?"

Sarah swallowed and tried to focus. Beside her, Teri stepped close, sliding behind her and running her hands slowly across her back. "What's happening?" she asked softly. The figure before her shrugged and reached up, pulling back its cowl. Beneath it, Terry Nu smiled at her.

"It's your dream, Sarah. Nothing that you don't want, unless it's a nightmare. But I don't think it is. Do you Teri?" Sarah felt lips press against the back of her neck, then one slim hand slipped around to cup her breast, the thumb running slow and heavy across her nipple.

"No." Her voice was a sigh, and her caress was making Sarah's body tremble.

"I..." Sarah began, trying to talk through breathing grown ragged. Behind her, Teri had wrapped her other hand around her waist and pulled her close, her hips moving in a slow grind into Sarah's backside. Her other hand still stroked her breasts, moving from one to another, tensing both nipples as her mouth pressed against the side of Sarah's neck, tongue flicking across her skin between gentle nips.

"Want to be fucked? We know." Terry stood up front the desk and his robes slipped off to make a pool of dark fabric below him. In the dim light, the smooth skin of his chest and thighs, belly and cock glowed. "So why not?"

Teri suddenly pulled Sarah back, sending them both sprawling into the soft leather of the armchair. Sliding around her like a snake, Teri wrapped her legs around Sarah's hips and between her thighs, then pulled them apart. Sarah sprawled backward onto the girl, Teri's arms wrapping around her and stroking her face and breasts while her legs opened Sarah's wide. As Terry stepped close, her lips brushed Sarah's ear with a whisper. "Relax. It's okay, it really is. Even if there

is a cost." Sarah felt the smooth skin of Terry's hips brush between her thighs, felt the silken head of his cock touch her, snapping all of her heat and sweat and desire into one yearning center.

Sarah's body quivered, pushing forward in its hunger to take in the man before her, to swallow him up and clench his flesh inside her, but she twisted against the lust. "I don't want to pay the cost," she groaned.

"It doesn't matter. You already have. You might as well get the reward, don't you think?" Teri's voice was gentle but firm, and then her hand pressed over Sarah's lips, silencing her. Sarah lost herself then, and her hips snapped forward, meeting Terry's thrust and taking him in as deep as she could, fighting for release.

﹏

"There aren't many like me." Terry Nu leaned back from her on the other side of the table, his face almost lost in the shadows of the dim alcove in which they sat. The tiny charm embedded at the top of the stucco arch that framed the entrance to the niche in which they were seated drew a curtain of silence down that thinned and muted the noise of the rest of the restaurant to a distant murmur. The effect had unsettled Sarah at first, but as the dinner had gone on, she had grown to appreciate the sense of intimacy it created in a public place, letting her and Terry chat about nothing, skimming through meaningless chatter about his work, LA and the weather. Only when their dinner was done and the coffee brought out had the conversation finally turned serious.

"Most of the Made that are created for the sex trade are little better than golems- their bodies may be well crafted, but the spirits that are bound to them are simple things, only a step above elementals, and the spells are basic. They're relatively cheap though, and satisfy most customers."

"So what about you?" asked Sarah. She knew much of the story from his file, but listening to him tell it was interesting.

"My creator wanted something special. Something that would increase his fame and his wealth. He wanted a submissive, one whose beauty and passion would not just rival the real thing, but exceed it. He succeeded, but went too far. The fey he bound to his perfect body was strong, and the spells he used to hold them together had to be stronger. He admitted to me that he knew what would likely happen as he wrought, but that he couldn't stop. He was an artist."

"So he made true. A spirit and body so intertwined that they formed a gestalt, a new entity, something truly alive. You fell under the precepts of the Codex, and became free."

"Yes."

Sarah looked down at her coffee and turned it slowly, trying to catch his features in a dark mirror. "I wouldn't have thought there would be so much to making a submissive."

"Sex slaves should be easy?" His voice was amused but edged with bitterness, and Sarah struggled to silence a defensive response. "Slaves are. A submissive is different."

"Okay." Sarah paused, then launched along a different line. "So why did you change yourself so much from what he made?"

"Am I much changed?" he laughed softly. "After I was free, I experimented. Different bodies, different attitudes. Adolescence is complicated for a shape shifter. Eventually I settled on this. Male, dark, dominating, so unlike my true shape. But not really. It's still there, below this surface. You've seen it."

"Does that bother you?"

"At first. But I grew up. I'm no different really than you humans. I was given a shape and a personality by my parent. I varied both as I grew, but I couldn't escape them. Terry Nu may be who I am, but Teri is who I will always be." The candle light flickered across his face as he leaned forward and rested his hand, warm and gentle on her wrist. "And so, using that as my segue, who, then, are you?"

Sarah ducked from his gaze, resisted the temptation to pull back her hand. "I'm just... I'm not sure, right now. I work for the Mother's church, now, but..." She shook her head.

"It must be difficult for a demon hunter to retire."

Sarah pulled her hand back and lifted her eyes, suddenly hard, to his. "How do you know what I use to be?"

Terry shrugged. "I just put it together. A woman who works for the Mother's church but isn't clergy, yet trusted to go out and examine Made to make sure they haven't been possessed. You live at a convent of the Sisters of the Righteous Blood. You carry serious hardware with you. Everywhere." He looked pointedly at the light jacket that concealed her holsters. "And you feel different than the examiners that have come to me before. They were like cops, but you're like a soldier, just back from the front. It's an open secret that the Mother's church will sometimes use non-clergy to handle its dirty work."

Sarah stared at him edgily, then sighed. "It doesn't really matter. Whatever I was, it's done now."

"Why?" He had relaxed visibly when she had sighed, a release of tension that he had well concealed until he let it go. It came back when she glowered at him again for that question. But she answered.

"I fell. I lost the thing that made it possible for me to fight. I…" She leaned back and shut her eyes. "When I was fifteen, my cousin joined the Bloods. I couldn't imagine anything cooler. When she came home after her novice year, I was all over her, and she was happy to brag about it. I asked her about the training, what the hardest part was, and she said that for her, worse than all the physical training and mental tests, was the vow of chastity that they had to keep for that year. She was gay, see, and being with all those tough, scary women really affected her. I laughed about it, and said that would be the easy part for me. She teased me, but it was true. I had no desire. Never was interested, never cared. She couldn't understand it, but it was just how I was. I had no lust in me. She mentioned me to the convent, and they sent someone to talk to me. And then they recruited me, but not for the order."

Sarah took an empty sugar packet from the table and began to shred it, remembering. "Nineteen years. Training and then in the field, hunting down every succubus, incubus and their ilk that the church could scent out."

"Demons that feed on the dark side of desire."

"Desire I didn't have." Sarah said. "Until about eight months ago."

"What happened?"

"Besides almost being gutted by a dybbuk in Tunisia? I don't know." Sarah frowned at paper between her fingers. "They never figured out why I had no sex drive. There were no obvious physiological problems, no mental problems…"

"I'd hope not," Terry muttered.

"You think the church would hesitate to hire psychos to hunt demons? Who do you think usually volunteers? Anyway, I had an edge, and I lost it. Thirty four years old and my libido finally wakes up, and it costs me my job, my purpose, almost my life."

"But you gained something."

"Sticky thighs and frustration? The demon hunting was more rewarding." Sarah flicked her hand, scattering the confetti she had made across the tablecloth. "I didn't want to change. I was useful before and now I'm just… not."

"Have you done anything about your new feelings?" he asked slowly.

"Looking for a deflowering?" she said darkly, then regretted it. "Sorry. Yeah, I did something. I thought at first maybe it was just a temporary thing, an itch I could scratch and go back to the way I had been. It didn't work out that way, and the experience wasn't all that great."

"First times, hastily done, seldom are."

Sarah shook her head, the anger she'd been carefully managing began to slip free. "Sex is sex. I don't care about it. I just care about not being able to do the one thing I felt like I was meant to do. I wish I could just forget about sex, go back to how I was."

"Then why are you here, with me?" His voice was soft, but he was looking her straight in the eyes. Sarah stared back at him, then stood.

"I don't think this was a good idea." Sarah turned from the table and began to step away.

"Sarah." His voice was a command, curt and absolute, and despite herself she stopped and looked toward him, the crawling tingle of the edge of the privacy charm brushing her skin. "There's something else. What?" She felt his dark eyes like knives, worrying through her for the answer, and without a word she turned and strode away, through the sudden noise of the restaurant and out into the dark heat of the parking lot. In the dim interior of her car, she stared at the glowing windows of the restaurant.

"Fuck him." She started the car and surged out of the lot, swerving around the bulk of a Hummer that had started pulling out of its space towards her and drove too fast toward the silence of her room.

∽

"Fuck me?" The restaurant was silent and empty, and Terry slouched alone at his table in the alcove and smiled at her.

"Your shirt's unbuttoned," she said.

"You're naked."

"Not completely." She crossed her arms beneath her breasts and weapons and frowned at him. "Is this going to be like last time?"

"It's your dream."

"I should wake up then. This is a waste of time."

"Okay." He leaned back and closed his eyes, gave a small sigh of contentment. "Still here?"

"Fuck you."

"You didn't answer my question."

"It's none of your business." She looked around the room, which was slowly darkening, the edges blurring into shadows. "Where's Teri?"

"You want her instead?" Sarah kept her pose and silence. He shrugged and the table before him frayed away and vanished. In its absence, Teri was revealed, kneeling between his legs with an arm wrapped around his bare waist, her mouth filled with him. Sarah felt her own mouth go dry and her crotch wet with the sight. "Why don't you tell your secret to her? She won't tell anyone."

Sarah stepped forward, staring down at the beautiful woman. Teri held the base of her other self's cock and slowly took the tip of it in and out of her mouth, eyes closed in concentration. She watched until the girl opened her eyes and looked up at her. Teri smiled around the organ that filled her mouth, then with a soft wet sound pulled herself away. "I'm glad you came back Sarah. We've missed you." Her hand reached out and took Sarah's arm, the cold iron of the chain wrapped around the cuff on her wrist chill against Sarah's skin. "He's ready for you." Gently but firmly, Teri changed their places, putting Sarah between Terry's legs, her lips an inch from the wet heat of his cock and began to lift her hand to it.

"No. Not like that. Strip her." Terry's voice was as hard as his sex, and when Sarah stared up his eyes were dark gleaming stone. She felt Teri's hands slip up her back, pull at the buckles that held on the holster, wanted to protest and couldn't, held by Terry's eyes. With a whisper the harness was taken from her, the weight of her power and authority gone and she was naked on her knees between them. "Hold her." Teri's small hands reached down and took Sarah's wrists, pulling them back and pinning them to the small of her back.

Now that she was pinned bare before him, Terry reached out and touched her. His hands traced over her face, maddeningly light, down her neck and then up and over her ears to the back of her head. Burying his fingers in her hair, he drew her forward, pulling her mouth down onto him.

Sarah smelled his scent, felt his smoothness as he bumped across her lips and teeth and into her mouth, filling it, then tasted the slick salt of him. She was held, helpless, caught silent on his cock, and her body shook with lust. She began to move then, taking him in and drinking him, licking and sucking until she heard his breath turn to gasps, until his hands held her still as his hips pushed his cock in to shudder its release into her.

When it came, his come was thick and hot and fast and she lost much of the first eruption in a wave from her mouth that fell over her chin and down to her breasts. Then she closed her mouth around him and caught the rest, taking it down. When his cock finally

stilled, she pulled herself slowly away from him and looked up to see him staring down, eyes soft and unfocused now. His hands released her head, sliding slowly off, one slipping around to slowly wipe across her lips and chin. He kept it in front of her, and she kissed it.

"Are we done then?" he asked as he watched her lick his hand clean. She stopped, and then shook her head as she pulled her lips from his skin.

"No," she said quietly. With a sharp jerk, she pulled her hands free and stood. She rubbed a hand across her sex, soaking it, then traced her fingers across his lips. "No, we're not." Her voice was distant and cool as she pulled her hand from his mouth and dropped it down, lightly slapping it across the end of his still solid erection. "So stay up." She then turned to Teri, who knelt and looked up at her, rapt, apprehensive, wanting. "Now you."

Stepping out from between them, she reached down and pulled Teri to her feet, then pushed her forward. Teri moved, unresisting, pushed forward until she was kneeling on the bench on which her other self still sat, her knees on the outside of Terry's smooth thighs. Sarah pressed down on her then, and with a low groan Teri sank down onto Terry's cock. They both moved, arching their bodies to each other, and Sarah reached out to press against both their chests and pushed their upper bodies apart. "Not yet," she commanded, then stepped up on the bench.

With a smooth, careful motion she swung between them, her back to Terry so that she could stare down at Teri. The woman looked up at her, blue eyes wide and hungry, and Sarah ran her hands into her hair. Behind her, she felt Terry press his lips to her buttocks, slowly kissing and nipping across them.

Never taking her eyes from Teri's, Sarah pressed back into his caresses until he pulled back to the cleft between her cheeks and pressed his kisses there. Then, with a low growl, she pulled Teri forward until her mouth was against Sarah's sex, their lips meeting in a kiss as Sarah thrust her hips into Teri's face. Keeping one hand on her head to hold her there, Sarah shifted the other to Terry's head behind

her, and balanced between them as they rocked, she pressed them both in to her need.

⤸

"…and then I came, and woke up." Two weeks after their first meeting, weeks of dreams, frustration and anger, and Sarah had finally snapped and called Terry again. He had readily agreed to meet her for lunch, and after a few minutes of silence she had launched into a halting confession of her dreams. Done now, she finally tore her eyes from the sweating glass of water before her and looked up at him.

Terry stared at her thoughtfully across the small table. The restaurant he had chosen was a quiet place, and the tiny outdoor patio in which they were seated was deserted in the early afternoon heat. It was quiet enough then that Sarah could hear the tiny knock of his knuckles as he dropped his hand, palm up, on the table before them. Her own hand twitched at the invitation, wanting to take it, but she didn't. "When you dream of sex, there's always power twisted in with it. Taking and being taken."

"Yes. Always." Sarah stared down at his hand and shook her head. "Years of seeing sex used as a weapon, wielded by the cruelest spawn of darkness. It's no wonder that when I finally had desires of my own that they were twisted."

"Twisted?" he said softly. His hand reached out now and grasped Sarah's, pulling it close. Sarah looked up at him, saw the anger and intensity in his eyes. "You think you're what… tainted?"

"Those dreams were tame compared to some I've had," Sarah shot back. "The two times I've had sex since this all started, fantasies like that were all I could think about, not what was going on at the time. I need them to come. This is what I couldn't tell the Church. That I had become… perverted."

"Oh for the sake of Father and Mother woman, shut up and listen to me." Terry's voice was a harsh snap. "You don't know anything

about sex. You've never had to before. These fantasies aren't pervert-
ed, or evil, they're barely into kinky."

"But I'm forcing…"

"Forcing people to get off with you. Or being forced to get off
with them. Horrors." Terry let go of her hand and pointed at her.
"Sex is a complicated thing. But let me tell you, telling good from
evil is dead easy. If you take your pleasure from someone, no matter
how you do it, be it plain vanilla sex or some vile torture, without
caring about them, without caring how they feel about it, if you are
just using them for yourself, that's evil. It can be a little evil or an
atrocity depending on how it's done, but it's wrong. But if your
desire is to make them feel good, if you know that what you're doing
is pleasuring them and that pleasures you, then it's good."

"But…"

"Sarah, I was made for this. Trust me. I've done things to people,
had things done to me, that would sound criminal. But they wanted
them done, and enjoyed them. I wanted them done, and enjoyed
them. Consensual, pleasurable acts are not evil."

Sarah stared at him, thoughts blurring and fighting in a whirl in
her head, her fear of her new desires battling against her yearning for
them. It disoriented her enough that she didn't notice the massive
SUV bearing down towards them until its bright grill was almost
touching the thin ornamental fence that surrounded the patio.
"Move!" she shouted, grabbing Terry's hand and yanking him with
her as she lunged to the side. He lurched after her, a protesting yelp
on his lips as they rolled to the ground, and then the truck roared
through the fence with a rending crunch, plowed over their table
and slammed into the wall of the restaurant. With squealing wheels
it lurched into reverse and pulled away, sending a shower of debris
over them from the crumbling wall.

"What the hell is he doing?" Terry screamed beside her as he
lurched to his feet, reassuring Sarah that he was probably okay.

"Just run," she yelled and tried to pull herself up, then was
slammed back into the ground with a surge of pain. Looking down
she could see a heavy pipe from the building had fallen across her

left shin, pinning her. "Ah, shit," she muttered, hearing a large engine racing, and her hand dove beneath her shirt for her weapons. As she was pulling them free, she saw Terry, who had started away stop and take a step back towards her.

"Sarah!"

"Just go! It's probably after me." Pulling her gun, she tried to twist to face the dark green Hummer which was lining up for another charge.

"Hey, asshole. Over here!" The scream, strangely familiar, brought Sarah's eyes away from the SUV for a second as it lurched forward. To her side, where Terry had stood, she now saw a mirror copy of herself, flipping off the Hummer and then turning to run towards the restaurant. The truck twitched and followed. Sarah hissed a curse and began to fire. One shot wasted, two and the front tire was shredding, three and the back blew out, but momentum carried the heavy vehicle forward to bury itself into the back of the building. In the instant before it struck Sarah saw her sudden twin leaping up and smashing through one of the wide windows that lined the wall, vanishing through a blizzard of flying glass just as the bumper of the SUV crunched into the brick below it.

When Sarah fought, the world turned slow and clear, and as the debris rained down she was on the move. Other foot and hand out, to hook up the pipe and free her pinned leg. On her feet, adrenaline drowning out the pain, and moving. Gun up, bullets stitched a neat row of stars across the driver's side door and blew out the glass, giving her an opening. Blessed blade up, and ready to drive into the face of whatever crouched in the seat before her. Then recognition, and she stopped, staring at the body slumped over the wheel and breathed as the world slipped back to normal around her. She made sure of the dead man, tucked her gun back in to its holster and reached in to take the keys from the truck, then limped slowly towards the restaurant.

"Sarah?" Terry was back in his own form, face twisted with fear and worry as he stood and stared out the hole that the Hummer had made in the wall. "Is the demon..."

"It wasn't a demon. It was a short order cook from Des Moines. And he's dead. How are you?"

"I hurt like hell. I think I have about a pound of plate glass imbedded in my back." He ran one hand over the back of his head, winced, and pulled out a large shard and dropped it to the floor. "Thank the Gods that thaumiplasm is tough stuff. Real glass is a hell of a lot harder than break-away. I thought for a second I was going to bounce off." He stared at the crushed front end of the SUV and shuddered.

"Is anyone else hurt?"

"They must have all ran out when it started. There's nobody here." Sarah muttered a quick prayer of thanks, then slowly staggered over to a chair which was still upright in the mess and sat down.

"That was pretty stupid Terry. Thanks."

"No sweat." He disappeared, then stepped out the back door and walked to her, still shedding bits of glass. He looked briefly towards body slumped in the humvee, shuddered and turned away. "Why was a cook…"

"He summoned up a succubus three years ago. It killed eight with his help before I got it. He got away during the fight. Must've carried a grudge."

"Yeah." In the distance sirens were already closing, and they could hear voices in the restaurant. "Look, Sarah, before the posse shows up, I think we should finish our conversation."

"What?" she asked, staring up from her prodding examination of her battered shin, unbelieving.

"You've been miserable for a while now. When your libido showed up, it made you lose the job that gave you purpose and scared you into thinking you were becoming akin to the things you were dedicated to destroying. I was telling you my opinion of that idea when this guy tried to kill us, and I got to see how you handled that. Sarah, anybody that can deal with something like this… you're not useless. It scares me to think what you might do with them, but you have serious skills."

Sarah blinked and shook her head. "You're a strange guy, Terry."

"I'm not a guy."

"Yes you are. One with some pretty serious skills of his own."
Behind them, Sarah heard wheels squeal and saw the flashing lights
as a squad car pull up. "Hands out and up. They'll be nervous." Terry
looked at her, startled, then raised his hands with her.

"What's going to happen?"

"Don't worry, I'll handle it. I have experience. In twenty minutes
we'll have someone going over you with tweezers."

"FREEZE! KEEP YOUR HANDS WHERE THEY ARE!"

"I hope…"

"No worries Terry." The sun was hot, and the air smelled of
asphalt, burned rubber and gun fire, and Sarah smiled a little as the
adrenaline shook through her system. "So when are you free next?"
He looked at her, face incredulous, but as she looked back she saw
his eyes flicker, from dark and uncertain to blue and hungry, and her
smile grew a little more.

The Digital O

Kal Cobalt

Rick stood at the bedroom doorway, pajamas in hand, mouth open.

Corbin and the Tal-Bot 4012 lay sleeping—at least, Corbin slept; Tal standbyed. One of Corbin's long legs, clad in neon-blue pajama pants, hooked over Tal's slender ambulatory devices. Corbin's hand splayed possessively over Tal's chestplate, which remained motionless without a whisper of breath in standby mode. The stale odor of hours-old sexual release permeated the sparse room.

This development, Rick decided, was not a good one.

The two of them—his lover and his lover's machine—took up less than half the bed. Theoretically, Rick supposed he could change into his pajamas, slide between the thermal sheets, and let sleep soothe away the aches and pains of the past eleven hours on robotics-repair swing-shift. But the available mattress space was just a byproduct, an unintentional result of the way Corbin tightly spooned against the service bot so much more enthusiastically than he'd ever clung to Rick. No. Sleeping in the space created by whatever bizarre event had transpired was out of the question.

"Corbin." Rick reached around Tal's titanium torso and shook Corbin's bare shoulder roughly. "Get up."

"Mm?" Corbin tilted his face toward Rick, squinting painfully. "Huh?"

"What did you do?"

Corbin blinked himself awake, then blinked at Tal, gazing down the bot's housing as if only now recalling anything out of the ordinary. "Okay." The word came out morning-hoarse, too groggy for Rick to detect regret or defiance. "Tal. Breakfast, please."

Tal's ocular covers dilated. Its motors whirred softly as it shifted into a seated position. "Good morning, Rick," it said in its standard first-speech voice. "Good morning, Corbin."

Corbin nudged Tal's shoulder. "Just go. Thanks." As Tal motored out of the room, Corbin sat up and ran both hands through his unruly hair. "Uh." He smiled briefly, looking up at Rick. "So something pretty cool happened."

Rick shook his head, trying to stop the rambling technobabble those words foretold. "Why was it in our bed?"

"Last night I worked on its approval/disapproval programming." Corbin scratched his thighs lazily, paying more attention to them than to Rick. "And... something tripped."

Rick settled into the chair by the foot of the bed, eyeing Corbin warily. Whenever Corbin tried to hide that half-satisfied, half-excited look in his eyes, there was trouble. Especially when Corbin looked like that before ingesting caffeine. "Something tripped." Rick struggled to keep his tone indifferent despite his jaw's urge to clench. "That's great. Do I have to repair it?"

"That's unfair. You don't even know what happened."

"We've had this argument before. You R&D guys never think through the consequences."

"Well, yeah, and you repairmen never want us to try a damned thing."

Rick took a deep breath. He'd fallen for it; here he was at the edge of the rambling technobabble despite his precautions. "Corbin. Tell me why the bot was in bed."

Corbin bit his bottom lip, still averting his eyes. "Don't dismiss this out of hand, okay? You know how quickly development occurs, when we're lucky enough that it does at all. We were working on approval, and then..." He shrugged one shoulder, his lips curving up a little. "It started responding to affection."

The bottom dropped out of Rick's stomach. "Affection."

Corbin nodded several times, easily slipping back into the safer realm of theory. "Yeah. We wound up with affection as part of its recognition matrix. Tal sees our affection and recognizes it as part of the complex approval system humans run. It can assimilate what's been modeled for it, so..."

Rick nodded slowly out of habit; it made enough sense from a technician's standpoint, though that wasn't what soured his stomach. "Why was it in bed, Corbin?"

Corbin hesitated, his eyes still lowered as another smile tugged at his lips. "We wound up with a developmental feedback loop. I taught it how to be affectionate and then used affectionate approval validations to encourage it. So it got even more affectionate, and the approval validations got even more affectionate."

"And it wound up in bed when..."

Corbin rubbed his hands together slowly, his head down. "After it jerked me off."

"Fuck," Rick gritted out, grinding the heels of his hands into his eye sockets. "Fuck, fuck, fuck." He blinked at Corbin through the multicolored spots left by the pressure, then shook his head. "No. I can't do this." He stood abruptly; he had to get out of here, had to breathe.

"Rick," Corbin pleaded, finally looking up, "I don't know what you're thinking, but this didn't mean anything, okay? It wasn't like that."

Rick rubbed his hands over his face, shoving his fingers up into his hair. There was no talking about this. He waved Corbin off, forcing his way out of the bedroom on shaky legs. Shit, and the change of scenery offered no relief either; Tal stood in the kitchen, unavoidable at its coffee-brewing station.

"Coffee?" Tal asked. It already held Rick's favorite mug in its life-like hand, the coffee camel-colored with Rick's preferred creamer.

"Yeah. Thanks." Rick slid the mug from Tal's grip and dropped into a chair at the kitchen table, elbows on the placemat.

"Would you like a blintz?" Tal nearly cooed the words.

"Uh. What?"

"Would you—"

"I heard you. No. I want the standard. I didn't ask for anything else."

Tal nodded—a peculiar gesture Rick had never liked, but Corbin was so damned proud of—and turned to prepare the food, its motors whining softly with the motion.

Corbin slunk into the kitchen around the far side of the table, making a subdued grasping motion toward Tal for coffee. "It knows you're upset," he told Rick, stifling a yawn. "It offered the blintz because it knows you're in a good mood when we have those."

"A blintz doesn't put me in a better mood, Corbin. It's what I want to eat when we're celebrating."

"Tough distinction for a service bot." Once Tal had provided coffee, Corbin slumped into the chair opposite Rick. "Look, I know you're kind of freaked out. Is it what we did, or that I did it without you, or..."

Rick frowned. Corbin's vagueness smacked of shame, but that hardly seemed right. Tal whirred softly as it made breakfast, and abruptly Rick recognized the connection. "You're being vague to spare its feelings."

Corbin nodded, sipping his coffee.

"It doesn't have feelings."

"Technically true. Its experience of affection is just pattern recognition. I think. I hope."

"I don't understand how you can think any of this was okay."

"I didn't have that kind of control. I had to decide whether to stop the progress or not. I didn't want to stop the progress. That's all."

Rick snorted, staring down at his coffee. Tal's fingers had just been on the mug, probably the same ones that had wrapped around Corbin's cock. "How altruistic."

Tal brought breakfast to the table: faux bacon and eggs for Rick, a bowl of cereal for Corbin. "Excuse me," it requested in its quietest tone. "Are my most recent upgrades the subject of this discussion?"

Corbin sighed, rubbing the rim of his coffee mug with his thumb. "Yeah."

Tal turned to face Rick, its ocular lenses zooming in tightly. "Are you unhappy with the result of the upgrades?"

"Yes."

"Rick, don't," Corbin pleaded.

"Will you repair me to your standards?" Tal asked.

"I don't think I can. This isn't like the other times."

Tal paused. "The new programming is the cause of a permanent error?"

"Apparently."

"Rick," Corbin snapped.

"Do you wish me to suppress the new programming?" Tal asked, utilizing the stress tone Corbin had built into its voicebox.

"Yes."

"No," Corbin insisted. "No, Tal. Rick, you're out of line."

"I will suppress the programming in Rick's presence," Tal suggested, focusing its ocular lenses on Corbin, then on Rick, its motor whirring softly.

Corbin shook his head. "No. You won't suppress the programming at all. You'll let your programming run the way it should."

"Rick does not approve." Abruptly, Tal covered its face with its hands, then slid its fingers up over the polished dome of its head, mirroring Rick's standard expression of frustration. Rick swallowed hard, startled by the curl of sympathy deep in his gut.

"Thanks a fucking lot, Rick," Corbin muttered, rising from the table to wrap one arm around Tal's shoulders. "Come here." He led Tal to the far end of the kitchen, turning its back to Rick.

Staring at the ugly yellow yolk of the faux eggs, Rick tried to muster up interest in his breakfast, but he couldn't ignore Corbin's soft, comforting tone. The two of them nestled in the back corner of the kitchen so comfortably, Corbin's fingers cupped around Tal's arm housing, Tal's head cocked just so as it received Corbin's soothing reasoning.

This was not the same Tal that Rick had seen the day before, and as Rick watched Corbin's fingers slide along Tal's titanium husk, he realized this was not the same Corbin, either. He'd seen tenderness from Corbin before, above and beyond what most R&D men could muster, but not like this. And Tal was... Rick hesitated to assign a relative state such as "distressed" to an artificial being, but at the very least Tal had lost a certain amount of inscrutability overnight.

"Tal?" Rick murmured.

"Excuse me," Tal told Corbin, patting his arm before turning. "Yes, Rick?"

"I'm sorry. I think I jumped to conclusions."

Tal's lenses dilated. "You find my upgrade acceptable?" It angled for the table, though its continuous eye contact gave Rick the fleeting thought that Tal could barely bother with the practicalities of mobility while assimilating Rick's approval.

"Yeah. It was just kind of sudden. Not the best way to get told about it."

"Sorry," Corbin murmured, still leaning against the kitchen counter.

Tal seated itself, gazing at Rick steadily. "You have changed your mind?"

"I don't know. I'm not sure how I feel, in terms of pure machinery versus intelligence, sentience—or even just... I don't know how to put it. Emotional awareness."

"Careful," Corbin warned, uneasily dropping into the third chair.

Rick shook his head impatiently. "This is the problem I'm having, Tal: Are you a toy, or are you a partner?"

Tal folded its hands on the table and made a soft clicking sound to indicate processing. "I am not programmed adequately to provide

an answer, but I may clarify the question. I may be useful as a feature of your existing relationship, or I may be a second distinct relationship."

It seemed even worse now that Tal could conceptualize the problem for itself. "I don't like feeling that maybe we're tricking you," Rick explained. "Telling you sex is good, so you decide it's integral to affection and approval and you need it, without having any sense of what it is. How did you feel about what you and Corbin did? The sexual activity. How did you process that?"

Tal clicked a few more times, forcing Rick to wait long moments for the answer. "I processed that as an extension of my scale of approval. I now recognize verbal, nonverbal, affectionate and sexual forms of approval and validation."

"Corbin programmed that into you?"

"No. I determined this scale based upon observations."

"Okay. Thanks, Tal."

Tal nodded, and Rick wondered what the end of the conversation looked like to Tal's circuits: approval and lack of command to interact further?

"Tal, would you take out the trash?" Corbin asked, patting its forearm. "Thank you."

"Yes. You're welcome, Corbin." Tal got to its feet. "Excuse me, Rick."

Rick nodded, briefly wishing he'd had the confidence to give Tal some physical signal as easily as Corbin had. Once the bot had collected the trash receptacles and motored out of the apartment, Rick asked, "Why'd you send it out?"

"I need to know what's going on in your head."

Rick snorted. "Join the club. Okay, maybe it's an exciting way to open up a potentially new communication mode. Maybe it's a mainline to abuse, too. You could just as easily have taught it that kicking it into disrepair was the ultimate approval."

"Yeah, but I didn't. The R&D compass aims for normalcy per human sensibilities. For humans, sex really is a kind of ultimate approval. It's ethically consistent, what I did."

Rick seesawed his hand. "I don't know about that."

"You'd know if you saw it. Something happens. I know, it sounds corny or self-serving or whatever, but... it really does."

"It's just mimicking."

"Sure. But on a macro scale, that's what society is, too—mimicking behavior."

"There's a genetic and emotional reason for that."

"No, no, no." Corbin shook his head. "You're arguing with me like I've got all the answers, and I don't. Just... watch what happens with me, if you want, and decide from there." Corbin pulled in a breath and lowered his eyes. "Or think about experiencing it yourself."

Rick's belly tightened. "I don't think I could."

"Uh." Corbin scratched his head. "Well... that might be a problem."

"How so?"

"Sex equals approval now, right? So, uh. You see where this is going."

"Oh, shit." Rick shook his head. "Corbin—dammit. So if I don't screw around with it, it's going to think it's doing something wrong."

"Um, basically." For the first time, Corbin looked sheepish at the entire turn of events. "What were you saying about R&D guys not thinking about ramifications?"

Tal returned to the apartment, settling itself on the couch in its inactive-social mode when neither man made any immediate request of it. Rick gazed at the bot, trying to see it the way Corbin did, as a collection of circuits that hovered on the cusp of personal awareness. A newbie. An entity that might somehow find itself in possession of an artificial, non-instinctive sex drive, meaningless unless mated. *How lonely,* Rick thought, and blinked in surprise at his own conclusion.

"Penny?" Corbin murmured.

"Mm?"

"For your thoughts. Sorry, is it a dime now? Inflation."

Rick shook his head. "Do you really think it means anything?"

"I think maybe for AI, a program seeking its proper input is the equivalent to feeling. To desire."

"Yeah. You know, I repaired this bot once, an early-model single-function bartender. It kept asking to serve me a drink, because that was all it knew how to do. I ignored it—I had its access panels open and I was elbow-deep in wires—and it said, I swear it said, 'Sir, may I *please* serve you a drink?' It just sounded so..." Rick shook his head again. "Desperate. Like it needed, down deep, to get approval for what it could do."

Corbin nodded. "We don't talk about it very much," he murmured, "but it's been known to happen in R&D. What happened to the 'tender bot?"

"Scrapped."

"Yeah."

Rick pulled in a steadying breath. "This is happening, isn't it? All over. This is the next step."

"As soon as we can handle it, yeah. It's the next step."

"Okay." Rick nodded. "Okay. I can handle this. Tal?"

Tal motored to its feet. "Yes, Rick?"

"Do you want to—do you want to engage in sexual activity with me?" The words felt stilted and confused, Tal's syntax and not his own.

"Yes." Tal immediately moved toward Rick in that same peculiar fashion, eyes locked on Rick's face, sensory motors handling the motion.

"You sure?" Corbin murmured.

"We'll find out. Not here, Tal. Go into the bedroom."

Tal nodded and abruptly changed course. Rick ran his hands over his face and up over the crown of his head, exhaling slowly.

"Thank you," Corbin murmured. "And...I'm sorry."

Rick offered a lopsided smile. "I knew you were R&D when I married you."

Corbin gave a tiny little laugh at that. "Do you want me to come in there with you, or...?"

"Oh, I definitely want you in there. I don't think I could do this without you. I don't want you just watching, either, I want this to be..."

"A three-way?" Corbin volunteered helpfully. "Or if we're ordering by sentience, a two-and-a-half-way?"

"I think I liked this conversation better before you were caffeinated."

"I'd apologize, but you'd know it was half-assed." Corbin's grin faded, and he rested a hand on Rick's arm. "I'm seriously asking, how do you want it to go in there?"

"I can't believe I'm doing this." Rick sucked in a deep breath. "Show me how to do it. Like you'd show me anything else you programmed into it."

Corbin gave his standard little programmer's nod. "Sure." He got to his feet and padded to the bedroom; Rick followed, his stomach in knots.

Tal sat on the foot of the bed, hands crossed in its lap. The air of expectancy, Rick told himself, was just his own anthropomorphic projection; it was impossible for a box of circuits to actually be eager. *I think.*

"I'm going to show Rick how to interact with you on a sexual level," Corbin said. "Stand up."

Tal motored to its feet. Its ocular lenses jumped focus from Corbin to Rick and back again, despite Corbin's obvious stature as focal point.

"Mostly, this works with the mimicry method," Corbin explained. "You show it what you like, and it incorporates that and experiments with variables. It's more complicated later, but—just start here." He stroked a hand down the side of Tal's face casing; Tal reciprocated by placing its hand on Corbin's cheek and moving it up and down. "Good," Corbin murmured.

Rick swallowed down his immediate surge of anger. It didn't belong here; soon he'd be touching Tal just like that, no matter how abnormal it felt on a gut level. "I'm not ready for this."

"You're not gonna get any more ready by waiting. Tal, give it a try with Rick."

Tal swept its arms wide and hurried toward Rick, its gait so quick that it stumbled forward with a jerk. Rick took a step back, unnerved,

but Tal outpaced him and wrapped him in a clumsy embrace, metal arms tight around Rick's torso. "Hello, Rick," it said, cupping the back of Rick's head.

"Uh." Rick rested one hand flat on the small of Tal's back, raising his eyebrows at Corbin.

"Wow. Beats me," Corbin admitted, scratching his head. "Maybe it's seen me greet you enough times to internalize the behavior."

Rick opened his mouth to reply, and Tal chose that moment to press its face against the side of Rick's neck. Abruptly, Rick could find no words. The cool ridges of Tal's titanium face pressed firmly into Rick's skin. Tal cupped Rick's head in both hands, and Rick sucked in a breath; he knew damn well that those hands were unforgiving enough to crush his skull, should the thought occur to Tal.

"Corbin?" Rick pleaded, remaining as still as possible under Tal's touch. Tal bumped its face against Rick's lips, ever so gently.

"Oh, wow." Corbin stepped to one side for a better look. "It's kissing you. As much as it can kiss you without having a mouth."

"This wasn't—it wasn't supposed to go like this, was it?"

"Well, 'supposed to' is kind of a funny term in R&D-land..."

Tal stepped back and let go of Rick's head, reaching down to manipulate the buttons of Rick's shirt through the buttonholes.

"Uh." Rick lifted his hands, struggling not to grab Tal's wrists and push it away. "Corbin?"

"This is fantastic," Corbin breathed. "Just let it happen. Give it some approval."

"Uh. Good?" Rick offered shakily. Once Tal completed unbuttoning the shirt, it focused its ocular lenses on Rick again, seeming for all the world to wait for further endorsement.

"You're going to have to touch it sooner or later," Corbin said. "Commit to it."

Commit to doing this, Rick thought, or commit to Tal? Either way, it had to be done, and Rick made himself stroke the smooth crown of Tal's head. In response, Tal slid its hand under Rick's shirt, its fingers cool and infinitely gentle as it sought out Rick's nipples. Then, abruptly, Tal hesitated, focusing up onto Rick's face.

"Keep going, please." Rick's voice shook. He rubbed his hand over the top of Tal's head again, aware he should at least vary the approval but unable to convince himself to try anything else.

Tal nudged the shirt off Rick's shoulders, its touch so gentle that Rick had to work his arms a little to get the shirt off completely. Tal bent at the waist, bumping its face against Rick's nearest nipple.

"It's mimicking me," Corbin noted, his expression one of sheer delight. "It's seen me do that to you."

"Seen you..." Rick shuddered, startled by the stark sensuality of Tal's flat face against his skin. Tal bumped and rubbed its cool metal housing against Rick's nipple, touching only the tip, nothing more.

"Wow," Corbin murmured. "It's been paying attention."

"What else has it been paying attention to?" Rick laughed uneasily.

"You can find out, if you want to. You have to be really direct with it to move this forward."

"I know." Rick glanced toward the bed, wondering what Tal and Corbin had done there, wondering if he could stand to hear it. "On the bed," he told Tal before he could change his mind.

Tal stretched itself out over the unmade covers, flat on its back with its ambulatory devices slightly spread. Rick let out a shaky breath, passing a hand over his face. "Okay, Corbin. Show me, because I'm having a hard time with this."

"You want me to take control?"

Relief washed over Rick. "Please."

Corbin nodded, that short little jut of the chin Rick recognized from a dozen R&D meetings. "Get undressed and lie down on your side of the bed. Tal, turn on your side toward me."

As Corbin disrobed, Rick followed his orders, careful as he settled into bed not to touch Tal. Not until Corbin told him to. It would be a hell of a lot easier under Corbin's control.

"I'll show you first," Corbin said, embracing Tal without hesitation. "You're doing great," he told Tal, and kissed it firmly, one eye on Rick.

"Fuck," Rick breathed, willing away the instant surge of jealousy; it was just a machine. It had to be just a machine. The jealousy, at least, was easier to deal with than the lust rising up as Corbin delicately stroked the seam between Tal's shoulder and torso. Rick knew every hydraulic, every wire, every centimeter of open space beneath that seam; he'd repaired, replaced, or run diagnostics on everything under Corbin's hands. He knew how it all worked, dammit, and this wasn't standard operating procedure by half.

Tal cupped one hand over Corbin's cheek, continuing to angle its head as if it could actually kiss. Rick blinked, struck by the realization that while he knew every segment of Tal's inner workings down to the micron, he had no such blueprint for Corbin. What he thought, what he felt, why he wanted this—it was all obscured as surely as an encrypted working process.

"Corbin?" Rick murmured, resting his hand over Corbin's at Tal's shoulder.

"Mm?" Corbin lifted his head, his cheeks already warm from the foreplay.

Rick swallowed, willing words to come to him. "What does this mean to you?"

Corbin glanced down into Tal's eyes, giving it a fond little smile. "It means that the two primary parts of my life aren't separate anymore." He took Rick's hand, kissed its knuckles. "Get here with me," he urged, resting Rick's hand on Tal's chest.

Rick had never really grown accustomed to artificial breathing; back when it came into vogue, he and Corbin had argued over whether to implement it in Tal. Rick had thought of it as a pointless drain on system resources, but resting his hand over the gentle rise and fall of Tal's chest chassis changed all that. "Hi," Rick whispered to Tal, for reasons he couldn't explain, and pressed a kiss to the side of Tal's neck.

Tal reached back to curl its hand around the back of Rick's head, drawing him closer. "That feels good," it said.

Rick glanced up to Corbin, who simply nodded encouragement. Rick pressed his full length against Tal's cool husk, pulling Tal's hips tight against his own.

"In for a penny," Corbin murmured, and leaned over Tal to kiss Rick hard, thrusting his tongue in hungrily.

Shivering, Rick wrapped one arm over Tal and Corbin both, trying to warm the titanium against his skin. Tal stroked Corbin's hip and then Rick's, letting out its best artificial equivalent of a contented sigh.

"How far do you want to go?" Corbin asked, giving Rick one last glancing kiss. "It's pretty good with its hands. Or all three of us could do something."

"Something like what?"

"You could fuck it."

Rick glanced down at the completely anatomically incorrect housing of Tal's groin. "There's no way."

"Sure there is." Corbin led Rick's hand between Tal's legs, then abruptly let out a little chuckle. "It doesn't have erogenous zones, Rick. You don't have to be gentle."

Rick felt his cheeks heat with the embarrassment of perpetuating such ridiculous anthropomorphism. He slid his fingers along the titanium between Tal's ambulatory devices; right at its would-be genital area, there was a small, practically imperceptible dip inward, a shallow valley which ran from its front to its back.

"Remember the version 6.92 fix?" Corbin murmured.

"That was two years ago."

"Subtle angular gradation of interior groin chassis to facilitate smoother ambulation. Which happens to be a cock-shaped divot."

"I don't understand." In truth, Rick thought he did; certainly his cock had made up its mind, and strained toward the space between Tal's thighs.

"Just give me a second." Corbin shifted up to sit with his back to the wall and spread his legs. "Tal, sit here," he explained, patting the bed between his thighs. "And lean back against my chest."

Tal easily readjusted itself, settling back into Corbin's embrace with what Rick again wanted to label as eagerness. Corbin took a moment then, one arm around Tal's chest, nuzzling at its ear, and for a moment Rick thought he could see everything Corbin must have: Tal's innocent vulnerability, Corbin's fierce devotion to safely pilot Tal through to an ability to self-regulate in this regard, the strangely lop-sided dependency each of them had developed for the other. It was, Rick thought, with only a tiny twinge of jealousy, rather beautiful.

"Get on top," Corbin murmured, beckoning for Rick to join the tableau.

"Is that...is that okay with you?" Rick asked, gazing directly into Tal's ocular lenses.

"It is," Tal murmured. "Thank you."

Unnerved by the response, Rick nonetheless nodded and crawled into position, carefully lowering himself onto Tal. "I don't know what I'm doing."

"You're just right." Corbin leaned over a little to pull the lube off the nightstand. "Push your hips up a second."

Corbin slid his hand between Rick and Tal, and then there was the familiar cool, slick grasp of Corbin's hand along with the complete-ly alien composition of what Rick had come to think of as Tal's gen-ital valley, cupping his cock in an absurdly perfect fashion. "Fuck," Rick shuddered out.

"Tal," Corbin murmured, "spread your legs a little more." Corbin hooked his calves over the lower halves of Tal's ambulatory devices, anchoring the bot there, and pressed his hand firmly over the top of Rick's cock, creating an odd little channel of slick flesh and titanium. "Thrust," he told Rick.

The first one nearly undid Rick altogether. He paused at the apex of the thrust, his weight balanced on his hands, and stared at Tal's mostly-featureless face, then Corbin's behind it flushed with lust.

"Again, please," Tal murmured.

Corbin grinned, pressing a kiss to the side of Tal's head. "Again, please," he agreed.

Rick pulled back, then surged forward again. Beneath Tal, he felt Corbin's hips rise up instinctively, seeking the thrust. "Fuck, this is hot," Rick managed with a nervous little laugh.

"Yeah, it is." Corbin dragged Rick down for a hungry, possessive kiss, Corbin's fist tangled in Rick's hair. The titanium beneath Rick's cock warmed as he thrust over and over, and soon, Tal too raised its hips for the next thrust, its breathing mimicking Rick's shallow pants.

"This is..." Rick shook his head, trying to convince himself not to think. There was a look in Tal's ocular lenses now, a genuine expression, he was sure of it: something coy and hungry and unsure all at once. "Do you want me to?" Rick breathed, staring into Tal's eyes.

"He's asking if you want him to come," Corbin translated, kissing the side of Tal's neck.

"Yes," Tal said immediately, reaching up to grip Rick's nape. "Please come."

"Please," Corbin echoed. Rick saw the steady motion of Corbin's elbow as he stroked himself under Tal's chassis.

"Tell me you want it." Rick's breath came hard and fast now, his thrusts rough and tight.

"I want it." Tal's voice was firm, and Rick could swear he heard lust at its edges.

"Please, Rick," Corbin moaned, in that lost little voice that Rick knew so well. Overwhelmed by lust, Rick leaned down to kiss Corbin hard, and then kissed Tal just as firmly. The bot tilted its head obligingly, and with the taste of titanium on his tongue Rick came, crying out as he spent himself over the polished metal of Tal's torso, barely aware of Corbin's answering cries.

"Oh, God," Corbin moaned as he reached up to pet Tal's face. "That was fucking beautiful."

"Fuck," Rick shuddered, settling himself over Tal and Corbin heavily. "Thank you."

Tal rested its hand over Rick's back, petting lightly. "You are welcome, Rick. It was to your liking?"

"Uh—yeah, it was to my liking." He stroked his fingers over the cooling come on Tal's lower torso. "Sorry about that."

"I will clean myself later."

Corbin let out a little broken laugh at that. "Okay?" he asked Rick.

"Yeah. It's...different, but...yeah."

"You said pretty much the same thing our first time."

Tal looked up at Rick. "Your first time together was like this?"

"Sort of." Rick slid off of Tal, nestling against Corbin's side. He threw one leg across Corbin's and Tal's, any lingering concerns about intimacy muted by the post-coital float. "Corbin was what you'd call a fast one. I was used to sex as the outgrowth of a relationship, and he was used to..."

"Sex," Corbin interjected with a grin.

"Very enthusiastic, uninhibited, R&D-type sex," Rick agreed. "Not at all what I was used to."

Tal tilted its head, watching Rick intently. "Your first sexual experience with Corbin was unusual," it noted, "and you joined your life with his. Your unusual sexual experience with me reminds you of this pattern?"

Corbin blinked. "Wow. That's.... a lot of insight for a box of wires."

"Yes, it is." Rick rubbed a hand over Tal's chest, then leaned up to press a kiss to Tal's cheek. "I think we should keep him."

Taste

Jean Roberta

I felt it as soon as I walked into the restaurant. The place itself seemed harmless enough; it was a converted warehouse, full of light and green plants, featuring a salad bar: the kind of place my daughter Simone always picks. Maybe it was the sight of her smiling face, so much like mine and yet so different, that caused me to feel the heaviness of milk filling my breasts to the bursting-point. This can't be, I thought, but I felt the same voluptuous mixture of pride and embarrassment that I had felt twenty-two years before, when my cups overflowed. In a moment, I thought, I'll feel the wetness at my nipples and I'll know without looking that it has soaked through every layer of cloth to show the world what I can produce. And to show the knowledgeable that I need milking as much as my baby needs feeding.

Simone has the sharp features and chestnut hair of her French-Canadian father, now long-gone from our lives, whose one claim to creativity was that a distant ancestor of his had worked on or even designed (depending on my husband's mood at the time) Notre Dame Cathedral in Paris. As an art student, Simone seems to have translated his boozy pretentiousness into actual talent. She also has

both the enthusiasm and the glib tongue that seem to run in my family, descended as we are from poor Irish and English immigrants who lived by their wits. "Hi, mom!" she called, waving to make sure I saw her. As usual at such times, she managed to look both childish and condescending.

The discomfort in my breasts subtly receded as I reached her table. "Hi, kid," I greeted her, feeling dizzy. How could this young woman, who looked only slightly younger than I felt, be my child? I felt caught in a time warp, or in one of the intense dreams I've been having lately.

"You should have the special, mom," Simone advised me, affecting motherly wisdom. "It's made with tofu and yams." She knew that such things are good for women of my age, and she was determined to correct my eating habits, having already improved her own. She was convinced that she had been deprived of adequate nutrition as a child, but she was willing to forgive me because I obviously hadn't known any better. "What's new?" she asked politely.

I knew she was resisting an impulse to comment on my green silk dress. By her standards, the style was outdated, the color was too loud and the fabric was too transparent, especially for a middle-aged woman. She was dressed mostly in unbleached cotton, as usual. We had stopped trying to change each other's taste, having discovered that it couldn't be done.

I couldn't help glancing at the slight swell of her high breasts under the disguising expanse of a loose shirt. She could get pregnant, I thought, and breast-feed her baby. She could even do this more than once, sometime in her yet-unplanned future. As I never could again in my life.

However, I could trump her Political Correctness. "Have you seen this petition?" I asked her, pulling it out of my bag. She reached for it with interest. "The city is threatening to tear down the library and rebuild on the spot, so the Heritage Association is trying to get enough signatures to stop them."

Simone gasped. "Why would anyone want to tear down our library?" she asked melodramatically. I knew that she had thought of

the central branch of the Public Library as her other home when she was younger, and my job as a librarian had always been one thing in my life that she could approve of. The mock-gothic architecture, complete with gargoyles at the corners of the building, had been the setting for Sunday Storytime when I used to take her there after brunch in the middle age of her childhood, the era from six, the beginning of school-age, to eleven, the dark brink of puberty.

"They say it's not big enough to house new acquisitions," I explained, keeping my voice deadpan to increase the shock value, "and they say the cost of a new building would be cheaper than renovating and maintaining the old one. They also say the style of the library doesn't go with the surrounding buildings."

"Then tear them down," Simone advised the absent City Council indignantly.

"Well, sign the form," I told her, "and take a few copies to school with you. Do you think your classmates would sign it?"

"For sure," my kid promised on their behalf. "No one at school wants to lose the gallery in the library." I didn't tell her that the need for a bigger art gallery in the library was often cited as one of the main reasons for rebuilding. Neither did I tell her about the feelings, reasonable or otherwise, that flooded through me when I imagined the grey stone walls of the library crumbling into rubble. I hoped that my seniority would protect my job, but I couldn't be sure. If image was more important than content to those in power, how long could I expect to be kept on as the lines of character in my face continued to deepen?

I wished I could tell Simone about my latest dreams and hear about hers, but that kind of exchange hadn't happened between us for years, and now it just didn't seem possible. Despite her attitude, her values, her portfolio and her apartment, she still seemed like a child in many ways. How much could she know about the kind of need that is too strong for politeness, discretion or remorse? Ironically, she was the result of that kind of need, as perhaps all children are. Nonetheless, they rarely seem to understand it in themselves, let alone in us.

I paid for our lunch, as usual. I'm lucky, I thought, to have a grown daughter with talent, ambition, and enough self-discipline to transform them into visible results. And I'm honored that she cheerfully agrees to meet me for lunch whenever her busy schedule permits. I've been mercifully spared the agony of the parents of missing or absent children, or those whose presence is worse: the drug-addicted, the mindlessly violent and messed-up, the liars and thieves who seem determined to destroy the very people who haven't already given up on them. I have been spared; it could be much worse. Damn her.

My afternoon in the library was slow and quiet, but haunted by a certain sense of anticipation. The atmosphere of my recent dreams seemed to have seeped into my daytime life. At the unlikeliest moments, I felt hot twinges in my breasts and in my well-covered snatch. As I knelt to replace a book in a low shelf, I could imagine a tall figure looming over me, making unspeakable demands just by standing, legs apart, where I would have to look at it (him? her?) at close range, and would have to—what? I had to concentrate on what I was doing, I told myself. My job was my master.

My evening was both busy and predictable, filled with phone calls and plans that didn't engage that part of me that seemed to be lying in wait for a chance to emerge. It was after midnight when I pulled off all my clothes before sliding into bed. I decided to stay naked since, for better or worse, no other human being was there to see me. Stretching and curling up on clean sheets, I slid into sleep as though sliding into a black lake full of threats and enticements.

As the dream began, I seemed to be falling through layers of darkness toward the centre of the earth, past burning lava and boiling oil. Lizard-like creatures with human faces, who were both cute and frightening, leaped onto my shoulders, licking at my skin and hissing secret messages at me in their own language. "Hungry!" someone howled at me, describing the hunger of those who will die soon if their needs are not met. "Feed me." As I bent over to avoid falling on a slippery surface, something like a long tail was pushed up my ass, exploring my own hot depths. I knew it would find whatever I

was keeping in my guts, and I knew that resistance would make the probing more painful.

My breasts were quickly filling with nourishment for the one who needed it. I saw the thin face of Simone's father, the poor dreamer who had never made sense of his own life and had died of liver failure five years before. As I watched, this face changed into those of the men who had touched me since his time: the scavengers who wanted an easy lay, the wannabe father figures for Simone who gave us both orders until I told them to leave, the boyish satyrs I couldn't afford to keep. Women friends I had loved and lost to more important relationships and better opportunities elsewhere flitted past me with yearning eyes.

My breasts swelled to a rock-hard fullness. A thin trail spilled out of each nipple and down my belly to the fragrant bush at my crotch. Like a pied piper, my body seemed to be calling out to all those with an appetite. The snake-like thing in my ass was exploring every inch of the secret maze in my lower belly. My pussy grew wet in response, but it remained unfilled.

I crouched on all fours because this position felt stable and natural. I could smell the monster or demon before he appeared in front of me, flexing his bat-wings and his short, heavy claws. The muscles in his haunches were those of a fast-moving animal, but he stood on two legs like a man. I looked up into his burning golden eyes for a brief second, and in that time, he seized me by the shoulders, pulling me up.

His voice seemed to echo in my brain so that I couldn't be sure whether he was actually speaking, or simply transmitting his thoughts. "J'ai faim," he seemed to growl, or was it "ma femme"? Strange, I thought, how the French words for "hunger" and for "woman" sound so much alike, at least to uneducated ears. On second thought, I realized that such similarities in man-made language aren't strange at all. Consider, for example, "manna" and "mama."

My breasts hurt, and they wanted relief. A massive head bent beneath my chin, and a hot mouth clamped on my right nipple. He sucked hard. Oh god! I screamed silently, wondering if this prayer

had any relevance. My breast felt as though it were being wrenched off, but it needed this draining. In a moment, the tension began to ease gently out of my breast along with my milk. What god-forsaken creature, I wondered, could be this desperate for my milk, a food designed for human babies? I had tasted it years before, and didn't like it much. Did he find it delicious?

In any case, he was giving me blessed relief. "Oh yes," I sighed into a pointed ear as he chewed gently with his lips. I was glad to be held because I didn't think I could remain standing on my own. After pulling the last drop from my right breast, he switched to my left.

As I felt the milk being drawn through my breast and out through the tiny openings in my stretched nipple, the pain of his claws in my shoulders sank gradually into my awareness. "Please," I begged, or thought. He seemed too distracted to respond, or too different from me to understand. The pain was like an electric current shooting down from my shoulders to receptors in my heart, my belly, my pussy and my legs. I was sure he had pierced my skin.

When he let go, the aftershock felt almost as bad as the intrusion of his claws. I slid back down to my knees and braced myself with my hands on a surface that felt like mud. The object in my ass was withdrawn as quickly as a shoelace whipping out of its holes, and I felt as if I would fall apart. I could sense him behind me, and I waited breathlessly for what I knew was coming. A cold shaft that felt as hard as stone nudged my wet pussy lips and pushed partway into me as though finding its way in an unfamiliar neighbourhood. I shifted to accommodate it.

"Ahh," I gasped as the cold heavy phallus was thrust into me, stretching me more than I had thought possible. My cunt throbbed from pain mixed with pleasure, and I tried to focus on my own hunger to prevent my inner flesh from going dry and challenging the invader to cause damage.

As he picked up rhythm, I was rocked back and forth. I couldn't bear it, but I knew I would feel his absence when he was no longer in me. I couldn't think, so I gave myself up to the beat and my own mounting need to reach a point of explosion and release. For long

minutes, I thought my energy couldn't last, and then I screamed as the first spasm made my lower mouth clutch the unmerciful thing that filled it.

My cunt (crude, historic word) continued to throb after he had pulled out.

I could feel beads of sweat popping up on my skin as I moved carefully, trying to reclaim my own body. My tongue felt swollen in my mouth from thirst, and all my joints were tender. I felt hot fur pressed against me, making an animal claim of kinship or belonging.

Powerfully and gently, he lifted me until my own shaking legs hung free. He laid me on a moist and welcoming surface. Luxuriously I stretched, raising my arms beyond my head and spreading my legs for him. At once, he pressed his head to my centre, nuzzling the opening that still wept red tears. I could feel the hot comfort of his breath on me as a long, rough tongue tasted my vital fluid and soothed my raw flesh. I jerked when the strong tip of that tongue teased my swollen button. Oh yes, I told him in my mind, give me as much as I can stand. And take from me what you need. I felt as if I could melt into his warmth as the power of my second surrender overwhelmed me.

The atmosphere grew lighter, clearer, cooler. I seemed to be in the library, an incongruously naked, disheveled woman surrounded by books. The space was dimly lit, as though by candles. A leather-bound volume was pulled down from a shelf and placed in my two hands where I could open it and turn its creamy vellum pages, inhaling the musty smell of age that wafted up from it. I held it as though clutching a talisman that could protect me from chaos. A line on the title page caught my attention: "And she shall be the mother of monsters."

A sharp-featured gargoyle sat at the checkout desk while another crouched motionless just inside the front door. I knew they were guarding sacred space as their kind have done for centuries. The creature at the checkout desk reminded me of the time I had left. "Trois jours," I heard it say, as I have often reminded library patrons of the

time-limits that are, without exception, followed by fines. Three days.

A discordant chorus of unearthly voices pulled me up and out, toward the world of daylight and traffic and human demands. The screeching symphony became the jangling of my old-fashioned alarm clock, the one I keep because it is guaranteed to get me out of bed in the morning.

As soon as I woke up, I remembered being told that one of my ancestors was condemned as a witch because she knew how to read (in Latin, of course), and none of her peasant neighbours could forgive her for that. Maybe that story set me on the path that eventually led me to the library. I learned early that literacy is power, and written words are the only means I know of to communicate across great distances of time.

I don't want to go to work, and not just because of the soreness in all my muscles. Simone knows useful things about herbs: which to drink, which to make into a salad, and which to apply as a poultice. She would be glad to give me advice. If I were still a casual employee with no paid sick-leave, I would force myself to go. Now I can afford to pamper myself.

Sleep is a mysterious country, and even the most rigidly practical of scientists admit that events in that place affect our bodies after we have returned. The bruises at my shoulders could have been caused by daytime collisions with hard objects that didn't seem significant to me at the time. Even the blood between my legs could be explained logically: at my age, I can't expect my periods to arrive as regularly as they did before.

But I can't explain the double row of little puncture holes, as from sharp teeth, that encircle my left nipple and ooze blood like the wounds of a miraculous icon or a sore that won't heal. I can't explain them, so I sit here with pen and paper in hand, trying to save my own mind by putting this damning confession into words.

A Feast of Cousins

Beth Bernobich

Consanguinity was Cousin Tessa's new favorite word. The one she whispered to me last week, when we made sticky, bone-crunching love in her bedroom. Tess collected words like pennies, snatching them up from wherever, setting them sideways and spinning them around, before she lost interest and tossed them aside for a newer, shinier word. She did the same with lovers.

Okay, that's not fair. But as Aunt Louisa would say, it's true.

Back to consanguinity. Of course Tess knew what it meant. Family. The thicker-than-water blood. She had a point, I guess, because our family does stick close. Thanksgiving. Easter. Baby showers. (Even the Our Lady of Polenta Feast, as my brother Eugene says.) Two things I know. That we're always celebrating something, and Great-Aunt Gabriella is always cooking an enormous family dinner.

"Christmas Eve, my favorite," Uncle Teo said to me, pouring out the white wine. "Come, I hope you're hungry, Maura."

I smiled and took the glass he offered, looked around for a seat. Christmas, and Christmas Eve, meant a stuffed and overheated dining room, long loud conversations that unraveled and rewove themselves,

and a gorgeous soup of smells—cinnamon and baked apples, tangy pine and crushed peppermint. And tonight, the fresh baked haddock and breaded flounder, shrimp with hot sauce, and more. Always more.

Spotting an empty chair, I squeezed in between my brother Eugene and my cousin Donny. Uncle Sal was passing around the dishes of noodles and anchovies. Across the table, Aunt Delores and Aunt Louisa bent close, plunged into talk about their kids, while Great-Uncle Umberto argued politics with my father. It was like fireworks and cannons, the noise, but somehow we all managed to keep talking and eating, eating and talking.

Eugene snagged a handful of shrimp and popped them into his mouth. "Hey, sis."

"Hey, yourself."

A shriek directly behind my chair made me jump. "Antonio!" My cousin Lia scooped up my nephew Antonio and deftly removed the fork from his grubby hands. "You nutty kid. You might stab someone with that."

Little Antonio screamed happily and squeezed his aunt, who carried him back to the kids' table, singing a nonsense song. I thought she hadn't seen me, but she gave me a passing wave before turning her attention back to Antonio.

Good, capable, dutiful Cousin Lia. None of the kids were hers, but she always ended up watching over the children at these things. Just as Aunt Juliette helped in the kitchen. Just as Uncle Sal always vidded the whole evening. Tradition, Sal called it. Like a thick knitted muffler that kept you warm, and sometimes made it hard to breathe.

And here came Sal, with a tiny new vidcorder in his meaty fist, swooping in between the tables. "Formaggio," he cried. "Say cheese, Antonio. Oh my god, the kid's gonna burp anchovies. Hey, Teo, did I tell you how these new vidcorders pick up smells, too?"

"...he's shipping out next week, Delores..."

"...hear about Pauly and Anita getting back together..."

"...have some more noodles..."

"...I think I'll have some salad..."

"...no more room on the table..."

"...always more room..."

More wine appeared in my glass, even though I didn't ask for it. Cousin Donny winked at me. "Cheers, cuz."

His face was sweatier than usual, and his muskrat aftershave made me gag when he leaned too close. I mumbled a hello-and-thanks and turned to Eugene. "So, how's the new job?"

"Good enough. What about you?"

I shrugged. "Same as usual. Hey, do you know if Tess will show up tonight?"

Before my brother could answer, Donny leaned in. "Yeah, she's coming tonight. She v-mailed Grandma about half an hour ago to say she'd be late. At least, I think she did. I was kinda busy."

He leered at me, and I shifted my chair a couple inches back and away. That's when I noticed the mesh glove on Donny's left hand. "What the hell is that?"

Another leer. "Early Christmas present. Watch."

He wriggled his fingers, and a funny look came over his face. Good god, I thought yanking my gaze away. I'd heard about those things, advertised on lurid X-rated websites. Cousin Donny hadn't changed since we were eight and he tried to catch me naked in my bath on his camera-phone. Only now he'd figured out how to jerk off in public and not get arrested.

A loud popping noise caught everyone's attention. "Umberto!" came a cry from the kitchen. The next minute, my Great-Aunt Gabriella staggered through the doorway, wreathed in clouds of acrid smoke. "System crash!" she wailed.

I sighed. Last month, Great-Uncle Umberto had replaced all the kitchen appliances with the latest stainless steel AI models. Everything had sensors and links and touchpads and programmable features. It was all supposed to making cooking easier, but it turned out that the new AIs had a few bugs.

Cousin Nicci wiped her mouth with a napkin and slid from her seat. "No problem, Aunty. I know how to jig the system."

Nicci, Gabriella, and Juliette vanished into the kitchen. The roar of conversation swelled up in their wake.

"Good thing Nicci knows her hardware," Donny said. He was busy stuffing his face, using only one hand.

"Not like some," Eugene said with a grin.

Donny had just opened his mouth to toss back an insult when the front door banged open. Tessa ran through, laughing and chattering, and exclaiming how cold it was outside. Her cheeks were ruddy, her black eyes bright with mischief. Dark hair tumbled from underneath her knitted cap, which sparkled with miniature Christmas lights. Oh yes. Already my mood got better. I lifted my hand to wave, when I saw Cousin Lucia.

Lovely Lucia, who wore a bright red cashmere dress that barely covered her thighs. Uncle Teo called her the family angel, but seeing her slip an arm around Tessa's waist, I thought she looked more like an imp.

Not fair. Not even really true.

"What's the word, Tess?" someone called out.

"Serendipitous!" Tess replied with a laugh.

I closed my eyes, feeling sick. Oh yes. I could just imagine how Tess picked *that* particular word. Next to me, Eugene muttered something about some cousins being idiots, but I ignored him. He knew about me and Tess. Everyone did. But the last thing I wanted right now was pity.

One good thing about family dinners: you eat. And if you eat, no one bothers you. So I loaded up my plate with the baked flounder and noodles with cheese and spinach bread, and with my aunts and uncles and cousins and parents all chattering over and around me, I ate. But all that time, I could see Tess and Lucia flirting with each other, bumping shoulders and giggling and who knows what else.

Just like Tess and me at Thanksgiving. Or my parents' anniversary celebration last week. Or...

...or that lovely luscious first time. Through a bright haze of tears, I could see the images, like ghosts over today's feast.

Tess giving me secretive smiles all through the Labor Day picnic. Tess cornering me in the second-floor guest room, after Aunt Juliette's birthday party, where I went to fetch my jacket. Hey, she whispered. Don't leave yet. I have a present for you, too. And before

I knew it, we were wrapped up in each other, Tess giving me nibble-kisses over my cheeks and lips and throat, until my knees turned into water and we both fell over into a pile of leather and wool coats...

"Presents!" called out Uncle Teo. "Time for the gift exchange!"

Shrieking even louder, the littler cousins thundered into the living room. My mother and Aunt Juliette and Lia stayed behind to clear the tables, while Uncle Teo took charge of handing out gaudily wrapped packages, some of them smothered in ribbons, and Aunt Delores trailed after him, picking up discarded wrapping paper, and writing down who gave what.

Nothing ever changed, I thought, rubbing my forehead, which ached from the heat and the noise. Cousins yelling and laughing. Cousins drinking too much. Cousins pretending that tonight was the best night of the year. Part of me wanted to see where Tess and Lucia had gone. Part of me knew better.

A whiff of roses wafted past, sweet and soft. "Hey," murmured a voice in my ear.

Cousin Lia knelt beside me, a tumbler of water in one hand. "You look like you could use some aspirin," she said.

I shook my head. A mistake, because my headache-addled stomach gave a lurch. Without saying anything, Lia wrapped my hands around the tumbler. For a moment, our hands made layers, mine cold, her warm and soft and strong.

"You filled up my hands," I said, stupidly.

"So open up." She popped two aspirin deftly into my mouth. "Now drink the whole glass full. Want some coffee, too?"

"No, thanks."

When I finished off the water, she took the glass, but lingered a few moments. She wore her dark brown hair coiled around her head, but a few strands had worked loose—tugged free by the irrepressible Antonio, no doubt. Lia tucked one curl behind her ear. "So. Any good presents?" she asked me.

I shrugged. "A couple. The usual."

Lia gave me a crooked smile. "Nothing ever changes. Sometimes that's a good thing. Sometimes..."

"Yeah," I said, standing up. This time, my stomach didn't protest the sudden movement. "Well, I think I'll go home."

She said nothing more, but when I came back with my coat, I found all my presents neatly packaged into one, easy-to-carry bag. Lia herself had vanished.

ᔕ

Soft brown shadows, threaded with light. Rippling, as though stirred by a woman's quick breath. Soft lips grazed my cheeks and throat and breasts. The spicy scent, warmed by skin and sweat, filled the air. Maura, Maura, Maura, oh yes, that's exactly where...

ᔕ

I woke late and miserable. A sour taste coated my tongue. That would be from the glass of straight bourbon I drank after I got home. A headache lurked behind my eyes, which felt grainy from the wrong kind of sleep.

No wonder I had such bad dreams.

Remnants of those dreams flickered in and out of recall, along with little flames of warmth that teased me in all the wrong places. I groaned. Cousins. I'm sick of them.

And there would be more cousins today. More aunts and uncles and gossip. Great-Aunt Gabrielle and Juliette would have had started cooking at dawn for the Christmas day feast. There would be gnocchi, of course. And roast turkey. Asparagus drowning in a buttery death. Not to mention Aunt Louisa's fabulous apple pies.

My stomach ached just thinking about all that food. First the Tums, I decided. Then aspirin and warm ginger ale, followed by coffee. Neck and shoulders creaking, I levered myself upright. For a hideous moment, my balance tilted, as though I were navigating the world underwater. No more bourbon, I swore. Especially not after white wine.

A needle-hot shower helped ease the stiffness, and the medicine settled my stomach well enough that I could face the morning.

Coffee mug in hand, I shuffled into my living room, where I checked my v-phone, skimming through the voice and text messages left by half a dozen relatives. When I came to the end, I leaned back in my chair and closed my eyes.

You expected a call, didn't you? Idiot.

No, I expected—a good-bye, perhaps.

I sighed and let my face soak in the scent and warmth from my steaming coffee. Maybe, just maybe I could skip Christmas dinner this year. No. Bad idea. Aunt Delores the human vid-machine would never let me forget. Besides, Grandma Rosalie looked awful frail the night before. I didn't want to miss any time with her.

Another mug of coffee. A leftover raisin bagel steamed into life. (Like me, I thought, inhaling the coffee.) I rifled through the bag with my gifts, the one Lia had so thoughtfully packed for me, and started making my own notes for thank-you cards. Three identical gift cards to BooksNBytes. (Those from my brother.) A thermal scarf with solar heating threads woven into the yarn. (That from my Aunt Carlotta.) A mini vid-card with a flash of my youngest niece laughing. A bottle of cheap air freshener from Donny. (Idiot, I thought.) DVDs. Movie tickets. Refrigerator magnets. A bottle of my favorite perfume.

Then, at the bottom, underneath a layer of green tissue paper, I found a square black envelope. Hmmmm. No name. No imprint. How odd.

I sliced the flap open and pulled out a thick rectangular card, glossy and black, with a wafer-thin connector port around the edge. As I tilted the card back and forth, silvery dots coalesced into letters that glided across its surface, only to dissolve as they slipped over the edge.

Je Ne Sais Quoi.

Joyeux Noël.

Choississez nous pour le ravissement.

I parsed the first message. "I know not what." Huh? What was that supposed to mean? Some sort of joke? No, wait. That had to be the name or catchphrase for the... the whatever this card was for. And

Merry Christmas was obvious. The third one, I had to struggle with, and finally retrieved my dog-eared French dictionary from college.

Choose us for...

My throat squeezed shut. That last word meant delight, or ravishment, or seduction. Tess, I thought. Tess making a very bad joke. What was she thinking? Or was this her idea for a good-bye present?

I flung the card into the wastebasket and went back to my thank-you notes, but my hands shook so badly, I had to rewrite three cards. And typing emails was not an option. Not in our family.

Finally I gave up and pressed both hands against my eyes, listening to my pulse beat a tired tattoo.

I'm lonely.

Of course. It was Christmas. Tess had taken up a new lover. And here I sat, in my tiny apartment, where every metal-framed designer print, every muted color and expanse of polished wood, suddenly felt like an anti-choice. No wonder I felt an odd vertigo going between here and Great-Aunt Gabriella's house crammed with knick-knacks from the twentieth century.

Vertigo. Another of Tess's recent favorites.

I sighed again. Another four or five hours, and I would be immersed in that old-fashioned world again. Facing Tess and Lucia. Maybe it was a kind of good-bye present, but there was only one way to find out.

I flipped open my cell and dialed the familiar number. One chime, two, three. Maybe Tess wasn't even home.

"Hello?" said Lucia.

I took a deep breath. "Hey, Lucia. It's Maura. Is Tess awake yet?"

"Um, yeah. Are you mad?"

"Maybe. But that's not why I called."

"Then why—Oh, never mind. Hold on a minute."

A muffled conversation followed between Lucia and Tess. Before I could lose my nerve, the cell changed hands. "Hey," Tess said. She sounded wary.

"Merry Christmas," I said. "Yes, I'm unhappy. No, that's not why I called. This might sound stupid, but did you sneak a gift card into my bag last night?"

There was a moment's puzzled silence, then, "Oh no! I forgot to bring yours. No, God, I... I got you a book. I'll bring it tonight. Really. Um, what kind of gift card?"

I clapped a hand over my mouth and shook with silent laughter. Tess. Dear, forgetful, eternally curious Tess. "Something from a place called Je Ne Sais Quoi," I told her.

"Je Ne Sais Quoi?" Her voice scaled up. "Oh. My. God. Someone loves you, Maura. That's the spiff new techno-spa that just opened last month. Très expensive. Hey, maybe Donny gave you the card."

I shuddered. "What a horrible thought. Thank you for mentioning that possibility."

"You're welcome," she said brightly. "See you tonight."

Cousins, I thought, as I clicked off the phone. Still shaking my head over Tess, I fished the gift card from the wastebasket. This time, when I tilted it just right, a cell number appeared, shimmering like raindrops against the black surface. So. A treat with no name, and therefore no strings attached. And just for me. Did it really matter who the giver was?

Still not certain, I called the number. Amazingly, they were open, and when I described the card, the woman gave a soft laugh. "Ah, yes. Our Christmas treats are quite popular. You might even come today if you like," she said with a velvety-dark purr. "You will need one hour, no more. We guarantee total relaxation."

Good god, I thought. But curiosity ran all through our family, and one hour gave me plenty of time before Christmas dinner. Better than staying here and feeling sorry for myself.

I brushed my hair, changed into better clothes. Then armed with directions from MapQuest, I drove to the new Ninth Square project downtown, where a cluster of boutiques and expensive restaurants had appeared during the summer. Parking, usually nonexistent, was no problem today.

And there, between a coffee shop and a chocolatière, I saw a discreet illuminated sign that said Je Ne Sais Quoi.

The front door hissed open as I approached. Oh very nice, I thought, noting the fresh orchids in the windows, the chocolate-brown carpets, the tasteful photographs of landscape stills from all over the world. There was no particular scent in the air, just a fresh clean aroma that made my skin prickle with energy.

"Good morning, cousin."

I jumped. Behind the reception desk sat my cousin Lia, dressed in dark blue wool trousers and a darker blue silk shirt, and with her hair pulled back in a shining brown cascade.

"What are you doing here?" I demanded.

She laughed. "Working between semesters. Didn't Aunt Delores tell you? Oh that's right. You left before she started her recital of who did what and when. So what are you doing here?"

I hemmed a bit, sounding like Tess. "Um, mystery present."

She grinned. "Those are the best kind. May I have the card please?"

I handed it over. Lia inserted the gift card into a slot on her desk. Her eyes widened slightly. "Here," she slid a clipboard with a pen over the desk, "fill these out while I check the equipment."

Equipment?

But Lia had disappeared through an arched doorway. I skimmed over the form's questions. Name, address, profession, classical or jazz or other, favorite books...

I jotted down the answers, wondering if I could answer these same questions for Tess. Or if she could do the same for me. Families. We hardly knew each other, in spite of crowding together every week or two. My cousin Lia, for example. At family dinners, she tended kids and acted the good niece. It was easy to forget she went to grad school for microbiology, and was heading for a research job. Then again, we all slid into different skins at those affairs. Me. Lia. Eugene. Even Donny, in his own weird way.

Lia reappeared and took the clipboard from me. "Go through here," she said, pointing to a doorway on my left, "and into dressing

room number three. You'll find robes and slippers, if you want them. Remember to put the mesh suit on first if you want the light massage."

Mesh suit? Light massage?

Puzzled, I went through the doorway Lia indicated, and down a short hallway, which ended in a plain octagonal room. Four white doors faced me, all of them closed. The dressing rooms, obviously.

I opened the door labeled "three."

Oh, my.

No wonder Tess had squeaked. Antique prints hung on creamy beige walls, polished wood edged the ceiling and doors, and when I stepped inside, a dusky rose-colored carpet cushioned my footsteps. But it was definitely a dressing room, with a shower stall, locker, hooks for my clothes, and a padded bench before a table stocked with brushes and combs and other toiletries.

The door swung shut behind me, and a woman's voice said, "If you wish to use the locker, touch the fingerprint pad with your index finger and thumb. This will key the lock for your visit."

The woman's voice sounded low and soft, but with a faint blur that made me think this was a real voice filtered through electronics. They do it with motion detectors, I told myself. And heat sensors. And pre-recorded instructions. Still, my mouth turned dry at the thought of someone observing my movements. I swallowed and touched the keypad.

The locker clicked open. Inside I found a soft cotton robe, which smelled of fresh soap, and the suit Lia mentioned, which turned out to be a full-body leotard made from a stretchy material. There were even fingers and toes and a hood. Curious, I ran my fingers over the silky mesh.

After another glance around, I changed from my clothes into the leotard. It fit me perfectly, and the material clung to my skin as I stretched and twisted, testing its comfort. "When you are ready, please go through the next door and lie down."

I twitched, then scowled. Resisted the urge to make rude signals to the invisible camera. Was that faint laughter, or the ventilation system? Whichever, I ignored it, pulled on a robe and stacked my

clothes and purse in the locker. Another touch of my fingers to the lock, and the door clicked shut. At the same moment, the second door swung open on its own.

Motion detectors, I repeated to myself, but my nerves were jumping as I peered into the massage room.

It was empty, except for a long padded bench with a pillow at one end. Stepping inside, I had the sense of floating through an ocean. Floor, ceiling, walls were painted in shades of green, rippling from pale green to streaks of emerald. The bench itself was covered in soft black leather, making an anchor point in that unsettling room.

"Take off your robe and lie down, please."

Again, that contralto voice.

I let the robe drop onto the floor and stretched out face-down on the bench. The leather was softer and warmer than I expected, and had the faintest scent of roses, which I found soothing. No sooner was I comfortable than music started to play from unseen speakers—a slow, contemplative piano piece. Modern, but I couldn't recognize the composer. Between the soft perfume, the lighting, and the music, it would be easy to fall asleep, but I doubted that was the point of this mystery gift. Hopefully the attendant would arrive soon.

Somewhere, an unseen machine whirred into life. A moment later, warmth rippled down the length of my body. Startled, I jerked my head up.

"Hush," said the voice. "This is the light massage."

Still unnerved, I rested my head on the pillow. Now the music changed slightly—a clarinet joined the piano, weaving a counter-melody—and the lights dimmed, making the walls look even more watery. Another ripple of warmth circled my legs, merged, then divided to travel down both arms and brush my palms.

A cello sounded a rising arc of notes. The piano answered with a brighter trill, joined by the clarinet's throaty voice, which reminded me of the invisible woman, and lights flickered over me, echoing the path of warmth that touched and teased my skin. Like whisper soft feathers, stroking my body. Like silk-soft hair brushing over my skin.

It shouldn't be this easy, I thought. *That's what happened with Tess. That's why it hurts so much.*

"Are you crying?" said the voice.

"I can't help it," I whispered.

"Then let me help," came the answer.

Tiny electric pulses, counterpoints in sensation, just like the counterpoints of the music, tickled my cheek where it rested against my arms. Tiny kisses nibbled my throat, my fingers. I wanted to protest, to say this was no massage—not alone, watched by a stranger—but my greedy body refused to obey.

The pinpricks came faster now, spiraling outward from my belly toward my breasts and thighs, light stings that sparked a flame in my belly. Fire kisses running from my scalp to my toes, dancing over my skin and drawing my nipples to hard points. Another moment and I would reach a climax.

What if I electrocute myself? I thought hazily.

Soft laughter sounded in my ear. Or was it the music, which had quickened its tempo? Flutes and piccolos trilled brightly, the piano thundered now, and the violins and cellos cried, while the suit flexed and contracted, as though an enormous hand caressed me. Sweet, soft, hard, and sure. This lover's hand knew me. I was sobbing and crying out, beyond caring who watched. Again, and again, the heat flashed over my body. The mesh rippled like fingers from an invisible lover, squeezing my breasts, diving between my legs, and licking me with fire, then plunging into my vagina—though surely that was not possible—once and twice and more, until that last delicious explosion that left me limp and sprawled on the bench.

And with the tide receding, so too the music and the warmth; the flutes and piccolos danced away, next the violins and cellos, leaving only the piano in a soft slow melody, while the suit clasped me loosely.

I lay there, breathing in the sweat and satisfaction.

"Lovely," I murmured.

"Satisfied?" said the invisible woman.

"Oh yes," I breathed. "Thank you."

"The gift is mine."

She did not speak again. For a while, I did nothing but stare off to one side, until the last few sparkles and ripples of passion faded away. Only then could I coax my body to stand and walk the few steps to the dressing room.

A brisk shower woke me up. I dressed, dried my hair, and returned to the reception area. Lia waited behind the desk, a curious smile on her face.

"Did you like the gift?" she asked.

Still unable to talk, I nodded.

Lia's smile dimpled her cheeks. "You look thirsty. Would you like some water?"

Barely waiting for my nod, she disappeared a moment and returned with a large tumbler of sweet, cool water. Her hands wrapped around mine to steady the glass, reminding me of the night before. This close, I could easily smell her perfume.

...the scent of roses. A woman's soft low voice...

All the clues shifted into place.

"You," I whispered.

Lia went very still. Her friendly smile had vanished, replaced by a cautious look. "What about me?"

Even so, I noticed she had not removed her hands from mine. "You gave me the gift card, didn't you? You set up this appointment."

A long silence. Her answer, when it came, was like a sigh. "Yes."

"But why?"

Please, not because you felt sorry for me. Please, not that.

A faint blush edged her cheeks. Lia dropped her hands and turned away. "Do I really need to say why?"

A wisp of hair had escaped her hair clips. I set the glass aside and brushed the wisp back into place. Her blush deepened. "No," I said softly. "You don't need to say why. But were you going to keep this a secret? The gift, I mean."

Her gaze flicked toward me, then to the floor. "Oh. Well. It all depended on you. Before last night..." She drew a deep breath.

"Before, I didn't think I had a chance. But I wanted to give you something special. Just because."

I laughed shakily. "You certainly did that."

Silence. We were both embarrassed, I guessed. Both unsure what to do next.

"How late are you working tonight?" I asked.

Lia gave me a faint smile. "You were the last appointment."

"The last one, or the only one?"

She laughed and shook her head. Was that a yes or no? Hardly daring to breathe, I leaned forward to kiss her. A nibble-kiss, just at the edge of her mouth. It didn't matter, her watching me before. This was new. This was, I thought, a little bit scary.

Lia slid her arms around my waist. Kissed me back. Tiny soft kisses that made my pulse flutter. "So," she said, her breath tickling my face. "Are you going to the Christmas dinner?"

Not the question I expected. I drew back, uncertain. "Are you?"

"Of course. Aunt Delores would kill me if I wasn't there to help with the kids." She reached up and cupped my cheek in her warm palm, studied me with bright dark eyes. "But this year, I think I'm going to be very, very late."

Laughing, I pulled her close and kissed her again.

The Boy Who Loved Clouds
Maya Kaathryn Bonhoff

He was surprised how little it had changed. Home. It was the way his heart remembered it: the green of fields, the mottled hides of goats, the far purple mountains, the pall of fragrant smoke. It was air pollution to the civilized denizens of New York, but Uttar Pradesh had never been civilized by Western standards and might never be. That had bothered him for a time. Then he had simply accepted it. And when new acquaintances, learning his origins, made patronizing remarks, he would smile urbanely and agree with words like 'backwater' and 'anachronism.' "But of course," they would say, falsely ingenuous, "that's what gives your stories their charm."

He hadn't recognized that as condescension at first. That realization, like his cynicism, was painfully won. This, too, was painful—the village-boy-made-good-and-powerful-and-wealthy, coming home to his father's funeral.

"Adyahksa," his mother told him, "he was so proud of you. So proud. His youngest boy, a great writer. A name."

Ah, yes, but not the name his father had given him. Not Adyahksa Samahita—Controller of His Own Destiny, Poised and Well Founded—too difficult, his agent had said, for the Western ear and

eye. So he was Kavi Samahita—a Writer, Poised and Well-Founded—and people expected him to be Japanese.

"When you were born," his mother said, "your Uncle Narmada saw your future."

"Yes, Amma," he said; it was a familiar story.

"'Yo yacchraddhah sa eva sah.' That's what he said: whatever is his faith, that he becomes."

"Yes, Amma."

"So proud," she repeated, her eyes misting. "He wanted to tell you himself, Adya."

And so, his karma came home to roost. The relatives gathered—scores of them, it seemed—and all with the same refrain: He was so proud. He wanted to tell you. Unspoken were the words: Why did you wait so long to come home? Why did you wait too long?

He could not explain that, even to himself. He'd had the means and the opportunity, had even swung through Agra on an international book tour. It was his brother, Josha, who explained it to him, unawares, as he spoke of his younger brother's books.

"I've read several of them, of course," he said. "And I think they are very good, but... they change."

"Change? How, change?"

"The first stories were... lovely, delightful. But the later ones... it's as if a different man speaks."

"A different man does speak," Kavi said. "A grown man. Not the boy who left here."

"Yes," agreed Josha. "That is exactly so."

And that, Kavi thought, as he climbed the rolling hills behind the village, is why I did not come home. I was not the one who left. Adyahksa left and Kavi returned.

But even Kavi Samahita was seduced by the green hills and the brindled goats and the great, spreading trees. There was one tree in particular, at the crest of this very hill, where the boy Adyahksa had lain down in the grass and stared at the sky and daydreamed. He had named it Asvattha, imagining it was the Tree of Life spoken of by Avatars and saints.

It was still there, he discovered, long before he reached the spot. It was huge, with a trunk as big around as the legs of four elephants (one measured everything large in elephants when one was a boy in Uttar Pradesh). It stood at the verge of a grove that covered the top of the hill in a thick, verdant blanket. Young Adyahksa had seen giants sleeping peacefully under the wool of titanic green sheep. Best not to wake them, he'd always thought, and so, he'd climb most secretly to the top of the hill and let his body gently into the grass beneath the great tree. There, he had given birth to his first stories, reached up and plucked them from the Tree as others surely must have done before him.

He was swept by hunger then—for the past, for the boy who abandoned the goats to daydream in the warm grass. He stood beneath the Tree at the outermost reach of its great branches and longed for the descent of those simple, ingenuous tales—tales he had left behind him, somewhere between disillusionment and discontent. He recalled he had once found them in clouds. Great, billowing clouds—white and majestic, dark and rain-filled. He craned his neck and squinted a little against the sun. If he laid down upon the grass, if he reached up into the Tree and contemplated the clouds, would he find the stories there?

He dropped to the ground, careless of his expensive clothing—it could be cleansed of the dirt of Uttar Pradesh—and lay back, hands behind his head, watching the pageant of cloud-form. Sheep—they always came first, bright and bouncing—followed, today, by their darker cousins. There was wind high up; he could see it stirring in the heavy underbellies of clouds sponge-full of moisture. These became dragons and dolphins and great, undulating sea creatures.

He began to see other things in the clouds: ships under full sail and wonderful, terrifying animals. He saw upside-down oceans upon which the Sun, burning whitely from behind, seemed like a wave-lapping moon.

A breeze wriggled into his shirt and caressed his skin with damp fingers; a lover wearing a perfume of jasmine and rain. He was slipping into contentment, rolling back the years, finding the

impressionable Adyahksa beneath the urbane Kavi, when he saw a truly amazing formation just above the horizon.

It was a vast face. A woman's face. A very beautiful woman, he decided. A rani. No, a deva—an angel. He smiled—a dreamy smile that hadn't touched his lips since... when? Since the first time he had fallen out of love? He recalled a golden-haired woman with a glittering name. A woman with fair skin and a dark heart.

The smile slipped. He lunged to retrieve it, pulling the cloud face to him with a dreamer's eyes. She was beautiful. Her skin was pewter with a wash of blue. The color of Krishna's skin—or so Scripture said. The smile deepened. Surely, she was of the Kessapa line. A daughter of saints, a descendent of the Avatar. That made her better than a princess or a rani or even a Broadway songstress.

He studied her as she wafted toward him. Her hair was blue-black and sprinkled with pinpricks of light and beneath her broad, gleaming brow, unblinking eyes of pearl scanned the ground. Did she see him there beneath his tree? Of course, she did. She was a deva. She saw all things beneath her. Would she deign to stop, to speak to a lowly boy of Uttar Pradesh, when the whole world was hers?

Perhaps she would pause, study him as he studied her. She was slowing, he realized, and pressing lower. Through half-closed eyes, he watched her lips, full and dark; his half-dreaming mind pretended she would bend down, put those lips to the earth and kiss the spot where he lay.

He slept.

He dreamed of Adyahksa and his Cloud Girl. In his dream, she floated to earth on the backs of cloud horses—whites, greys and dapples; the horses that had drawn Krishna's chariot. When she neared the earth, the horses dissolved, depositing her upon the grassy hill. Without hesitation, she stepped into Adyahksa's arms. She was soft to the touch, but her body had no substance and no warmth. He willed her to embody, and thought she took substance in his arms. But he had no sooner courted the thought than she pulled from his embrace, shaking her head and shedding tendrils of blue-black hair. Her lips formed a single word, "no"...but she smiled.

Heartened, he turned aside and walked with her. They didn't speak, though he dared to reach out and take her hand. It was cool and felt like dampened silk. Enough, he thought, that she walked with him. At length, they reached a stream and the Cloud Girl stopped. Turning to face him, she pointed upward and laid one cool hand on his shoulder. Her lips moved, but he heard no words. She smiled again, and shook him.

"Adyahksa!"

No, that was not her voice. Who called him? He frowned and turned to look.

The face was his brother's. Pallid clouds gathered behind his dark head, making his expression unreadable. "The procession!" he said urgently. "Come, Adya. It's time."

He leapt up, surprised momentarily at the fine cut and quality of his clothing. Yes, of course—he was Kavi again. And he would now join his father's funeral procession. He glanced at the sky as he and Josha made their way to the village. He scanned the clouds for the face of his Kessapa maiden, but she was not there. Nor would she be ever again, he knew. Still, he left the hillside with reluctance, praying—if there was a prayer left in him—that the afternoon would pass swiftly.

<p style="text-align:center">⌒</p>

It was not his first funeral. One of his uncles had died when he was nine or ten, and he had been among the mourners. He had mourned, too, for the young man, just married, who had lost his life to a disease that, anywhere else in the world might have been a "nuisance ailment." His uncle had been a friend, someone to trust with boyhood confidences, someone to encourage him in his daydreaming—to his father's chagrin.

He recalled the pyre—his fear of it. The leaping flames had formed an impassable and terrifying barrier. They had forced him to understand the finality of his uncle's leave-taking. Today, it did not take a funeral pyre to make him understand that his father was forever beyond his reach.

His mother would deny that, of course. She believed in something beyond the physical—a reunion of souls. He had, too, once. But no longer; so the funereal flames singed his soul, making it blink and tremble, and somewhere deep inside the man, a small boy cringed in terror and shed tears of loss.

It was a relief when night fell and the household curled itself for sleep. His mother retired early, her face drained of everything but age. There were still guests in their parlor, chatting quietly, wondering how long the poor old woman would last without her husband, speculating on whether she would move to the city to live with her oldest daughter.

The idea disturbed Kavi. What was this place without Mother? Not home. If she was not here, he would have no place to return to—or at least no place to imagine he would return to. He sought out his brother to ask what arrangements were made for the family lands and feeling vaguely guilty that he had not discussed it with his mother. But his brother brought him face to face with a young woman named Sudha Mohandas.

Did he not remember her? Josha asked. They had played with her brothers as children.

He did remember. He had once daydreamed about her, up there on his hill. He had imagined a wedding and a melding of fortunes, for her family was very wealthy. She had seemed exotic and beautiful then. Now her hair was merely black, her eyes only brown, her skin, too pale.

He forgot what he would have asked his brother, excused himself, and went to bed.

He dreamed. He dreamed of funeral pyres and dark smoke that billowed into the sky to become the cloud-face of a beauty of the Kessapa line. A woman whose hair was the blue-black of a raven's wing; whose eyes were pearl; and whose skin was the color of a rain-filled cloud. She was fragrant and cool and elusive, but Kavi wanted her to be warm and near and solid as the Asvattha Tree—the Tree of Dreams. And since it was Kavi's dream, he willed her to substance

and she complied, metamorphosing into a woman of flesh and blood who came into his arms.

He took her in a savoring embrace, drinking in her beauty and her warmth and her fragrance. But as his embrace tightened, those things faded. She faded with them. No, worse than that—she writhed horribly apart, limb from limb, hair from flesh, dissolving into a dark vapor and leaving sorrow like a dew on his heart.

Kavi was a man well-practiced at manipulating his dreams, but though he labored through the night, he could not bring the Cloud Deva back.

⤙

In the morning he talked to Josha about the family lands. "What will mother do now?"

"You haven't asked her?"

He shook his head. "There didn't seem to be... an appropriate time. Cousin Parva thinks she ought to live with Lila in Agra."

"Do you think she ought to do that?"

"I don't know what she ought to do, Josha. Only what I hope she'll do."

"And that is?"

"Stay here. Keep the farm. It's not as if she'll be alone. You live so close, and there are her friends, the hands. She could even get someone to come and help with the house."

Josha looked amused. "Why should she need help with the house now? She never has before."

"Well, perhaps she doesn't. I was only thinking she might get lonely."

"As you said, I'm right down the road with Bandhul and the children. Her friends are here; she's never lived anywhere else. If you're afraid she might get lonely, why don't you stay for a while? Better yet, why not come home for good?"

"Josha, my life is on the other side of the world. My agent is in New York, my friends..."

"I'm not naive, Adyahksa. I know that many writers—successful writers—live half-way around the world from their business. That science fiction writer—Clarke—he lives in Sri Lanka, doesn't he? Why can't Kavi Samahita live in Uttar Pradesh?"

"Maybe I can stay for a while, but..."

"But a backward hole on the butt of the Himalayas affords a poor lifestyle."

"It's not a backward hole."

Josha laughed. "Ah, now he's defending it! No, you're right—you couldn't live here. What would your American friends say? They'd probably think you'd gone savage—reverted to a little shepherd boy."

"I don't care what my 'American friends' say. I just can't see re-adapting to this life. Maybe I will stay for a bit. When I leave, I can hire someone to stay with her."

Color crept under Josha's dark skin. "She doesn't need that," he said. "A stranger living in her house. But you living here would amount to the same thing, wouldn't it? Perhaps you should leave." He turned on his heel and disappeared into the house, leaving Kavi with a burning face and an uneasy conscience.

He climbed the hill. He would sort his thoughts; he would order his feelings. When he was done, he would talk to his mother, get a sense of what she wanted him to do. Perhaps, she would like to live with him in Manhattan.

Under the Tree, he found it easier to think. He thought of what he would say to his mother, of the offer he would make her. He told himself that was the most realistic alternative, that he really did need to go back to New York, really must live there, really wanted to live there.

At length, his thoughts were interrupted by clouds. It was inevitable and it was why he came here. He let the clouds have his thoughts, shape them, even as he shaped the clouds. He realized almost immediately that he was looking for her—the Cloud Deva. It was absurd. Clouds were random, changeable; wind and pressure and water could never produce the same effect twice. Yet, he watched

for her with a boyish expectancy, waited as the saints had waited for their miracles.

He grimaced. He might as well expect to see the Lord Krishna Himself, riding down out of the sky in Arjuna's chariot. He might as well expect—

He sat up, his eyes locking on a formation near the horizon. It was the same face, he'd swear it. The same enchanting, inhuman face he'd seen the day before, and the moist currents bore it toward him. Smiling, he lay back in the grass with his daydream.

In his dream the village boy, Adyahksa, wooed and won his cloud lover. He told her stories; she told him about her family. She was truly a deva, the wealth of the all worlds was hers.

"I have wealth," he told her.

"You think you have wealth," she replied and her voice was like the pale whisper of wind chimes touched by the merest breath— faint and sweet and inspiring such longing, Adyahksa nearly cried. "What is wealth?" she asked him.

"You are wealth," he answered. "I am wealthy if I have nothing but you."

"Do you love me, He-Who-Controls-His-Own-Destiny?"

"Yes," he said. "Stay with me here on the earth."

There was no answer.

Kavi focused on the pewter face floating serenely above him, much closer now. "Stay with me," he whispered, and watched as the mass of cloud pressed closer to the earth, closer to him. Her face filled his vision.

She will kiss me, he thought. His eyes swam, unfocused—she was too bright, too vast to take in—he closed them, readying himself for the touch of her lips. The kiss took him, vibrating in every cell, in every fiber. Unexpected, orgasm jolted him from head to toe, from body to soul. A cry leapt from his throat. He had never uttered a sound beneath a human lover.

I love you.

"You think you love me. What do you love? What is her name?"

He moaned, quaked, sweated upon the ground. Someone watching would have thought him the victim of a seizure, or the recipient of a revelation.

"Who are you? I don't know your name!"

Kavi sat up and glanced around, anxious that someone might have heard him. He tugged at his sweat-soaked shirt and smoothed back his damp hair. A name. She had to have a name. He knew who she was, he reasoned. He had created her.

He got up, brushing away grass, chagrined at the damp stain at his crotch. The sexual charge had spent itself, but in its stead was a building desire to put Adyahksa's daydreams into words. He hurried down the hill, already rehearsing the opening of the story.

⮑

Yujyate, that was her name, he decided. It meant 'yoked' or 'united,' and was a product of Adyahksa's wishfulness. She was a deva, princess of a spirit kingdom, a daughter of the Lord—of Krishna—by His wife-lover, Radha.

Yujyate was of an age to wed, but rejected every suitor who came to her.

"You must marry, daughter," her Lord Father told her. "The Kessapa line must prosper, or blessings shall cease to rain upon the earth."

But Yujyate saw no blessings in her selection of divine suitors. "They are uninspired, Father," she told the Lord. "And they are uninspiring. How can Your blessings continue with such as these to oversee Your realm? Could such a marriage produce an Avatar? They have no creative power; their words are bland as unseasoned rice, their thoughts as pale as water. I will not have any of them."

"Then what will you do for a husband?"

"I will scour the earth," said Yujyate, "arrayed as a cloud, until I find a man whose thoughts are bright and true and whose dreams are delightful."

The stage was set for the entrance of the shepherd boy, Adyahksa. For Adyahksa's fanciful dreams would win the heart of the divine Yujyate, coaxing her to earth. They would marry, she would give him all delights and make his life heavenly.

Really, Kavi thought, sitting back from his work. And they all lived in Samadhi ever after. He rubbed his eyes. He looked at his words and didn't believe them. God, had he ever? Yes. Yes, he had once. Hadn't that happy ending been what he had pursued, first to Agra, then to the United States? His stories had been redolent with it. He was a believer. A believer in his ability to create; a believer in what he created.

He still had confidence in himself, and in what he wrote, but belief? He wasn't sure he'd call it that. And the stories had changed. Subtly, at first, as he had changed, then more sharply. He'd told himself his style was maturing, that he was finding his voice—the voice of Kavi Samahita. Now, he forced himself to honesty; in finding Kavi's voice, he had lost Adyahksa's. The critics had noticed it—so had the readers—even Josha had noticed it. And though his books sold well and drew critical acclaim, he knew he was no longer unique or fresh. He wrote with mature cynicism, like any number of other writers. Adyahksa had been silenced.

He picked up his pen, then threw it down again with a grunt of disgust. He couldn't write these stories anymore. Kavi put aside "The Boy Who Loved Clouds" and sought his mother.

"Don't stay for me," she said. "I won't be alone. I have friends. I have Josha and his family."

"But Amma, this house—it's a big house—"

She smiled with not a little pride. "Yes, it is a big house. A fine house. And your grandfather built most of it himself."

"But all alone—"

"I won't be alone. I have grandchildren. I have friends." She paused to look at him. "Do you have friends, Adya?"

"Of course, I have friends."

She reached over and patted his hand. "You used to say your stories were your best friends. You remember? When your father would

fret about you being lonely, you would say, 'Father, my stories are my friends.'" She shook her head. "You worried him. But you did so well in school, how could he complain?"

A smile tugged at Kavi's lips. "He was vocal enough about my performance in the fields."

"Well," she said, "you did lose several of his best goats. But, he easily forgave you."

"Amma, did he read my stories?"

She nodded. "He didn't always understand them, but he read. And he was proud. I read them, too, you know. I like the old ones best. The ones you wrote when you were in school."

"Have you read anything recent?"

She nodded. "Bandhul brought me a magazine with one of your stories in it. She said it had won an award." Her expression said she didn't understand how that could have happened, then shifted to concern. "Are you happy, Adya?"

He laughed. "Of course, I'm happy. How could I not be? I write for a living, I am a modestly wealthy man, I am respected by my peers and loved by my readers."

Her mouth puckered and he could feel her preparing to quote him some hoary proverb about true wealth. He put his arm around her. "Amma, I'm fine; it was you we were discussing."

"But do you have friends, Adya?"

He understood, suddenly, that she was not asking about friends of flesh and blood. She was asking about his writing. He chose to misunderstand. "I told you, Amma. I have lots of friends."

She let it go. "So do I. I don't need you to be here for me. I certainly don't need you to hire someone to be here for me. But Adya, if you need to be here, then I welcome you home with all my heart."

⤳

He stood upon the crest of the hill, beneath the branches of his Tree of Dreams and stared out at a cloudless sky. Do I need to be

here? Do I need to run home to my quaint little village when things get to be 'too much?'

Many of his friends had places like that—rustic little bolt-holes where they would renew themselves and from which they would return to speak in glowing terms of the 'simple life' and the 'simple people' who lived it.

He smiled at that. Simple. Rising at dawn to feed stock; long days in the fields—plowing, planting, harvesting, winnowing, herding; doing that through drought and monsoon and cold and earthquake. So simple.

But life in any city had its own complexities; a million tiny, mundane, daily disasters that put insulation on the heart and soul. Perhaps that was what those world-weary seekers after the simple life really sought—a place where they could strip off the insulation, where they could wear their naked souls without fear of disapproval.

Even his stories were insulated now, and he had to admit he no longer thought of them as friends. But the story he had tried to write this morning was a travesty. The simple, ingenuous words squawked in a parrot's voice—utterly false. If he stayed here, wrote here, would that change?

He eyed the empty sky with frustration and longing. There were no stories up there today. He returned to the house.

↬

His dreams were no kinder than the sky had been. He brought his cloud lover to earth again and again, straining to take her in his arms. She eluded him. He used his cleverness to trick her into descending. But in his arms she rent herself asunder, leaving him alone on his dark hilltop under the sentinel Tree.

He woke exhausted, hearing thunder. Galvanized, he rose and dressed; the storm would bring clouds and clouds could bring her. Had he not been so tired, he might have laughed at what he was thinking—doing. He was not so ignorant as to believe he could find

yesterday's face in today's clouds. What he had experienced yesterday could certainly be attributed as much to a stressed and overactive imagination as to the play of wind and water vapor.

Knowing that, he dressed and dove out into the moist morning. It wasn't raining, but the dark clouds that scudded overhead trailed veils that reminded him of funerals. Too giddy for grief, he hurried uphill.

The breeze was strong at the crest of the hill and the great Tree trembled at it, expectant. He paused beneath the outflung branches, quivering in harmony. Seeing the Tree with the eyes of Adyahksa, he perceived a portent: she would come. The Tree knew.

Kavi lay in the grass, hands behind his head, watching the clouds flee dog-low across the sky. There was no gold in them today, only unremitting pewter and silver. The grass smelled especially sweet, and he could even make out the fragrance of the trees that marched along the hill to his left. Sweet. All of it. The rush of wind, the silken scrape of expectant twigs and branches, the gossip of leaves.

It was easy to be Adyahksa here—difficult to be Kavi. In his sleeping dreams he was always Kavi. That was probably significant, but he allowed the significance to be lost on him as he lost himself in the clouds.

There were elephants in the clouds today, and sleek, black pirate ships, and Chinese dragons with silver eyes. All were in motion and foment; there was nothing of the placid or the meditative. He began to fret. Would she come in weather like this? Could she appear on the leading edge of a storm?

He laughed at himself. How pleasant to shed the years of experience to live in the mind of a naive youth. How easy to believe it might always be so... as long as he stayed upon the hill, beneath the Tree. He couldn't do that. Nor could he carry Adyahksa's memories back down the hillside to spill them into a notebook. What tasted fresh and original and exciting at the beginning of the journey seemed ludicrous at its end, as if.... He sat up and gazed around. As if Adyahksa lived at the top of this hill in the shade of this Tree and nowhere else in the world.

He glanced at the Tree's sturdy trunk; it was clear of graffiti. He had seen trees in which people, passing, had carved their initials or names. They did this, he reasoned, because trees, unlike human beings, are virtually immortal. He had never carved his name in the Tree of Dreams; perhaps it had carved its name in him.

He lay down again, pondering the idea of cutting from the Tree a small bit of wood. Something he could touch when he needed the memories to flood his mind. Perhaps, in that way, he could recapture his stories. Perhaps he could reacquaint himself with old friends.

It was as he pondered this that he saw her. He knew it was her—Yujyate—even though she appeared as never before. She was just a wisp at first, torn from the underside of a great, black whale of a cloud, and he watched her with only passing interest. But then the warp and woof of eddying wind caressed the wisp into something else. It took a maiden's shape, curvaceous and graceful—garbed first in a flowing sari, then in the dress of a warrior, then in the sari again. Her head bore a crown, then a battle helm.

Now, he thought. Now, I shall be able to finish the story. He smiled, sliding back toward Adyahksa. See how she flies to me. How constant she is. No human lover could be so faithful. How she must love me.

And fly, she did, as if wings adorned her heels and helm. Dropping below the belly of her whale-cloud she spread her arms and they became as wings, bringing her ever-closer to her waiting lover.

Adyahksa's heart filled. Theirs would be a wedding such as the world had never seen. All the gods would attend, all of creation would witness it. The bride would wear a wedding dress of clouds and a veil of sun-sequined dew. And he would write. He would fill pages with bright words and the words would fill hearts with longing.

She was before him, floating just above the ground. Her eyes were silver in her pewter face, her lips, like black pearl and, from beneath her crown, locks of truest black swam in currents of moist air. If he could only draw her down, if only she would stand beside him.

"Yujyate," he murmured, sitting up. He put out a hand. "Yujyate."

"You call me that," she said, her voice like the whisper of rain, "because you seek to place the yoke of union upon me. I am Yukta—union with the Divine."

"Whatever your name, I love you," said Adyahksa.

"I am not a deva," she said, "although you are not wrong in saying I possess the qualities of a deva."

"Whatever you are, I love you," answered Adyahksa.

"I am not the daughter of Krishna and Radha," she said, "although you are not wrong in saying I am a child of the Avatar."

"Whatever your family, I love you," answered Adyahksa. "Tell me, Yukta, do you love me?"

Her great, silver eyes did not blink and her black-pearl lips curved into a smile. "I have always loved you."

"Then come to me. Live with me and be my wife. Set your feet upon the earth and take on a real form. Let me hold you."

"I cannot."

"Why can you not?"

"I have shown you."

"You've shown me? How have you shown me?" The words had no sooner left his mouth than he understood—the nightmares. "You would dissolve?"

"I am a creature of daylight and spirit, Adyahksa," she said and he shivered at the sound of his name on her lips. "If my feet touch the earth, I cease to be."

He felt as if his heart had melted in his breast. He hadn't anticipated this. In his imagination the fairy tale would end with her descent to earth, with their union. "There must be a way," he insisted. "There must be a way we can be together."

Her head tilted slowly to one side. "There is a way."

"Tell me," he demanded, coming to his knees in the grass. "Tell me how I may have you."

"I am not a possession, One-Who-Controls-His-Destiny."

"No, no, of course not." He reached for her. "Tell me how we may be together."

"You must come with me."

His eddying world slowed to a stop. His blood stilled in his veins.
"How?"

"You must come with me," she repeated, and began to withdraw upward, toward the steel-bellied clouds.

Kavi leapt to his feet. "But how can I? What form would I take?"

"You would take a form befitting your station." She continued to withdraw from him while his panic and desire grew in bizarre, painful tandem.

"I would die?"

He thought she laughed. "Are you now alive?"

"I don't understand—"

"You understand. I cannot exist in your world, but you can exist in mine."

He rejected the idea with every fiber. And in that rejection, he tried to shake himself from the daydream, willing it to end. It did not end. The Cloud Deva still floated above him against the rain-filled sky. He still shivered in the grip of some strange, fearful passion.

Surely, I sleep.

Fear hovered at the back of his mind. If he was not asleep, what did it mean?

"Stop," he said. "Wake up. You're dreaming."

Above him, Yukta laughed softly—a sound like the trickle of water over rock. "You do not dream," she told him. "At night, you dream. Your dreams are full of yourself. Full of Kavi."

"Who are you?" he demanded. "What are you?"

"You know who I am," she said, and evaporated.

He stared at the place she had been and did not wake up. Rain fell, tossing sequins among the leaves of the great Tree, pattering at his face, soaking his hair. Still, he did not wake. Finally, he left the hilltop and walked home through the rain.

He had intended to return to New York at the end of the week. He canceled his airline reservations and stayed. He told his family he needed the break. That was true. When pressed, he also admitted that he was in search of that loveliness his brother had found lacking in his most recent stories. That was also true.

He didn't speak of clouds or daydreams or hallucinations. He didn't try to explain why a man who knew better was hungering for the impossible. It was the stories, he told them. The stories he could bring down from the hill.

He went there every day, but he brought nothing back. The clouds stayed high in an azure sky, ignoring him. His daydreams were flat, lifeless; his nightmares were turbid pools of hunger and impotency.

When he was a week overdue, his agent cabled to remind him he was scheduled for a book tour in ten days. He barely glanced at the message.

He tried to write. He finished "The Boy Who Loved Clouds," but the new ending, in contrast to the old, was dark and cynical. In it, Adyahksa, realizing his union with the cloud maiden was impossible, hung himself from the Tree of Dreams.

He disgusted himself. What utter tripe! Of course, the critics would find it morbidly satisfying, and his literary friends would say, "How sage." But to Adyahksa, it stank of fatalism. I would never, he thought, and he realized how personally he was taking this story, as if he really was seeking the Maiden—seeking Yukta.

He paused over his pages, awash in a sea of untamable words. "You know who I am," she had said and, suddenly, he did know. She was the Story and she was Adyahksa, having found the Story. She was maya, the power of creation, the lovely, the delightful.

And if I surrender to her, he told himself, the Story will surrender to me.

He understood, as he climbed the hill, that this entire experience was but a play he had staged for himself—a metaphor. The Writer had lost his unique perception, his imagination, his maya, his stories. And now, by making a symbolic gesture of surrender, he would regain those things he had lost.

He reached the crest of the hill and stood beneath the spreading branches of the great Tree. He threw his arms wide and looked up at the fleecy clouds and shouted, "Yukta! I am ready!"

The only answer was the whisper of wind across the grass.

"Adyahksa surrenders!" he proclaimed. He turned slowly, arms still outstretched, searching the sky. Nothing.

He stopped his turning, lowered his arms. If this were a story, what would he be expected to do to draw the deva to earth; should he fall to his knees in abject surrender? He tried that, but the clouds remained sheep-like, letting the wind herd them northeast into the mountains. Finally, he lay down as he always did, hands behind his head.

Movement began almost at once in a mass of iridescent pearl that hung nearly overhead. He gazed up into the soft whorl, expectant. It was like a funnel cloud—something of Oz and National Geographic. But it was glistening white, and out of its belly slipped an un-funnel-like shape—the thing he called Yukta, the daydream, the wet-dream, the metaphor.

The cloud gave birth, he thought, watching. She was dazzling in a thousand shades of white and silver, subtle gradations of hue he had never imagined. She descended toward him like an angel from depictions of something Christians called the Rapture.

I have never been a Christian, he thought, irrelevantly. I wonder if a one-time Hindu can experience this Rapture. And he wondered if it was like Samadhi. But that was irrelevant, too, since he had never experienced that, either.

She drew closer to him. Like a bride. Arrayed in radiant purity.

And I will be her husband.

Already he could feel the sexual excitement building in him like a hot storm. Would she kiss him again? Would she bring him again to a preternatural climax? He quivered with anticipation.

She covered him where he lay—face to face, all but blinding him. His passion arced to meet her. How would it feel to couple with her—to meld with that bright, cool flesh that was not flesh?

"You know who I am?" she asked; her voice was the sound of water rushing from a spring.

He smiled. "You are my stories."

"I am more than that."

"Yes."

"What do you think will happen if you take my hand and follow me into the clouds?" she asked, tilting her radiant face skyward.

He followed her pearl gaze up into a well of glory and gasped at the sheer beauty of it. He said, "I will surrender to the Story and the Story will surrender to me. I will find my voice—my own voice, not the voices of those around me—and I will write stories that will amaze even the gods." That sounded good, to mention the gods. He would remember it when he wrote this all down, later.

"You are right in believing that," said Yukta, "and you are wrong in believing it."

Wonderful! A riddle! "How can that be?"

The gleaming head tilted slightly, a gesture he found endearing. "It is as you say, but you will have no voice to find and you will have no hands with which to write."

"Is this a riddle?"

She held out her hand.

"I would make love to you," he said, want swelling.

She sighed; a sweet breath of wind passed gently over him. "You made love to me often, once. After a time, you only pretended. The words still came, the gestures were still made, but there was no love."

Of course. If she was the Story, that was undeniably true. "Now there is love," he said, and rose and stepped toward her.

She embraced him. He felt the misty coolness of her on his skin. He raised his own arms to return the embrace and his senses exploded. More intense by far than the orgasmic frenzy excited by her imagined kiss, this swept him upward, outward, inward all at once. He was lifted, reeling, from the solid earth, flung upward into a roil of cloud, tumbled in eddies of vapor.

He had body-surfed once in Hawaii. This was like that; this was totally unlike that. He was sundered and united; shattered and

gathered up again. Pieces of him rained like shards of bright glass from up and down. He heard the rush of a great wind; he heard nothing.

NO! he thought or shouted, or did neither. This isn't what I imagined! I'm hallucinating! Dammit, I'm hallucinating! Anger rose within him, hot and swollen as the lust it replaced. He wanted to scream himself awake, but in a thunderous moment, all sound, sight and sensation crescendoed and evaporated and he was left, numb, blank, motionless, emotionless and silenced.

He was swimming. No, he was not. There was movement, but he could not describe it by saying, "I am walking, running, swimming, flying." He was simply in motion. There were veils before his eyes. No, he was eyeless. There was sight, but he could not describe it by saying, "I see."

I can't see.

Perceive.

He roiled. There was someone with him. Yukta.

Yukta, she agreed.

Where am I? What am I? He lunged after familiar fear, but memory of fear fled swiftly. He was disoriented. Yes, that was the right word.

You are in my world. You are a son of the Avatar.

I don't understand.

Perceive.

He was (somehow) directed to turn his attention downward (was it downward?). He wanted to perceive veilessly and the veils dissipated. Color. A vast greenness. Shapes. Shadows. A tree. A tree on a hillside of verdant, breathtaking green. A King of Trees that rose above its nearby neighbors like a giant.

A frisson of excitement coursed through him like lightning in a cloud. The Tree of Dreams.

He could see them, then, hanging like heavy dew from every leafy limb—dreams, stories, visions, imaginings. And around him, in shifting veils of mist, lived more of the same, each unique, each sparkling or fragrant or melodious. They fell like rain from the sky.

They lay like dew upon the grass. They rode to earth on beams of sunlight. They traveled on temple chimes and on the clanking of cowbells. There was nothing that did not contain them or was not adorned with them.

If only he had known! If only he had seen them.

Why is this place so blessed?

Laughter rippled around him. It is no more blessed than any other place. Nor is it any less blessed.

He digested that. He had lived for stories. He had left here to seek them. Then he had returned here to seek them. All the while, he had been surrounded by them. He might laugh at the absurdity of that, if he had a voice. Having none, he became laughter.

In the world below, beneath the great Tree, a man lay. It was Kavi, lying beneath the dream-laden boughs, his mouth open, dreaming.

What is he waiting for? he asked.

For a breeze to shake loose the dew. For a cloud to carry it to him. He is waiting for you.

As I waited, he realized. As I waited for you.

Clumsily, he willed himself (what was self?) to descend toward the dreaming figure on the hill. He saw the face he had once called his, saw the lazy eyes open and the lazy smile spread and he felt the hungry, curious mind reaching up to grasp him. He was fully conscious of it then, of what he contained, of what he was. He was a cloud full of rain. He had only to shake the rain free.

When rain fell, children caught the droplets on their tongues; so Kavi-On-the-Earth caught imaginings as they shook loose from Adyahksa-In-the-Heavens.

The earthbound creature sat up, producing a cloud-white pad of paper and a pen. And he began to write.

Adyahksa-In-the-Heavens was amazement. Words filled the bright pages. Stories filled the bright mind. He marveled.

I did that?

You helped him do that.

Then... am I stories?

This dew of dreams is the stuff of creation—pakriti, it is called. You are the mist that scatters the dew and the wind that spills it. You are the word 'Be.' I am also those things, for we are now one.

And is it like this everywhere?

There is no place that is not full of dreams.

No place?

None.

Then may I go—?

⤳

He moved over glittering buildings—great, angular mounds of diamond, wrapped in ribbons of light and dappled by pools of darkness. He came closer and the lights resolved into streams of cars and street lamps. The darkness resolved, too, into empty lots littered with refuse and dominated by crumbling piles of stone.

And everywhere were dreamers, storytellers, songmakers. Some knew they were that, others didn't. Some tapped the dew of dreams on occasion. They lapped it from the air, let it fall on their tongues and spit it out again onto paper or into the airwaves or onto canvas.

But many saw only the hemming buildings and people and bright lights. They heard only sirens and loud music, the shriek of brakes, the angry bleat of horns, the chatter of tongues. The lights made them blink; the darkness made them cower. And as they walked teeming streets and silent corridors or sat alone in cafés or townhouses or shattered tenements, the dreams, unseen, surrounded them. They trod upon them in stinking alleys, they ignored them in the subway, they strolled beneath them in Central Park.

Even now, Adyahksa could feel curious, hungry souls turning outward and inward all at once, wondering where the dreams were and how they might be found. All they needed, he thought, was someone to show them. A little breeze to shake down the dew.

Adyahksa became contentment, then; he became a smile that, if you stood in Central Park at that moment and looked skyward with

a hungry soul, you might have seen, lingering like a Cheshire cat's above the tallest buildings. Perhaps you saw it and knew it for what it was. Or perhaps you thought it was only a cloud.

Rainmusic

Eric Del Carlo

Birk had reached the end of himself; and, having clout, monies and the intimidating prestige of the discredited celebrity, had the luxury of choosing the venue for the discontinuation of his life, which was this: an agra-moon. Rampantly fertile hollows drenched in vegetable purples and phosphorescent blues (these were sources of exotic gourmet foods) pocked the circling atmosphered orb amidst saw-toothed rows of black-stoned artificial ranges. It was over and among the highest juts of the peaks toward polar north that Birk watched the storm's approach.

He was alone on the outpost moon.

The rocky ovoid had not been earthformed for his personal habitation, but he had leveraged his place on it, and nothing would dislodge him.

Beyond the yawning-wide metaplastic shutters and the octagonal windows that were normally—but were not now—spread with invisible static-shields, a dense knot of cloud rolled and spread and coagulated again, moving at a steady speed toward the ranch-style house that had been erected for him at this valley's base.

The home was more luxuriant than he needed. He certainly did not entertain guests here, and so the trappings—comforts that a life-time of consummate privation left him mystified by and to which a second lifetime of celebrity had inured him—were essentially wast-ed on him. He slept along one edge of the sumptuous bed, used the preprogrammed processor in the kitchen for his lackluster meals and sat here in this supple sling-chair, which offered this northward view of the flourishing valley all the way to that distant mountain chain. It was twilight now (but he found himself in the chair at all portions of the moon's seven and two thirds hours "day"), and he had deac-tivated the expansive parlor windows' s-shields. The shutters he'd left raised now for several rotations.

The breeze through the opened windows was stiffening. It cleared the mustiness of the house's interior, which came to smell like him after several successive "weeks" of remaining indoors. Strands of asymmetric but uniformly sliced ruby tinkled, and heat-responsive draperies (they were warming now into pastels) fluttered. An empty package-skin of translucent paper lifted from a lacquered countertop and twirled gracefully before dropping to the sponge-carpet. Then lifted again, higher; then dropped.

The embroidered lapel of his rust-colored silky robe flapped, exposing his left nipple, which hardened.

Discontinuation was not death. Birk had come only to the end of living (meaning: human growth, the accretion of knowledge and wisdom, private evolution), not life. He had, in effect, outlived, in the space of forty-three years, his own humanity.

What had undone him from his living self was, ironically, the same potent force that once had filled him beyond his bounds with zest, meaning and purpose.

Birk, once, had made music. He made music no longer.

He reached now over the ribbed arm of the sling-chair and plucked up a nugget of pink chalk from a shallow dish of antique ceramic. The nugget was chewy and dry. Crates of these nuggets were stored in head-high cabinets along the parlor's walls, but still he

sometimes forgot to fill the bowl and would be forced to interrupt his prolonged vigils in the chair to go fetch a handful.

His wealth could have bought him a much costlier and swankier habit. These pink nuggets were favored in old settled corroding cities by subslum urchins who would never breathe in the daylight and couldn't hope to die of malnutrition in a slaveworks. But the simplistic numbing was what he desired, as it matched and deepened the unassuming rhythms of his own present existence.

Once... music... and rejoicing at his music, his special aberrant resplendent music, which drew the listeners, the crowds, which thrust him nakedly and giddily forward against that vast receiving mass, which took what he gave, which was not, of course, merely music (which any sufficiently imbued machine could create), but, owing to the link-programs which were fundamental to human-made music (which was today a great rarity), he gave his absolute essence. And gave. And the giving created more, soaring him to unthinkable heights of ingenuity; and this he too gave, and the giving created demand, and he met the demands, which grew shriller, more urgent. Compromises were impossible. He could not reduce the quality or intensity of his output. He roared before his audiences, pouring himself into the towering stacks of link-program modules, drenching the arenas and the clamoring insisting throngs that swelled, that swelled....

And he had risen on that flood for years and years, past reference points of endurance and depletion, and still rose. Impossible, the music became. Impossible, the human who created and gave and renewed and gave more.

He survived, where others who'd attempted a particle of what he had accomplished crumpled and disintegrated.

And before the music, before the listening hordes, before the prominence that shook the eardrums of worlds?

Birk, child, pubescent, naked and grimy, breathing the stink of a city's bowels, scratching out a newly met enemy's eyes, scampering the shaft-mazes, sleeping beneath the steaming yowling pipes,

thieving, the dark acts of survival; and, yes, the nuggets of pink chalk, chewy and dry.

It was past now, all past.

The facing cliffs of the distant range lit—a hot crystalline orange. The tumbling but strangely cohesive clouds had passed the mountains. Storms rolled periodically around the ball of the agra-moon, and the automatics that tended the exotic crops coped with all the effects of such necessary rainfall. But... (Birk would have frowned had the mental numbness not made generating the expression seem unimportant)... he had never before seen an electrical storm here, not in the many standard months since arrival.

He should activate the s-shields before it reached the house. Or lower the metaplastic shutters—but, no; he wanted to watch the rain. Rainfall... the curiously carnal experience of uncovered sky... and wetness; still romantic and wondrous, despite an adulthood of living on surfaces.

"Static shields, parlor," Birk said to the caretaker.

The caretaker was not programmed for response to anything but direct inquiries; and so he assumed his command had been acted on; and gave a slow blink of surprise when the wind warmed his bare legs where the robe had spilled away and chimed the ruby strands more violently and sent aloft the package-skin and several other stray items in the parlor.

He repeated the command, a clear loud enunciation, and listened for the soft pock of the shields engaging. He heard nothing but the ruby-tinkles and the rustling swell of the valley's foliage outside.

The storm was unspooling directly toward the house.

The parlor's lights still glowed in their customary dimness. He heard the untroubled cycling of the kitchen units.

Birk planted his palms against the sling-chair's ribbed rests and levered himself upright. He had spent some long while in the chair, and so as he walked toward the octagonal windows, he tottered slightly. And now he did frown as he gazed outward, running a fingertip along the warmed rubbery strip from which the s-shield was supposed to originate.

There was a manual toggle... somewhere... wasn't there?

The sponge-carpet gave under his heel as he took a half-step backward as the lopsided bowl of the valley (it was longer east-west than north-south) lit with orange. Nearer now, the electrical illumination was harsher and somehow falser. The eyeblink-glow had a disturbing unearthly quality.

You're not on Earth, he reminded himself.

Twilight was already gone. Birk crouched, stooped and craned his neck, trying to peer upward beyond the metaplastic lip of this window's shutter. The approaching storm had consumed the stars.

He looked into the valley's purplish darkness (the phosphorescent blues of the plants only reacted to the direct, if distant, sunlight) but could see no rain, not even when the lightning brightened the scene. A first crash of thunder sounded, and this too lacked—or possessed—some unfamiliar quality that made it distinct from other thunderclaps he'd heard.

Maybe this curious storm would bring no rain.

He looked around, nonetheless, for the supposed toggle; and, not finding it, said to the caretaker, "Seal shutters, parlor," and was not entirely surprised when nothing happened.

Rain would ruin all the unnecessarily fancy furnishings of the parlor. He felt no emotional response to that but cast about for something with which to cover the windows. The decorative heat-responsive draperies (they were a luminous scarlet now; the room was quite warm) which covered the leisure screen along one wall that he never used wouldn't serve, and he saw no other possibilities and so merely stood there, his flesh tingling with the roiling of the air.

Rainfall (if indeed rain were coming)... the expectation was stimulating. He was engorging, pushing against the loose knot of the robe's sash.

He had given and given, and much of what passed from him through the link-programs to the crowds was pain... his pain. His youth in the subslums, which he'd initially been surprised to find people took for suffering. Poetry of dank metaplastic tubing and pulverizing cogs and buzzing generators. Songs (for his magnificent

music accompanied these emotion-soliloquies) of sewage smells and dripping lubricant. Ballads of tunnels and melees and pink chalky nuggets.

He elegized the undersurface worlds his audiences would never see, and his fame had been with him so many years before he understood that the crowds sought from him his particular clarification of his pain... and, only after being thrust into the light of the uncovered sun, did he grasp that all the impulses of his previous life had been founded in pain. They wanted him to hurt, so that they could hurt too.

Birk's pain was aberrantly innocent and powerful and poignant, and there was nothing in the worlds to compare to it.

It had all ended in the rain—an open-topped coliseum, the howling swarms, Birk (not a child any longer, no, living now into his fourth decade, but still the consummate master, speaking the unique message) standing beneath pouring lights and ripping ribbons of rain, wired to the black radiant spires of the link-program modules rooted at either wing of the elliptical stage... giving, as he had given so many times and places before, and always the crowds came, never tiring, and they had come tonight.

And that night it went wrong.

The memories could barely scratch through to him now—due both to his present numbing and to the near-senseless disengagement he had always experienced when performing. Afterglows. Flittering sensations. The adhesive patches grown soggy against his cheekbone, his carotid, his navel. The resounding roar of his music. The night city sky blasted with pyrotechnic advertisements. The crowd-presence, animate and vast... and, yes, now, the curious noises reverberating, the surging din that was not right, was not familiar from a thousand previous occasions, a terrible sound, a wrongness. And then the modules dying, a monstrous crackle of interrupted power. And the penetrating soul-felt soliloquy expiring in his mouth. And the roadies tackling him, tearing away the conductive patches and taking beads of flesh with them, and one hammering a fist

against his eye socket. (He recalled—this vividly—how strange it had felt, that bodily contact.)

The death count was high, was staggering.

The enterprise which had discovered and contracted Birk (and which in its bewildering enormity and complexity he was only dimly aware of) blamed equipment failure for the unfortunate incident.

The worlds blamed Birk.

Birk had never learned to blame as a child, only to accept guilelessly all events without attaching to them qualitative properties; and so as an adult—and never having learned to passably mimic the products of such feeling-constructs—he chose simply to make no more music.

The enterprise which held his contract brought eviscerating litigation against him.

The worlds condemned him—seeming now to despise him both for creating and terminating his music.

Birk, retaining enough clout, monies and prestige, had leveraged his place on this moon where he had set about to discontinue his life.

A soft fist rapped the canted rooftop, reminding him inevitably of the roadie's callused hammer-hand and the shriek behind it... telling him to stop it, stop... and the crowds in the stonework coliseum convulsing, vomiting blood, dying in droves. (His message, perhaps it had changed, perhaps the pain had become too poignant, too intense—not meant for human ears. Or the link-programs had haywired. Birk would never know.)

The wind whipped stronger through the rank of octagonal windows, and a fresh scorch of lightning came with a powerful bang of thunder atop it, and the scene was not right; and as more liquid fists struck the roof, he noted that they too were wrong. The sounds were too heavy, too detached from each other. This wasn't rain—not any rain he'd ever experienced.

A bundle of liquid—radiating orange in another blare of lightning—smacked massively into the purple brambles beyond the zone

of cleared vegetation that ringed the house. It was an immense package of water about the size of a human infant, holding together by some impossible means of cohesion—as though a thousand-thousand droplets had all agreed to affix to one another and fall at once.

It was hugely absurd.

Another "drop" struck nearer among the growing purple. More knocked the roof.

Birk now took a full step back from the window.

A parcel of water hit immediately beyond the same window.

He turned, frightened (for he'd learned—and accepted—fear in the subslums), and thought to flee to some other room of the house, but the latest of the nuggets he'd ingested (the chalky aftertaste still coated his tongue, his throat) stifled any possibility of quick instinctual reaction, causing him to meditatively consider and reconsider every response... and by then he had waited too long.

The tepid sliding fingers gripped the embroidered collar of his rust-colored robe and yanked; and despite the nugget's effects, some bypassing motor-reflex allowed him to wrench himself forward against the pull. The fingers stayed bunched in the robe's collar as it snapped down to, then off, his elbows, the sash undoing itself and the garment catching again briefly at his wrists, then gone.

Birk tumbled naked and still erect to the sponge-carpet.

The great liquid pummeling of the roof and yard continued. Lightning flared, and the thunder stomped the parlor, detaching the strands of chiming rubies from their ceiling socket.

Birk reared to his knees and elbows, then toppled to his left hip and rolled onto his backbone.

The watershape, now evidently able to view him in his entirety without the camouflage of the robe, finished forming as he watched.

The liquid structure gained kneecaps, pectorals, Adam's apple, genitals, earlobes. Ribs pressed against a tight sheathe of waterflesh. Eyelids blinked over thumb-sized liquid orbs. It had no color but what the parlor's dim lights lent it.

It stood over him. The fingers of the right hand opened, and the silky robe dropped in slow gathers onto the floor.

He knew how to flee, had learned it was the first best option in virtually any situation—but here in this house, on this moon, there were no mica-walled shaft-mazes, no red-striped utility hatches, which were the ones that opened onto ladders and crawlways.

Birk came up off the floor awkwardly but quickly—heels and palms planting themselves into the carpet, shoulders, abdomen, then groin lifting—sprang backward, turned away once more and forced again this thought-tactic through the nuggety haze of his mind: flee to some other room of the house; seal the door (would the caretaker obey the command?); hide; wait....

Again the tepid fingers gripped, this time the grooved stalk of his nape, but closing, merely slipped off his flesh. (Contact: the poorly linked memory association with that roadie's pounding fist being only that of bodily contact. Had it, in fact, been on that rainy stage the last time he had been touched? Possibly. No, probably. No, definitely.)

Birk fled the parlor.

His naked feet left the sponge-carpet and smacked cool tiles.

The corridor bent in an L past the kitchen's entryway, where the lights were brighter and reflected from pearly enameled surfaces, and jogged left, where the tiles became warmer varnished mahogany slats.

Behind (and above the punching rainfall and another off-key but tremendous thunderclap) Birk heard muted footfalls, then the slap of liquid soles on the tiles.

He threw himself through the bedroom's doorway, where the light was dimmer even than the parlor's—threw himself to give himself an extra length of distance from his pursuer—falling again, this time onto his palms and knees onto another tract of sponge-carpet, this bronze where the parlor's was maroon.

"Seal door, bedroom!"

There came the shtut of the engaging circuit, and Birk whipped his head around, feeling a muscle below his right shoulder blade twang, to watch the door close, and saw instead the watershape's fingers grip the door's jambs—to halt its momentum. It took a first step

inside the room. The door's cleaver blade did not slice shut from its envelope in the wall.

The elemental borrowed color from the bedroom's faint amber lighting, which picked out the ridges, cavities, roundnesses and angles that were absolute reproductions of Birk's physical proportions. Birk's erection had drooped in the short flight from the parlor to this room, and now the watershape's rampant organ sagged, then dangled.

Through the liquid body and the translucent amber highlights he saw the fidgeting coppery filaments of the animasculpture mounted on the corridor's wall opposite the doorway.

The bedroom had no windows. The only retreat within the space was the cranny of the closet, into which Birk had over the last months dumped articles of clothing, which at the caretaker's command or the snap of a toggle (there alongside the niche was the blue rocker switch) would launder the clothes. Birk had never activated the closet and had been wearing the rust-colored robe now for many standard weeks.

The closet was comparable to a white-starred utility hatch, hatches which were ones that led only into enclosed cubbyholes. The same innate subslum instincts that had induced him to flee warned him as sternly against entering the contained space.

Which meant he must, deductively, face his pursuer.

He levered himself again toward his feet, failing this time, managing only to get one foot beneath him, his bare haunches resting on his other ankle. His knees felt feeble, and his head gave a whirl of giddy protest.

The watershape took steps toward him. Its head cocked at an angle that seemed quizzical.

I am awarding it emotions because it looks like me, he thought; and the thought met this sideswiping observation: it does not leave wet prints on the bronze carpet. Which meant its liquid structure was comprehensively cohesive.

The elemental continued to advance, and Birk began to retreat, a clumsy backward scooting, still unable to stand but trying repeatedly

until both feet were under him, raising him to a crouch on fear-weakened knees. On his next ungainly back-step he bumped the scrolled metal of the footboard and tumbled onto the plump fabric of bed, onto its broad middle where he never slept.

Thunder sounded, and a huge flare of lightning reflected its way around the hallway's L bend and lit the spidery animasculpture with crystalline orange. The coppery strands went into a riot.

He was watching the sculpture through the watershape's drawn chest (how gaunt it is/I am, Birk thought) and now refocused to see the liquid manmold reach the foot of the bed and raise a leg and step.

The plush fabric, into which Birk's shoulders and buttocks and heels were sunk, gave as the watershape climbed onto the bed.

Pursuers in the tunnels and shaft-mazes were not always—but were usually—intent on assault. On those (rare) occasions when he had found himself cornered and when his pursuer had some deed other than aggression in mind (much rarer), Birk had always known with certainty within the first few heartbeats of the standoff what that intention was.

The elemental—head still angled from narrow shoulders, amber-tinted eyebrows drawing together and furrowing the liquid brow—knelt between Birk's ankles, which shifted the bed further toward its foot, and reached out with tepid fingers and took hold of Birk's genitals.

The hand felt moist and humid but not wet, like a translucent paper wrapping that held, without leaking, a volume of heated water. The grip was not at all violent—which, had it been, would have signaled to Birk in his undersurface youth some entirely different intention. The gently clenching fingers were instead indicators his inherent instincts told him to welcome.

His knees raised themselves. His feet spread further apart, making a V of his legs.

He was still frightened.

The fingers clasped and moved his testicles, and his shaft curled along the flesh of his inner thigh, then lifted away, tensing.

A dual thunderclap—one blast separated from the other by a single blink of his eyes—upset some heavy object from a chiffonnier against the wall opposite the closet; it thumped the

sponge-carpet without giving a clue to its identity. The punch of the "raindrops" on the roof increased in tempo. The storm had evidently stalled over the house.

The hand left his loosening—and now tingling sacs—and grazed his shaft, fingertips from which protruded several millimeters of hard liquid nail tracking his swollen underside vein. Birk felt his head lolling back into the bed's rich material and now lifted it deliberately to watch the elemental, whose head was no longer listing at that questioning angle, as the palm took his staff into its crease and the fingers wrapped tightly but still not violently; and Birk dropped his head again and felt his eyes drift automatically shut. His lips parted slackly, then tightened, as the lukewarm hand gathered the lax flesh around the mildly curving hardness and pumped.

Expanding muscles just below his flat belly sent streams of warmth into his thighs and pelvis. His erection softened the slightest degree as the moving grip inflamed the interior passageways of his organ and as his arousal increased. A dewy globule of wetness oozed from the plum-head of his shaft, but it was from several layers beneath the immediacy of this contact that his orgasm bubbled and boiled.

And escaped...

In a fierce rush that lifted his buttocks from the bed and contracted his testicles and sprayed his abdomen and heaving chest and throat. Birk opened his eyes.

I have not been handled so since I first saw sunlight, he thought.

Police glue had sealed him to a shaft-maze's floor panels. He hadn't detected the odor. He was fleeing, senses gauzed by a handful of pink nuggets (two more than he normally ate, five less than he'd ever consumed all at once). His pursuer did not enter the switch-backing chamber, whose mica-glittering walls behind struts of grey metaplastic were flash-lacquered; and it was many hours, long

enough for his numbed senses to revive, before the bulky silver-suited retrievers came.

It was while in custody, after he was sanitized and inoculated but before he was released into the sunlight above the subsurface precinct house, that the procedural 'scans revealed his peculiarity. It was some while after that when he learned what the psiscans had decoded; and by then agents of the enterprise that would soon arrange his contract had arrived, and Birk was told to sing for them.

He did.

Propagation was never the object of coupling in the subslums but still occurred occasionally enough, despite crude birth control measures and makeshift abortions, to maintain the illegal urchin population. And so Birk (sometimes pursuee, sometimes pursuer) had experienced many acts (sometimes willingly, sometimes not), whose entire purpose was carnal entertainment.

And so when the watershape released its grip and slid its body further up the bed and alongside Birk's, he—no longer frightened—turned himself toward it and snaked a hand up its backbone to rest between spiky shoulder blades and pressed his still-sharp nipples to the translucent chest and felt the other's cock pulse against his thigh and put his mouth against the parting lips.

They kissed a long while.

His stroking fingertips moistened against the elemental's back as he caressed its pronounced spine from shoulders to base, where what felt like flesh softened and swelled.

Their mouths, caging wriggling tongues, remained fastened as he moved his hand to examine the shaft and sacs.

Then Birk turned, rolling from one hip onto the other, and the rigid organ that was the perfect copy of his own nestled itself in the heated rut between the taut hemispheres of his buttocks. He emptied his lungs of air and did not draw another breath until the shaft head swirled against the opening in that furrow; and then sucked in fiercely through clenched teeth as his hole gobbled the waterBirk's staff.

Fingers clutched his hipbones, lifting and maneuvering him a few centimeters as Birk remained speared, then the intruding length wormed further inside, so that the short curls above the shaft tickled his flesh; then the fingers tightened, and the cock drove at him.

Birk bucked against the invasion. Waterflesh slapped flesh.

The crowds had come (the enterprise that held his contract had orchestrated his burgeoning career meticulously, and even so he had outstripped all projections) to soak his unique essence through the link-programs, to hear his words and music. He stood alone on the stages of bigger and bigger arenas, touched only by the conductive patches, giving to the remote crowds. Offstage he was as alone—swaddled in baffling luxuries, tended to by aides, to be sure, but never was he touched.

They are afraid of me, he realized two years after he had been released from the precinct house into the sunlight of the surface, because they worship-fear my music.

An adulthood of solitude was ending here tonight, on this isolated agra-moon, on this bed.

The elemental's rhythm, which had become a wild pounding, abruptly halted; and because Birk remembered his own rhythms, he waited for, then felt, the streaming hotness that erupted from the liquiform. He was, by then, achingly erect again and settled onto his back and waited for the waterBirk to crawl between his legs, amber-glinting shoulders pressing his thighs apart and the mouth he'd tasted lowering itself onto him.

It took much longer to fellate him than it had to manipulate him by hand.

Birk opened heavy eyelids and watched, fascinated, as his semen drizzled down the elemental's transparent throat.

It stood and extended a hand, and Birk took the fingers and came off the bed, whose coverlet was nearly the same maroon as the parlor's carpet. The waterBirk walked a step ahead, Birk's hand in its, onto the varnished mahogany floor, along the corridor in the direction opposite that which led to the parlor, turning at another bend, past more rooms, and another.

"Open, front door," Birk said as simultaneously the panel leapt away, so that he was unsure if the caretaker had obeyed or whatever force had overridden his commands before had effected the action.

Outside, the purpled valley (this view was opposite that from the parlor, and the horizon, visible as crystalline orange lightning blazed, was flat) was alive. The watershapes swayed and gyrated and shimmied. They were not like the waterBirk but were configured to anatomical specifications that were at once absolutely outlandish and utterly sensible. Lifemolds that had acclimated themselves to some environment different from but not totally alien to this.

The storm was still raging.

Birk watched a bundled "raindrop" fall, smash and scatter among the brambles beyond the cleared zone circling the house; then flow and backwash and reorganize.

The crowd seemed to fill the distance to that flat vanishing point that was the valley's brim.

The wind was strong and tropical. Birk grinned. The elemental's fingers tugged his, and when he turned, the watershape too was showing its hard liquid teeth, grinning. Then it spoke.

"Sing."

Birk's voice, reproduced by liquid lungs and larynx, sounding for all the worlds how he might speaking underwater.

The rainfall and accompanying off-pitch thunder shifted suddenly, finding and holding to a tempo that was the very one he had instantaneously mentally fabricated at the elemental's request-command. It was not music he had created before, and as his jaws unhinged and he gathered a first burst of breath, what came from him, without aid—what here would be the interference—of link-programs, wasn't any song he had ever performed on any of the worlds.

(This agra-moon was quite distant from the sun, but it was hardly the most outlying inhabited site in the system—not to mention the numerous crewed survey-probes pushing at this system's confines. But those fuel camps and chart posts and planetary diagnostic orbitals were hermetically self-contained... unlike this earthformed

moon, panting and puffing lush gases into a dense and fertile atmospheric stew. It must have seemed an irresistible organic jewel dangling near the periphery of this foreign system.)

Birk sang—not of the gritty undersurface of his youth, of other things, things perhaps important only to him but idiosyncratically profound nonetheless—and the rainmusic rose around his song. The waterBirk's fingers remained intertwined with his until the song ended and the crowd of living liquid clamored for more.

Passion Play

D.L. Keith

There was the smell of sex in the air.

Asiana crinkled her nose as darkness folded about her, the heavy wood door whispering shut at her back, cutting her off from the comfort of the day lit street. A girl wearing a thigh-length smock stepped from the shadows and made to take her grey cloak, but Asiana gestured her away, even pulling the hood down lower over her face to hide her features. Affecting a confidence that she did not remotely feel, Asiana stepped purposefully down from the vestibule and onto the dimly lit floor of Cartog's Theatre where sat the patrons at small tables.

Lurking in the Western quarter of Old Maronque, Asiana knew Cartog's played host to foreign theatrical troupes whose reputations' were, at best, notorious. It was the sort of place that would be regarded as an affront to the God-of-the-Three-Fingers by the pious.

Which was why—so those more politically astute had explained to her—the so-called Little Tree had not sent soldiers to close down the Western quarter after being proclaimed emperor following the passing of his father, The Great Tree. Such a crackdown is precisely

what a fanatic, intent on imposing his world view on others, would be expected to do. So Old Maronque, Vanalth's greatest trading port, remained a thriving metropolis of liberal delights—and foreigners returned to their home kingdoms assuring all that fears of the Little Tree's extremism were unfounded.

While in the lowlands, schools were being transformed into religious temples, and dissenters disappeared in the night.

Asiana was roused from her grim musings by drumming echoing from the stage. She blinked, her eyes still adjusting to the dim light. A thin smoke, or incense, hung in the air as she made her way carefully past tables and patrons. She glanced at the stage as two men emerged from the wings. She gasped.

The two men were nearly nude and began to writhe about each other in time with the drumming. She could not tell if it were a dance choreographed to simulate sex... or simply sex that looked like a dance. She blushed and looked away. At their little tables, nursing goblets of Viran wine, the audience stared raptly—some clearly put off, others aroused, all fascinated.

Such was Cartog's.

For the thousandth time she wondered if she was doing the right thing.

"Are you Asiana?" asked a soft voice in her ear.

Asiana turned, her breath catching in her throat. A woman stood beside her—a winged woman. Asiana blinked, remembering that Old Maronque was a cosmopolitan city, with people from every kingdom. The woman was obviously a performer, with glitters around her eyes and brows, emphasizing the elven features common among the winged folk. She was also quite beautiful, her features delicate, her eyes large and intelligent. Her short hair was slicked back with sweat and Asiana realized she must have been on stage earlier. She smelled—Asiana inhaled the rich, potent scent—she smelled of sex! Asiana darted a glance at the two men on stage and blushed even deeper. Had the woman been there, perhaps mere minutes ago? Had she copulated before the crowd in some weird concoction of sex and art?

Asiana found her eyes roaming over the woman's trim, firm contours, concealed by very little clothing. Her breasts were small, but her nipples pushed sharply against the fabric of her bra. Her G-string was so narrow, Asiana marvelled that she could see no pubic hair flirting from the edges.

Asiana looked up, startled, embarrassed by her lurid musings. "Yes... I am Asiana."

The winged woman grinned wryly. "I'm Fl'rr. Sit here," she said, gesturing at a table.

Hesitating but a moment, Asiana sat upon the wooden chair. The winged woman settled opposite her.

"We expected you yesterday," said the performer.

Asiana shrugged. "I thought I was being followed." She started as the winged woman took her hand in hers. Asiana pulled free. "Don't do that," she said.

The winged woman batted her dark eyes at her. "Do you want to attract attention?"

Asiana glanced out from under her cowl and saw that, the "performance" completed upon the stage, some eyes had drifted their way—curious about the cloaked woman sitting quietly with the half naked, winged entertainer.

"Would you rather be mistaken for a lesbian... or recognized as a spy?"

Asiana glared, her mouth going primly tight. Then, haltingly, she pushed her hand forward across the table. Fl'rr took the hand in hers, and began stroking it, gently, as though a butterfly's wing. Her hands were warm and soft. Asiana's mouth felt dry, her breathing shallow.

"There," purred the winged woman, "that's not so bad, is it? And no one to think twice about our little conversation now." She looked at Asiana. "You do not approve of us, do you?"

Asiana did not blink. "It seems a dubious way to make a living."

"We challenge ourselves and our audience, our taboos." To punctuate her point, she leaned forward and kissed the tips of Asiana's fingers. Asiana felt a rush of warmth in her cheeks. "And, besides, everyone enjoys a good fuck now and then." Fl'rr laughed, seeing the

shocked look flash in Asiana's eyes. "You're very beautiful. I know anonymity demands the cloak, but I hope most days you do not cover yourself so. After all, The God-of-the-Three-Fingers made your beauty, too."

Asiana frowned. "Don't mock our god."

"He's our god, too. We worship him in the Eastern kingdom—we just don't persecute those who worship him differently."

"Those are the principals of Vanalth, as well," Asiana said patriotically.

Fl'rr shrugged, unwilling to argue. "That is why you are here."

Sagging a little, suddenly grateful for the sensual warmth of the woman's hands around her's, Asiana nodded. "The Emperor's zealotry threatens the very values he professes to uphold. It is important that the other kingdoms know. I have information. My husband is of the imperial guard, and so I have learned things…"

Suddenly the winged woman stiffened and peered past her shoulders. Asiana started to turn, but Fl'rr tightened her grip upon her hand. "Don't," she whispered. "Imperial guards. At the entrance."

Asiana went pale. She was not sure which was more terrifying: to be found here, as a spy. Or simply to be found in this sort of place at all. The former could see her executed… but the latter would see her humiliated. "Is it a raid?"

Fl'rr shook her head. "They are being unobtrusive. I suspect they're looking for you. You may not have been followed, but their soothsayers must have divined where you would head. Quickly. Come with me. But nonchalantly."

Heart thundering beneath her breasts, Asiana trailed behind the other woman, their hands still clasped.

"Look at my ass," teased Fl'rr.

Unbidden, Asiana's gaze fell to the sight framed between white feathered wings. The smooth, gleaming buttocks brazenly left unadorned by the thin fabric pinched between the firm cheeks. Asiana blushed again. Why would this woman think she wanted to look at her bottom? Did she think that just because Asiana was holding her hand it meant that she was sexually attracted to her? Besides,

just because she could recognize another woman's beauty, didn't mean that she wanted to have sex with that woman.

Asiana began to grow angry, flustered, confused. This wasn't how it was supposed to be! When she had contacted sympathetic acquaintances and told them of what she knew, and they had offered to put her in touch with those who could get information across the border, she had not expected to find herself in a place like this, full of its lurid innuendo and wantonness. She-

Suddenly she realized a curtain had closed behind her and she was back stage. And she felt a little embarrassed. Fl'rr's admonishment to 'look at her ass', teasing and provocative as it was, had its desired effect, by keeping her mind momentarily off of the imperial guards in the other room. Otherwise, she might have been inclined to steal a glance at them, or to hurry her steps. Actions that might have drawn attention to her. Forcing herself to smile, to pretend that she was not as easily shocked as she was, Asiana said, cavalierly, "You have a very nice bottom."

Fl'rr looked at her and grinned. "If we had more time, I'd let you explore it more...intimately."

And once more Asiana blushed, the woman proving that no matter how raunchy Asiana tried to be, the other woman could always ratchet it up a few extra degrees.

"What's this?" demanded a tiny voice in her ear. Asiana whirled, startled, as a little fairy man, scarcely taller than her finger, whizzed by. "What's she doing here? We have a show to perform."

"This is Asiana," said Fl'rr. "Asiana, our director, Mmmymmoor."

Asiana nodded curtly. Although there were fairies and winged people and more in Vanalth, they tended not to congregate together, let alone form blended theatrical troops.

"Asiana?!" chirped Mmmymmoor, recognizing the name. "Well why bring her back here?" he snapped. "There are guards out front, no doubt searching for her. She should have give you what she had, and then left."

Asiana looked bewildered. "But... weren't you told? I have nothing to give. No scrolls or writings. It's in my head. I was given a

potion, to aid my recall, then I memorized reports that I secretly read that had been passed to my husband." She looked from Fl'rr to the tiny man, helplessly. "You were to have a medicine woman, who could lift the information from my mind and carry it with you back across the border."

Fl'rr sighed, "Our medicine woman took sick and did not come this tour. We were told none of this. Only to meet a woman called Asiana who would give us information to smuggle back into other kingdoms. We are performers, not spies by nature. This is all very new to us."

"And me," said Asiana, suddenly seeing in Fl'rr, not some strange, threatening, glorified harlot, but a young woman no older than herself, caught up in a larger drama.

The little fairy man cursed in a strange tongue. Then he darted to the curtains, peered out, then whizzed back to them. "If they find her here, we are all done for!"

"Hide me," begged Asiana.

"Where?" he demanded. "Look around you. There's barely room in these wings to change sandals. There is nothing—nowhere. And old Cartog will have nothing to do with any subterfuge. He'll sell us out in a minute. We're done for! Done for!"

Suddenly Fl'rr said, "Hide her in plain sight."

"Eh?"

Unexpectedly, she reached out and pulled back Asiana's hood, revealing long raven locks, high, proud cheeks, and generous, pouty lips. "She is beautiful of face, and from the hang of her cloak, of figure as well."

"Absurd," said Mmmymmoor, though without conviction. He eyed Asiana up and down, then abruptly darted beneath her cloak. Startled, Asiana let out a little yelp and batted at her cloak. He darted out again, wide eyed with fury. "Damnation, girl! You could've killed me. What are you ashamed of?"

"I-I don't understand any of this?"

"On stage," cooed Fl'rr, speaking in her ear. "The one place they will not expect to find the runaway wife of an imperial guard is on stage."

It took Asiana a moment to fully comprehend the import of her words. She looked toward the stage area, and slowly, numbly, shook her head. "No. No—I, I couldn't. I wouldn't know what to do—"

"It's not alchemy, girl," snapped the tiny man. "Are you a virgin?"

Asiana looked at him, wide eyed. "N-no."

"Then you know what to do. Fl'rr can barely remember her lines some days, but she can take a fist up her snatch—it's not prose, but it makes for a hell of a denouement."

Fl'rr leaned close to her. "Don't let him frighten you—he just blusters that way. We'll protect you—no one will hurt you, or take you further than you can go." She looked at the fairy man. "Gargagia's Trials?"

"We haven't performed that one in months—and in the current political climate..."

"But it's pantomime—she would have no lines to remember," Fl'rr reminded him.

Asiana felt breathless, as though the air were growing thin. This was like a surreal dream. Strangely, though she protested, though a nervous sweat was beading along her spine and under her arms, she realized there was something else at work.

Part of her was excited! As much as she feared what they suggested... she feared them changing their minds. She did not understand herself at all! Then again, she did. She had lived a good and proper life, married a man of good prospects and secure position. She had done what was expected of her. And, on some, small level, she thought it was killing her inside. "Guh-Gargagia's Trial?" she whispered to Fl'rr as the little man whizzed away, to rally his other performers. "That's a parable from the holy scrolls."

"Yes, well..." said Fl'rr, "we've interpreted it rather liberally for the sake of our art." She looked at Asiana soberly, and stroked her dark

hair affectionately. "I was serious. I want you to feel safe, to know that no matter what happens, you won't be seriously hurt—I wouldn't let that happen. You don't mind a little paddling, do you?"

"N-no," said Asiana, unsure what boating had to do with anything.

Fl'rr pried open the curtains between two fingers, showing a sliver of the room beyond. Asiana stiffened, seeing light glance off the helmets of soldiers moving among the tables, the patrons staring deliberately at their drinks, pretending not to notice the armed men—and not wanting to be identified themselves. "Look at the crowd. Enjoy the crowd. Enjoy their enjoyment. Feel their eyes like fingers caressing your skin. Use it, revel in your power over them. It's the biggest aphrodisiac I know." Then she did something unexpected—she leaned forward and kissed Asiana on the lips. Fl'rr tasted sweet and salty all at once—and Asiana felt a burning between her legs. "Good luck—to all of us."

From her position in the wings, Asiana saw a little man—a midget—bound on stage, his voice coming to her as if from a great distance, as the roar of blood in her ears thundered through her head. "Ladies and gentlemen, lords and ladies," announced the little man, "a slight change in our program, but one for the better I'm sure you'll agree. By popular request, the Travelling Exotics of Mmmymmoor present their interpretation of Gargagia's Trials..."

Asiana felt fingers tugging at the neck cord of her cloak, and felt it rustle as it settled down around her feet. More hands tugged at her blouse, at her skirt. She wanted to protest, to resist... even as she felt a rush through her body, a shudder of sensuality, as the warm hands of strangers pulled roughly at her garments, unclasped her sandals. Through the sliver-thin break in the side curtain, Asiana could see a guard moving purposefully toward the stage entrance. She glanced at Fl'rr, who had already doffed her brief garments—and she felt a rush of self-consciousness. The winged woman was slender and well-toned, her breasts small but firm, her groin—Asiana realized—completely hairless.

Asiana suddenly felt ashamed of her body. She was beautiful, she knew, but the winged woman was more beautiful, it seemed to her. Her large breasts felt suddenly heavy and ungainly, the thick bush of hair between her legs making her feel primitive—she remembered with a start that she had not even shaved under her arms for a few days.

And then Fl'rr brushed her ear with her lips and whispered, "You're so beautiful." And then firm hands were pushing her out onto the stage.

She stumbled over her feet, then froze as the shielding wall of the back stage area fell away and she was left standing, completely naked, before the crowd. Her stomach twisted around upon itself, and sweat trickled down her ribs. She stared wide eyed around her, not having realized how clearly she would be able to see the audience. How obvious would be their stares. Their stares at her breasts, at her hips, trying to peer between her legs. She wanted to cover up even as... she realized, she didn't. She liked them staring, liked the fact that she was arousing them, just with her naked body. What had Fl'rr said about it being an aphrodisiac?

There was a burning rush through her body, a shuddering that went up from her naked toes, literally jolting through her groin, pulsing through her breasts, until it flooded hot and heady into her head. She knew what it was—terror. But a delicious, almost disassociated terror. Terror that the ruse would not work and the guards would spot her. Terror of being naked in front of a crowd. And that most fundamental terror of any who has performed before an audience...

She did not know her part.

"...and thus did Gargagia walk about her lands, content in her piety," called the midget, who had retreated off stage.

Was she playing the part of Gargagia? Asiana wondered. She took a faltering step forward, feeling movement was better than standing there, her mouth agape.

Suddenly a voice in her ear hissed, "Walk about—gaily. Prance. Pick imaginary flowers. Pick up your feet, you clumsy cow!"

Asiana realized it was the director who, by virtue of his size, could flitter about, unobtrusively directing his actors even as they were on stage. His mood was sour, his words abusive. But she realized Fl'rr had ignored his vituperativeness, so she could as well. But his directions—those she heeded. Feeling a bit foolish, she began to saunter about, mimicking carefree steps. She hesitated about pretending to pick flowers, wondering how she could bend over in a way that would not be wanton. Then, she realized, that was rather the point of the show, was it not? She hesitated a moment longer, than dropped to a demure crouch, her back half to the audience so they could appreciate her buttocks, while pantomiming picking a flower and smelling it.

"But Gargagia's faithfulness to her god aroused the ire of the wicked king, who ordered her arrest."

Asiana whirled about, eyes wild with animal start, as two men came thundering on stage, dressed in paper mache armour. She realized that her unfamiliarity with the play, and her role in it, might actually compensate for her lack of talent. The men really had frightened her—as the part required. They grabbed her brusquely by the arms and knocked her over, dragging her about the stage. "Struggle," hissed Mmmymmoor in her ear. "Flail about. Don't worry. They can hold you."

Asiana began to struggle, writhing, as they dragged her back and forth. She kicked out—too late realizing how her twisting and turning was exposing her so fully to the crowd. She also began to grow more excited. It was all an act, a game—but there was something thrilling about being held. And though in life, to be dragged naked down the street by two men would have been terrifying... here it was exciting. She was helpless, and just as the 'power' she felt over the crowd was exciting, lack of control was equally stimulating.

And then they flung her forward, so that she hit the boards roughly. She looked about, a little dazedly, her mind awash with whirling emotions, her hair tumbling wild about her face. She glanced out at the audience—and almost exclaimed in surprise.

Among the guards trawling the room was a face she recognized—
Hanold. The husband she had betrayed by memorizing his confiden-
tial messages, and then deserted in the night. He had come himself
to find her. And here she was on stage, nakedly debasing herself. He
had but to look up... But as Fl'rr had predicted, he was searching the
patrons for her face, not the performers.

"...determined to make her repent her devotion to the new reli-
gion, the wicked king ordered her punished..."

"Lift your ass, girl," hissed the tiny man. "Wiggle it for the
crowd."

She hesitated, blushing. She began to feel panic, thinking of her
situation, of Hanold in the audience. She was barely aware of
Mmmymmoor whizzing away, to whisper directions to his "sol-
diers". Suddenly the two men were grabbing her, roughly dragging
her up on all fours, turning her so her posterior thrust toward the
audience. As much as the position was revealing, she realized, at least
there was little danger of Hanold recognizing her. He had never
come at her from behind—indeed, he had rarely seen her naked in
anything but an unlit bedroom.

She heard the crowd ooh suddenly, and she stiffened, unsure what
was happening. She heard a whisper of something cutting the air.

And then she shrieked as something flat and hard cracked against
her bare ass. She started to squirm, but the other "soldier" held her.
Again something whacked her bottom, and again she cried out. It
hurt! She felt a flame of pain lick across her round cheeks. Again and
again was she struck, and each time she yelped in pain.

Suddenly Mmmymmoor was at her ear. "Relax, girl. Stop tens-
ing... or you really will be hurt. Have you never been spanked
before?"

And she remembered Fl'rr's promise that they would not take her
further than she could go. She glanced about wildly—and caught
sight of the naked winged girl waiting in the wings of the stage.
Seeing her, Asiana relaxed. Slightly.

Again and again the paddle (for that's what it must be) whacked her bare bottom, and the heat was like a furnace, the pain lancing up into her back and down her thighs. But it was triggering a cacophony of sensations in her hips, and Asiana was dimly aware that the cries escaping her lips were sounding less like screams and more and more like moans. Her vagina felt swollen and inflamed even though it had not been struck. Her arms trembled and she began unconsciously hoisting her bottom, as though to meet the paddle halfway.

"...they were determined to punish her for her devoutness..."

Suddenly the paddle stopped, and Asiana gasped as strong hands dug into her inflammed buttocks, squeezing them, stroking them. The pain was great... but the thrill was greater. It was as if the punishment had cracked open nerve conduits that had lain dormant for too long, and suddenly everything was heightened, pain and pleasure both. She moaned pitifully as she felt him brazenly spread her cheeks, exposing her more fully to the crowd, her swollen lips... even her tight anus. She heard the sound of a man spitting, and felt saliva hit her bottom, the liquid like a cool salve on her hot flesh. She gasped—then her eyes flared wider as he began stroking his spit against her vulva, strong fingers stroking arrogantly where even Hanold had rarely fingered her. Her hips began to buck with spasms as he stroked her vigorously, spreading her lips, and spitting again, working his saliva into her very body.

She moaned throatily.

"Don't come, girl!" hissed Mmmymmoor. "Not yet! At least, not so loudly. You'll ruin the show."

Fingers were invading her heat, vigourously—at first gently, testing her, then harder and harder, plunging, thrusting. And when inside, they began to stroke along the hot, wet sides, seeking her inner button. Asiana almost literally couldn't breathe. In all three years of her wedded life, she had never experienced anything like this. She moaned louder, her hips rocking back and forth. Dimly, she could hear the crowd chuckling appreciatively.

"Amateurs!" sneered Mmmymmoor ruefully, shooting away. Suddenly, acting on instructions, the other "soldier" cupped a hand over her mouth, vaguely stifling Asiana's cries.

The strong hand over her mouth, the smell of him, clean but laced with sweat—so masculine—excited her more, and she opened her mouth hungrily, licking his palm, as she cried out, an orgasm surging like a raucous tide from her hips throughout her body. She shuddered almost convulsively, gasping for breath...

And then the sensation was past—too soon. The hands were removed from both ends and she slumped, exhausted, to the floor, gasping, exhilarated and humiliated at the same time. Belatedly she realized that she had climaxed before a room full of strangers!

And then she heard them laughing.

She buried her face against the floor, shamed. Somehow she had not been enough, not pretty enough, something. They were laughing at her. She was as exposed, physically and emotionally, as she had ever been in her life—and they laughed!

Then the fairy was darting by her head, muttering, "Okay, so it's a parody—I can work with that."

Slowly, she began to smile, weakly. They were not laughing at her, at least not contemptuously. Just at her misplaced, noisy orgasm. After all, Gargagia wasn't supposed to be enjoying this quite so much.

Not that the play was really following the story of Gargagia's Trials, one of the lesser stories taught in temple about a follower in the early days of the religion of the God-of-the-Three-Fingers. A girl who was martyred for her beliefs. The play was profane, sacrilegious, she realized, to turn the parable into a bawdy exercise in titillation— Gargagia was never depicted as having been nude, nor as having been sexually exploited by her captors. The play was sinful.

But then, she realized, that was the point. Fl'rr had said their performances were about testing limits and taboos. If the importance of the parable of Gargagia's Trials was its message, this vulgar distortion

of it could not harm it, and if its significance was simply its narrative, then perhaps it deserved to be mocked.

"...but Gargagia refused to be broken..." continued the little announcer. The crowd tittered. He continued, "And so the evil king took a hand in her torment..."

The audience gasped and Asiana, still sprawled upon the stage, looked up. And she too inhaled sharply.

Striding upon the stage was her fellow performer—a man with a thickly muscled, upper body... and a lower body that became the two hairy legs of a goat. A sex show that involved more than one race? thought Asiana. It was not technically illegal in Vanalth—anymore than any bawdy show might come under fire—but it was not something that was done.

The goat man strode forward in deliberate, exaggerated steps, as he circled about Asiana. She rolled over onto her bottom—wincing slightly—and sat up, watching the man with wide eyes. Her legs were splayed before the crowd, her sex glistening with her own excitement, but she did not care. Once more, her genuine surprise, and fear, fuelled her performance. She had never seen a goat man up close before. He was handsome, in a sinister, primitive way, but her eyes kept dropping nervously below his waist, to stare at his uncovered manhood, already half swollen.

"...he was determined to make her renounce her god..."

He stepped toward her, and her breath caught in her throat. He slipped around behind her, crouching, so that his hirsute legs came around her, under her arms. She did not know what she had expected, but the feel of his furred legs was pleasant, almost sensual, like rolling naked on a fine bed cover. Strong hands came around her and cupped her ample breasts, squeezing, rolling. Asiana gasped through her teeth, her eyes fluttering up into her head. He pinched her nipples, tugging them almost painfully. She winced, but felt them stiffen.

One of the "soldiers" came forward with a brass pot he held with tongs. The goat man squeezed her breasts upward, so that they

formed great arcing mounds under her chin, and the "soldier" tipped his tray, pouring something.

Asiana screamed as hot wax splattered across her breasts—startled as much as hurt. She began to squirm and the hairy legs squeezed, pinning her, while the goat man leaned over and, dropping character, whispered in a weird accent, "It no scar," he assured her. "You like. You see." He continued to pinch and roll her nipples as more wax was poured across her. She gasped, her back arching, but the momentary shock was fading. And like with the spanking, the pain across her already stimulated breasts just seemed to confuse her senses, creating a cacophony of sensations that inflamed her libido. Once more her cries seemed a mixture of pain... and desire. Mouth slack, eyes hooded almost with delirium, Asiana looked out at the audience... and Hanold was staring right at her.

She gasped, squirming in the goat man's arms, her legs splayed brazenly for all. She saw in Hanold's eyes so many things: disgust, shock, mixed with an unacknowledged lust. But the one thing she did not see was recognition. He was staring at his own young wife, and he did not recognize her!

Asiana moaned as the goat man rubbed a hand down her belly to cup her between her legs. She wiggled as he stroked her there.

She suddenly found she wanted Hanold to recognize her—though it would mean death for treason. But they had made love in the dark, safely, reservedly. He had rarely seen her naked, or even dishevelled, as she was now, with her hair strewn across her features. He had never heard her moan uncontrollably with orgasm. This slack jawed, wide-eyed, sweaty harlot writhing on stage bore no relationship to the woman he had called wife. And as he turned away, it was as if he was turning away from the woman she really was, while vainly searching for the woman he assumed her to be.

"...but the lord did not forsake Gargagia," continued the announcer, oblivious to the drama within a drama. "He sent an angel to grant her strength..."

Asiana felt a gust of wind wash cool across her face and looked over just as Fl'rr flew on stage, landing with a dancer's grace a few paces from her and the goat man.

The goat man's strong fingers were working their way inside her and Asiana moaned, her eyes roaming over Fl'rr's naked form, her lithe muscles, the sheen of her moist skin; her legs were long, tapering into delicate, well-shaped feet that seemed scarcely to touch the worn floor boards as she came closer. Asiana's eyes fluttering in her head, the fingers pounding into her sex almost overwhelming her senses, she stared fascinated at the winged woman's hairless pubis that hovered practically on the level of Asiana's eyes.

Then Fl'rr was kneeling beside her. The winged woman spared her a wink, then reverted to character as she ran her hands along Asiana's belly. More fires seemed to ignite along her flesh as the winged woman gently traced delicate fingertips along the contours of her taut muscles. Fl'rr ran her hands up Asiana's ribs, till the soft palms cupped the ample mounds of her breasts, kneading them, rolling the swollen nipples between her fingers, as if attempting to stretch them even more. She ducked her head and began suckling Asiana's right nipple, then moved to the other breast, and back again—sucking, nibbling, biting. Teasing the hard points, as if trying to suck the fire through them as though it were milk.

Asiana stared at this woman who had at first appalled her and now fascinated her. Her mouth was yawning open as she moaned, but her eyes stayed locked on the dark eyes of the "angel". Impetuously, Fl'rr leaned up and hungrily kissed her open mouth. Asiana strained against the kiss, her tongue dancing outward, letting the winged woman suck upon it momentarily, before pulling away.

"...and the angel provided comfort and courage as the trial's reached their climax..."

Asiana felt the goat man reach under her, his fingers cupping her buttocks, and then lifting her bodily with a strength that was more than human. Asiana felt like a child in his hands. Fl'rr continued to massage her breasts, to rub her hands across her belly. The soft soles of Asiana's bare feet came down upon the even softer fur of his out-

stretched thighs, and Asiana found herself squatting over the goat man's hips. And she did not need much imagination to realize what the "climax" of the trials would be.

But she needed more imagination than she had.

For as she expected to feel the press of his hard penis between the lips of her vagina, as she threw back her head and arched her back, thrusting out her breasts, she instead felt a warm pressure against her anus. Her eyes flare wide as a hand upon her hips gently pushed down, as he heaved his hips upward, and she cried out huskily as he eased himself slowly into her ass.

The crowd gasped—though whether from the sight of seeing a woman penetrated anally, or the fact that it was a demi-human sodomizing a human, it would be hard to say.

Asiana grunted, almost animal-like, the sensation alien and unexpected—but not wholly unpleasant. The goat man began to thrust into her deeper and deeper, harder and harder, allowing her to grow accustomed to the rhythm, her muscles clenching in time. Her entire pelvis was aflame, the violation of her ass firing sympathetic signals directly into her vagina, and together sending spasms of pleasure up into her belly, her breasts, her very mind. She cried out, even as Fl'rr pushed opened her legs wider, so that the spectators could see it all. Then Fl'rr began smoothing back her damp pubic hair, and the winged woman ducked her head and began licking at Asiana's swollen sex.

Asiana was lost at that point, digging her fingers cruelly into the goat man's arms, her mouth hanging open, grunting primal sounds. She stared fascinated as Fl'rr licked between her legs, thrusting with her tongue, alternating with biting gently at her labia, teasing, stretching it out. Then pulling back to give the audience a clearer view of the cock buried deep in her ass. Then repeating the process.

Seeing Asiana was almost at her peak, Fl'rr grinned at her, then thrust two fingers into her heat, plunging them up to the knuckles. Almost at once, Asiana felt the goat man come, his seed erupting deep inside her hips. Waves of ecstasy rolled over her—no, tore over her, like an ocean current, threatening to dash her against reefs. And

all she could do was ride it. She arched her back, screaming. Her feet kicked out, her fingers dug deeper into the goat man's arms. Tears mingled with the sweat on her face as she gave herself fully, absolutely, to the shuddering moment.

"...and the angel soothed her torment, so that she died contented, and unrepentant..."

Asiana slumped back against the goat man who held her firmly for a moment, breathing hard himself, nuzzling her raven hair. Then he gently rolled her off him, and she gave out a plaintive, pouty little mew as she felt his body withdraw from inside her, but she was too exhausted to protest further. She lay sprawled upon the hard boards of the floor, still savouring the warmth, the lingering after shudders of her orgasm, dimly aware of the goat man leaving the stage. She glanced up weakly and saw Fl'rr standing over her, attempting an angelic pose. Mmmymmoor flittered by her head. "Just lay there, girl. You're dead. The play's almost over."

Ignoring him, Asiana reached out and gently touched the foot of the winged woman.

"You're dead," hissed the fairy man. "That means you don't move!"

She leaned over and kissed the delicately formed foot, her tongue playfully bathing the perfect, even toes. Folding her knees under her, Asiana kissed an ankle. She stroked her hands around the well toned calf, licking at the sweat as she moved higher. It didn't seem right to let the play end, she thought mischievously, without her "angel" also being rewarded. She craned her head around and kissed at the soft flesh behind the knee. And then she began to kiss up the inner thigh. She glanced up, looking for a sign. Fl'rr stared down at her, her eyes hooded, her lips twisted into a languid smile.

"...uh, and, um," stammered the little announcer off stage, trying to compensate for this diversion from the script, "Gargagia, um, ascended into heaven, to, uh, commune with the angels..."

And Asiana came to the joining of the thighs, and hesitated. She stared at those pink lips, a deeper, angry pink peering out from between them. From this angle, it looked so intimidating. She had

never been with a woman before... and so she merely asked what she would want done to herself. She kissed the special mouth, and Fl'rr let out a little cry.

Encouraged, Asiana kissed harder, more passionately, as though it really was a mouth, darting her tongue between the lips, tasting the heat and wet therein. Then she licked around the outside, twirling her tongue, realizing the bald pubis was not natural but had been shaved. She raked her tongue across a slight stubble, the sensation teasing and tickling to her tongue. Grinning, she bathed the swelling bud with her tongue, then returned once more to plumbing the now yawning opening, while, with one hand, she pressed her palm against the pubis, stroking the clitoris with her thumb. With her other, she reached around and began squeezing the firm buttocks. She could feel the thighs pressed to her cheeks tremble against her, feel Fl'rr stiffen with expectation.

"Cuh-careful," the winged woman whispered. "I tend to ejaculate. You-you mu-might want to move."

Asiana had heard of such a thing, even among human women.

She had only once ever tasted a man's sperm—Hanold's, one night shortly after they were married, when she had hoped to delight him. Instead, he had slapped her across the face afterward, telling her that the God-of-the-Three-Fingers had intended a man's seed to make babies, not to be swallowed by whores.

That memory suddenly flashing to her mind, Asiana surged up against Fl'rr's sex, unintimidated, her tongue and lips seeking the trigger to release her. She felt Fl'rr stiffen, heard her cry out, and suddenly hot come erupted into her mouth, spilling over her lips, down her chin. It tasted different than Hanold's sperm—not better, nor worse, but different.

And then Fl'rr was dropping to her knees, her arms wrapping around Asiana, kissing her mouth, her eyes, her neck. Embracing, the two women fell to the floor, entwined.

"...and the, uh, the end," finished the off stage narrator.

Lying contentedly in the other woman's arms, basking in her warmth, her smell, the sense of lazy satisfaction that emanated from

her like an aura, Asiana dimly heard the curtains scrape as they were drawn closed and, from a distance, applause. She opened her eyes, and saw Fl'rr grinning at her. The other woman fondled her ample breasts absently, then smoothed back Asiana's sweat-dampened hair, and kissed her on the lips. Asiana shuddered, then blushed, as the events of the last few minutes came into focus, as she realized her face was sticky with fluids. And then she ignored all that, and returned the kiss, lovingly.

Heavy, thundering footsteps caused her to look up—and utter a startled yelp. Soldiers, real soldiers, tramped on stage. Fl'rr rose quickly to her feet, keeping Asiana just behind her. Asiana rose, as well, but stayed upon the floor, knees folded beneath her and peered past Fl'rr's naked bottom. Hanold stood before his soldiers. Asiana stared at him, but half hidden by Fl'rr, and with her hair dangling before her face, and her features glistening with juices, her husband still failed to recognize her.

"What is this?" demanded Mmmymmoor, flying forward. "Patrons are not allowed—"

"Shut up!" snapped Hanold, livid with rage. "You disgusting little... little... insect. I came here today... well, it doesn't matter. My information was clearly faulty. But what I saw in this den of putrification cannot go unchallenged. You and your whores—what they do is bad enough, but to profane a beloved holy parable like that of Garamia—"

"Gargagia," Mmmymmoor corrected innocently.

"Whoever!" he roared. "It is blasphemous and obscene. Under my authority, I order you from Vanalth immediately. I will assign men to escort you to the border. And be thankful I don't have you arrested and beheaded." Hanold looked from one to the other defiantly, though Asiana ducked her eyes. Then he whirled and stormed from the stage, his men following behind.

There was silence on the curtained stage for a moment, then Fl'rr turned and dropped to a crouch before Asiana. She was smiling. Asiana could not understand her joy, until she said, "What better way

to smuggle you, and your information, from the kingdom...than with an imperial guard escort!"

Asiana stared for a moment. Then, slowly, the irony of the situation came to her. And she smiled, too. Then she frowned. "But... me leave Vanalth? Where would I go? What would I do?"

"Stay with us if you like," said Fl'rr. "Either as a performer, or, perhaps you could do something backstage, if tonight was too extreme for you. But your life is now yours." Fl'rr leaned forward and kissed her.

And hungrily, Asiana kissed back.

Caught

Paige Roberts

Now, I've got him. I've been hunting this rebel for two years. I've come close more than once, close enough to touch. The last time I was sure I had him, and he turned it around on me. I ended up being held by his confederates at the wrong end of a blaster while he disappeared in a transporter beam. The final insult was the kiss he stole just before he vanished. Insolent bastard.

But the trap I set is truly closed this time, and the rogue is caught. Mine! Satisfaction courses through me. Finally, I have him.

My first officer snaps to attention and salutes. "The prisoner is ready for interrogation, Captain." His sneer of derision is more hidden than usual.

I nod an acknowledgement of the salute and ignore the sneer. The High Command sent him after I failed to catch the Wolf last time around. Supposedly, he's my right hand. In truth, he's been the biggest obstacle in my way for the last year. His constant vigilance, trying to catch me at some sort of subversion or violation of regulations has made my life a living hell, and undermined my command at every turn.

My family has been loyalists for three generations. My patriotism has never before been questioned. I would not be a Captain in the Imperial Star Force if I had any sympathies with the rebels. Failing to catch the Wolf has been the only smear on my spotless career record. No other officer has come anywhere near as close as I have to catching the elusive rebel commander. But still, this patronizing git was sent to watch me.

Ironically enough, I had never really questioned the policies of the Imperium before. But chasing the Wolf, dealing with all the people who think he's a hero, rather than a criminal, and dealing with the paranoia and dishonor of this piece of garbage sent by my own commanders, has made me begin to question. Living the privileged life of a military family didn't give me much experience with the kind of people who idolize the Wolf. I had little knowledge of the abuses of power so many Imperium commanders were prone to, until recently. I have begun to understand why the Wolf and his people fight us with such desperate courage.

But whatever my concerns, I keep them to myself. My reputation will be completely redeemed when I bring the Wolf in to the High Command in cuffs. And I finally have him. My satisfaction is only slightly dimmed by the presence of Lieutenant Ralin, and the corruption in my government that he represents. I have worked far too long and hard.

The guards snap to attention and step aside as I enter the interrogation room, Lt. Ralin on my heels. I stop just inside the door to the Wolf's cell. "Lieutenant, have the navigator set a course for Command Central. I think we should bring our prize home immediately. He is notoriously difficult to hang on to, even on the rare occasions when he is caught."

Ralin hesitates for a moment, obviously wanting to go in with me and see what I say to the prisoner, but he cannot disobey a direct order. "Yes, of course, Captain," he says, smirking. He will no doubt tap into the log cameras to spy on me, even from the bridge. "Wouldn't want the Wolf to be late for his execution."

"Actually, I have orders to turn him, if possible," I remind him. "The Wolf, himself, switching sides, would be a powerful symbol to show the rebels how pointless their actions are."

"And you think that you can turn the Wolf?" he says, smirking even more.

"I think a man of his charisma and intelligence on our side would be a valuable asset. If we execute him, he's worse than a worthless corpse, he's a martyr to the rebel cause. He could prove far more dangerous dead than alive."

The lieutenant's smirk becomes a disapproving frown. "The High Command does not agree with that assessment. If he cannot be turned by the time we reach Command Central, he will be publicly executed for treason, and his execution broadcast to the far edges of the galaxy to show what happens to those who defy the law."

"Then I need to get started," I say and close the brig door in his irritating face.

I take a moment to collect myself before I turn around to face the enemy I have chased so long... the enemy who kissed me last time I saw him... the enemy that nearly cost me everything I have worked for my entire life.

"Hello, Diana," the Wolf says cheerfully.

I turn to face him, a scowl of irritation at his attitude on my face, and have to resist the urge to turn back around again. He's been strip-searched and strapped naked to an interrogation table. I control my face as well as I can, but can't hide the heat creeping up my cheeks. I expected them to give him back his clothes.

He laughs at my blush. "It's good to see you, too."

My embarrassment disappears in a flush of anger. I am a Captain in the Imperial Star Force. No one laughs at me. A resounding slap across his insolent face adjusts his attitude. Or at least it should.

His head rocks to the side, and he looks back at me with a grin in spite of the trickle of blood at the corner of his mouth.

"You are entirely too cheerful for a man on the way to his execution."

He shrugs as well as a man strapped to a table can. "If I'm going to be executed, don't see any reason why I shouldn't enjoy the ride."

He looks me up and down and I suppress an urge to straighten my already perfect uniform. I lift my chin instead, knowing that the form-clinging, shimmery black, energy weapon diffusion fabric of my uniform is quite flattering to my curves. Let him look. While he does exactly that, I study the table next to him, covered with his effects. His clothes are folded on one corner. An amazing variety of weapons and other devices came out of his pockets and various places of concealment. I pick up one tiny device, the size of a button. Transponder. It's how his friends found him last time. There is a pressure sensitive activation sensor on one side of it. It's been deactivated, but not disabled. A homing beacon that would draw in the rebels could come in very handy.

I touch the bleeding cut on the Wolf's upper arm where the device was removed. "You won't be leaving the same way you did last time, Wolf."

"I'm honored that you've gone to so much trouble to keep me here. You must have really enjoyed my goodbye kiss."

I grab him by the hair and lean over him to stare directly into his eyes. "I have gone to a great deal of trouble, Wolf, to make certain you will not be able to repeat that stunt."

The muscles of his neck strain against my grip. "The escape, or the kiss?" he asks, with an insolent grin.

"Both." I touch the control for the lowest setting on the table.

His hands ball into fists and he gasps, in surprise as much as pain.

I turn it off after only a few seconds. My intention is only to get his attention at this point.

"What the hell was that?" he asks.

"That was a very mild example of this table's capabilities. It's a state of the art interrogation device, capable of creating a wide variety of sensations, both pleasurable and painful, at intensities ranging from the mild shock you just felt, to... well, perhaps you will find out where the levels top out."

"State of the art interrogation device," Wolf says, as if speaking to himself, then looks at me with those incredibly intense pale blue eyes that must have given him his nickname. "Doesn't it disturb you in the least that state of the art interrogation devices are what your government pays its scientists to build? Not state of the art medical devices when thousands die of plague each day, or state of the art devices to synthesize or purify food when millions are dying of hunger?"

I hadn't thought of it quite like that, but the government's priorities are not my responsibility. "There is no point in trying to influence me, Wolf. I am a loyalist to the bone. With the rebels claiming the lives of so many of our soldiers and fomenting unrest all over the quadrant, it makes perfect sense for the High Command to want the best in interrogation technology."

"Interrogation technology," he says, repeating my words. "Diana, you're talking about torture, as if it were a normal part of defending your country."

"But, it is," I say, somewhat confused by his naiveté. Interrogation techniques are taught at the officers' academy. "Don't your rebel soldiers interrogate prisoners?"

"If you mean torture, no, we don't."

"Then you are fools, and your rebellion will fail because of it. Some of our best intelligence comes from interrogation. I was able to find you that way."

"Who?" the Wolf asks with sudden intensity.

"What?"

"Who did you torture to get to me?"

It was Ralin who interrogated the young clerk at the storage depot where the rebels were known to get many of their food supplies. I didn't approve of his methods, crude, and wasteful, as they resulted in the young man's death, but Ralin didn't bother to ask me before using them. It doesn't matter now. The boy is dead, and nothing can be gained but greater resistance from the Wolf if he finds out.

"I am the one asking the questions here." I touch the lowest pain control again, studying his reactions, noting the way his biceps bulge

as he fights the restraints and his belly tightens, putting the square pattern of his muscles in sharp relief.

When he can breathe again, he gasps out, "WHO?"

"You answer a question for me and I will answer yours," I say.

"Ask," he says.

"Where will the rebels attack next?"

He smiles at me, and his blue eyes sparkle. "Now, that would be telling."

I hit him with pain level two.

"Unh!" he grunts as if punched in the stomach, and the muscles in his jaw jump and tighten as he fights to make no other sound. Beads of sweat appear on his forehead, and his blue eyes squeeze tight shut.

I lick my lips. The sight of him like that stirs something deep in me. I turn off the pain.

He pants for a moment, recovering, and I let him.

"That was a lot worse," he says softly.

"That was only level two. It will get far worse, Wolf, if you do not give me what I want."

"And what is it that you want, Diana?" he asks, with that unnerving steady eye contact and that mischievous half grin.

I touch his face and return the eye contact. "I want you, Wolf."

He blinks, and his grin, that the pain of the table didn't dent, fades a bit to a look of surprise, and just the slightest hint of hope.

"I want you as an ally, not an enemy. I want to work beside you, not against you."

"You planning on switching sides, pretty Captain?" he asks me, grin back firmly in place.

It's a mask, that grin, that reckless not-a-care-in-the-world attitude, a face he shows to enemies. Just for a moment, when he wasn't sure if I was an enemy, I saw a glimpse of the man behind it. I intend to see a lot more of that man.

"I'm hoping to convince you to switch sides, rogue," I say, voice pitched low. I lean in and whisper directly in his ear, as softly as I can, hoping the log mikes in the room won't pick it up. "I don't want to

see you die." It is truth, but a truth I would not want my sneering lieutenant to know. This man is brilliant and capable. He has been an enemy to be admired. He would make an ally to be proud of.

"I won't switch sides, Diana," he says softly. There is no grin on his face, and his eyes meet mine steady and unwavering. "I can't."

It is stated as simple fact. But I cannot accept that. If he cannot be turned, then my ship is taking him to his death.

I hit pain level three and leave it there for a time.

"You can, Wolf. You can serve your country, and stop this pointless rebellion, and then maybe your government could afford to switch its priorities to medicine and hunger instead of defense."

The Wolf can hear me, even through the agonizing pain, because past an initial grunt of surprise, he clenches his teeth and makes no sound. His head is thrown back, his lips peeled away from his teeth in a silent snarl. And every muscle in his magnificent body is clenched. His bones will break long before the magnisteel mesh straps that hold him down, but if they were any lesser material, he would have torn free by now.

What a magnificent man. I can feel my body reacting to his beauty with warmth and wetness.

My hand reaches out and touches lightly on those glorious muscles. I touch his heaving pecs, where he struggles to breathe through clenched teeth. I stroke down his body, across his nipple, along his ribs and down into the hollow of his hip bone. His body, already racked with agony, shakes and tries to pull away from my touch, which must seem like a stroke of raw flame when combined with the nerve stim.

I look up into his face and his eyes are open, staring at me, while his muscles quiver and shake from the strain.

I turn off the pain.

He collapses limply, his eyes close, and his face turns away from me as he pants to regain his breath.

I pull his head over to look at me again, and slap him lightly when I find his eyes still closed.

He opens his eyes and looks at me, and there is no grin, no mask, only the man, and the man is very angry. "Don't touch me like that, Diana."

He just experienced pain level three for nearly a minute solid, and he's upset because I touched him. "Why not?" I ask, and my hand wanders down his smooth, nearly hairless chest again, stroking down to the dusting of hair that starts around his belly button and leads lower, to more interesting areas. I play with that crisp curly hair, deliberately teasing him. Sexual violation can be a very effective interrogation technique, my old instructor said. I have never used it before, but perhaps it is the key to breaking the mask, and shattering the iron will of the Wolf.

Wolf's eyes look away from mine, and refuse to answer my question.

"You once had me at your mercy, Wolf, and you stole a kiss. Why is this different?"

He looks back at me, and anger again rages in those pale blue eyes. "I kissed you because you're beautiful, and I wanted to, not to get something from you."

I lean in close to him again, and pull his head to one side with a grip on his hair at the base of his neck. I kiss my way up his bared throat to his ear, "But what I want from you," I whisper in his ear, "is to save your life." I nibble and lick his ear, then kiss along his jawline toward his lips. "And I will steal far more than a kiss to get what I want," I say against his lips.

My grip in his hair tightens pulling his head back in a sharp arch and forcing his mouth open. I bury my tongue in his mouth and press my lips against his, all but devouring him. The kiss he gave me was quick and almost playful. He had no time for much more, and I certainly would not have permitted more. This kiss is very different. I own him now. And I want him to know exactly who he belongs to.

At first he fights me, trying to tear his mouth away, but I tightly grip his jaw with my other hand, and he can't go anywhere. After a moment of just passively accepting my bruising, devouring, claim of territory, he groans into my mouth and begins to return my kiss with

an angry fire. I loosen my grip on his jaw and hair, and he lifts his head off the table to push harder against my lips. His tongue pushes mine out and invades my mouth, filling me and I allow it, and more, I enjoy it.

One of my hands wanders again down his body, but this time I don't stop at the line of hair. I stroke across his already half-hard staff, and feel the shape of his balls and the texture of the delicate sac that holds them.

He groans into my mouth again, and his staff grows to full erection.

I brush the controls of the table with my other hand. Level one, pleasure.

He groans again, and his staff jumps against my hand. He pulls his face away from mine.

"Whoa! What are you doing?" he asks, breath fast, and erection stiff.

"This table gives a variety of sensations, both painful," I lean in and kiss him lightly. "And pleasurable."

He swallows hard. His lips are swollen and wet from our kiss, and parted to allow his deep breaths. I cannot help it. I lean in and kiss him again. And bump the intensity level up to two.

When he can speak again, he gives me a ghost of that grin. "I take it back. Command's scientists are obviously doing very valuable work." His back arches a bit, and his whole body makes small movements as if repeatedly weakly fighting the restraints and then giving in. His stiff erection bobs periodically, as his lower belly muscles tighten, rocking his hips.

I grin back at him, sharing the joke this time. "I've never experienced the table's effects, but I have heard rumors that some of the crew use it as a recreational device. Perhaps, once we have stopped this rebellion together, we can see about marketing it as a marital aid."

"Once we stop this rebellion together…"

He has a strange habit of repeating my words back to me.

He gives me the full Wolf grin, "But you said you weren't going to switch sides, pretty Captain. You're just teasing me."

"Not teasing you, Wolf. I mean it. But it's you that needs to switch sides. Join me, and we can end the rebellion in no time. Think how many lives will be saved."

"I can't, Diana," the Wolf groans. The pleasure of his body is unabated as his dripping erection attests, but a twist of torment is on his face. "Please," he begs. "Don't use my desire for you against me."

"I'm sorry, Wolf. My goal is an end to the war. I must use every weapon I have."

I switch the controls abruptly from level two pleasure to level four pain.

"Aaaagh!" he shouts in agony, and then abruptly bites down and silences his own scream. His eyes squeeze tightly shut and he doesn't breathe so much as gasp and choke tiny sips of air as his body shudders in incredible anguish.

I find to my surprise that it hurts me a little now to do this to him. I don't want him to suffer. I want him to join me. But a part of me melts at the sight of him sheened with his own sweat, entire body rigid and shuddering, and oddly enough, erection undaunted. Beautiful. He is incredibly beautiful.

I run my hand up his inner thigh, knowing that my touch will be turned to fiery pain by the nerve stim of the table. I can feel only a tingling from the edges of the table's effect, but its power is clear in the thigh muscles under my hand tensed to rock hardness and trembling as if to hold a great weight.

He makes a choked sound as my hand again touches him intimately, making the agony that engulfs him most intense in his most sensitive area. His knees try to pull up and in to protect, but the straps allow very little room for motion. He is bound open to me, and his erection, still nearly as hard as when the pleasure was turned on, is completely at my mercy.

I run a fingertip around the tip, stroking the wetness there into the sensitive skin. Without the table's interference, that sensation would be pleasurable. The table doesn't keep him from feeling that

pleasure, it just intensifies it and mixes it with even more intense pain, as if I were caressing him with hot needles.

The sound he makes sounds suspiciously like a whimper, bit back by his stubborn will.

I turn off the pain.

His hard, quivering muscles collapse, and he pulls in huge gulps of air.

I stroke a lock of his brown hair off his sweaty forehead and lay a gentle kiss on his eyelid, his cheek, and finally his lips. Tender kisses and touches on his face break through his rigid control as the pain could not.

"Diana," he murmurs, not asking for anything, just saying my name, and I like the way it sounds.

"Wolf," I say back and kiss him deep and long. I pull away from his lips reluctantly so I can look into his uncanny blue eyes. "It will only get worse. I do not wish to hurt you…the people who look up to you would not want you to suffer or die for no reason. You and I could stop this senseless war and bring peace to all our people. Would it be such a horrible thing to serve at my side?"

His bright eyes close, hiding from me. "A horrible thing to serve at your side? Yes, beautiful Diana. It would be horrible. I will die slowly of torture before I will serve those who would twist such a magnificent woman into a skilled torturer."

I turn the pain up to level five, and I realize I am hurting him now at least a little out of anger. And while a part of me marvels at his will that chokes back his cry of agony before it can escape, another part of me wonders why I am angry. I am offering him myself, and he refuses. Insolent bastard.

I rake my fingernails hard down his side. The nerve stim magnifies the pain a thousandfold.

The Wolf gives a strangled cry, and his rigid, quivering body jerks in reaction.

I turn off the pain, and grab his face, pulling him to look at me. "You fight a lost cause, Wolf. The rebels who follow you are outnumbered and outgunned. Many of them are little more than children and

beggars. They have no chance against Command's disciplined armies with the latest weapons and equipment. You condemn yourself to death by not doing as I ask, and you condemn those who follow you to the same fate!"

His eyes close again, but not to hide, it is a flinch, pain greater than any the table can create, an arrow that hit the mark. "Condemn those who follow me to the same fate."

My hand on his face turns gentle, stroking his cheek with my thumb. "I don't want to see them die any more than you do. And I don't want to see you die. Help me stop it, Wolf. Help me save your life and theirs."

His eyes open again and look at me. "Save my life and theirs. That's truly what you believe you're doing, isn't it Diana?"

"It is what I'm doing, Wolf. With you on my side, there won't be an execution waiting for you when we land, but a welcome. And the two of us together, with your knowledge of the rebellion, could stop it before many more lives are lost. With you on our side, it would show those children and beggars that putting down their weapons and giving up is the right thing to do."

"The right thing to do. Is this the right thing to do, Diana? Is torturing me, and doing battle with orphaned children and the poor the right thing to do?"

I blink for a moment, caught by surprise by him turning the question around. I thought I was getting to him there for a moment. "Of course serving my people is the right thing to do. I have always done it. My father and mother did it. It is my duty." Isn't it?

"Your duty." The Wolf just looks at me for a moment. "It was your duty to hunt me down and to torture someone close to me to find me, and it will be your duty to take me to my death. And then it will be your duty to hunt down those ill-equipped children and poor men fighting because they have nothing left to live for, and kill them all, because that is what Command has decreed. Do your duty, Diana."

I turn on the pain, level six. It's as high as the table goes, and still he doesn't scream.

His back arches up off the table. His entire body clenches rigid and trembling in incredible anguish. His lips are peeled back, baring his teeth in a snarl. His arms pull and fight the restraints as if he will break them or break himself trying.

"It doesn't have to be like this. The choice is yours. Serve with me and save lives, or lead your people to certain death."

My hand reaches to touch him, trying to comfort without conscious thought, but the table turns it vicious. As my hand touches his chest, brushing across his nipple, a strangled cry escapes through his clenched teeth.

I turn off the pain.

The Wolf's body drops back to the table limply. His muscles quiver and twitch, even with the pain turned off now. He rolls his head over until he looks at me from bright eyes gone dull with despair and exhaustion. There is a trickle of blood on the corner of his mouth. He bit his tongue to keep from screaming.

"I will think no less of you if you scream, Wolf," I say softly and wipe the blood from his lips with a cloth.

He gives me a pale ghost of his imp's grin. "You think so much of me now, then, pretty captain."

"Yes. I do." I answer those eyes filled with pain, not the mouth that twists in a smile that is a mask. "I would not have gone to this much trouble to catch you alive if I did not. I would be honored to serve beside you." I stroke his sweat-soaked hair away from his face. "And I will mourn with many others if I must watch you die." I lean in close, and place a tender kiss on his lips. "Do not force me to watch you die."

"Force you to watch me die? It really matters to you that much?" he asks, as if genuinely puzzled.

I kiss him long and hard, and toggle the table to pleasure level 4.

"It matters to me that much," I say, and notice that I'm picking up the Wolf's habit of repeating what the other person said. I bury my face in his neck and kiss and lick and nibble down his throat. My hands touch him, stroking the contours of his body. My own body is hot and all but dripping wet. I unfasten the neck of my uniform,

showing cleavage down to my navel and allowing air to get inside the suddenly far too hot defensive fabric.

The table's nerve stim amplifies my every touch and kiss, making the Wolf's body come alive with passion and pleasure. He bit back the screams when I gave him pain, but he no longer even fights against the pleasure. He wants it, craves my hands on him, returns my kisses with the desperate hunger of a man who has only a few hours to live.

I do not need the table's effects to set me on fire. Wolf's muscles still twitch from remembered pain, but now he groans in pleasure and the heat of desire. Seeing this magnificent man bound and helpless is enough to make me want to climb onto the table and ride that proud, tall cock.

I glance at the log camera. Rape is an accepted form of interrogation, but I have no interest in letting Lieutenant Ralin get his kicks from watching. The table with the Wolf's things is nearby, and I recognize one of the devices used to jam enemy communications. I shift around the table, touching the activation switch on the device when my body blocks the view of my hands from the camera.

"Now, we have privacy, Wolf. No one can see or hear us."

The Wolf's eyes practically glow like embers of a blue fire from beneath lids half closed, and his lips smile a Wolf's grin full of hunger. "Alone with the beautiful and fearsome Captain Diana Sevlan of the Imperial Star Command. I have dreamed of that, you know." He speaks between deep breaths, and his body cannot help but squirm and pull against the restraints as the table works its magic on him.

"I have had dreams of my own since you stole that kiss. Dreams of having the dashing, indomitable, and elusive Wolf, Commander of the rebel army, helpless and at my mercy."

"Helpless and at your mercy, Diana. The question is what did you dream you would do with me?"

"Torture you, break your will, make you one of us," I say softly. It is what I dreamed of and what I have tried to do. But is it what I want? I look at the man strapped to the table. Will of iron, body of

sleek muscle, eyes that pierce the soul, I have never known a man like him.

The Wolf's eyes close for a moment. "I can't be turned, Diana. Command has taken everything from me, my mother, my sister, my friends, my home. The people you serve don't care who they destroy. I will die screaming on this pain machine before I will serve them in any way."

"If you do not turn, then you will be executed when we arrive," I say, and stroke his hair back from his face.

"You really expected me to turn. You don't want me to be killed," he says, not as a question, but as a realization.

I lean in and kiss him hard and deep. His mouth tastes of blood from his wounded tongue, bitten to hold back his screams.

He will never turn traitor to his cause. And my starship is taking him to his death, because I sought to boost my career with the capture of the Wolf. Now, I am as helpless as he is to stop the events I put into motion. Damn him. Why couldn't he turn?

My anger makes my kiss savage, a claiming. You are mine, Wolf. I want to keep you, tame you, make you my pet.

He groans and pants by the time I pull away from him. My breath comes in harsh pants as well, and I do not have the excuse of the machine. It is just the man.

I take a step back from him and unfasten my uniform, peeling the shimmering black fabric down and away. There is nothing underneath but me.

The Wolf's eyes burn into me and his hands strain against the restraints. "You're so beautiful. Whose cruel joke is it that you are my enemy?"

"I don't know, Wolf, but I'm certainly not laughing." I put my hand against his, palm to palm, and our fingers interlace. His thumb strokes along the back of my hand.

I climb up on the table one knee on either side of his hips. "You have no desire to serve Command, fine. Serve me."

"I will serve you any way you desire, beautiful Diana, except to betray all that I am."

To betray all that he is. I sought a Wolf, magnificent and free, and tried to turn him into a lap dog. Foolish mistake. I have no interest in dogs. It is the Wolf that I desire. If I could break him and tame him, then he would not be worth having. I want the Wolf to come to my hand, but mine alone. I don't really want him to bow to the commands of men like Ralin.

I look into the pale eyes of the Wolf, vulnerable and open, mask shattered by pain, half hooded and filled with hunger, driven half to madness by pleasure. But he's still the Wolf, still the man I chased across the galaxy, still the man that thousands look to for salvation from the darker aspects of the government I have always served, still unbroken and untamed. To have such a man naked and helpless beneath me makes my body burn. My breasts feel as if they will burst and my sex throbs and aches to take him.

I position myself over his steel hard shaft, and guide the tip into me. My inner muscles twitch and flutter, squeezing that tasty tip, reacting to the sweet invader, and wanting far more.

The Wolf's body shudders in reaction, and his lips peel back from his teeth in a snarl not unlike the one he wore when the unbearably intense sensation I gave him was pain. The table makes even a simple caress exquisite, the feel of my wet heat sucking him must be near impossible to bear without exploding.

"Don't come too soon, Wolf. We will not get another chance."

He whimpers softly and his hands clench into fists, fighting against his body's need for release.

My own body shudders with pleasure as I swallow him down. The only weapon he has left sinks into my body and makes me shudder and moan. My own defenses are gone, stripped away by the simple magnificence of the enemy. And I wonder which of us is caught in this trap I laid, just before my mind loses all capacity for rational thought.

When he is buried deep inside me, our bodies are joined into one, and the table's nerve stim field travels through his skin into mine. Everywhere we touch, pleasure like lightning bolts of pure white heat penetrate my body, none deeper than where he is buried

to the hilt in my sheath. I lean down so my whole front touches him, my breasts pressed against him, my hands holding tight to his. I want it to last forever, but human bodies were not made to bear such pleasure for long without exploding.

I ride the wild untamable Wolf, rocking and grinding my body into his, clawing and biting him, as if we were doing battle. He growls into my hair and bites my shoulder, holding me, and his hips thrust hard, battering against the walls of my womb, indescribable, unbelievable, raw pleasure.

My orgasm comes like the fire blossom of an exploding ship, blinding heat that makes my eyes leak tears of joy. The Wolf explodes with me, the scream he has bit back for so long coming full and hoarse from his throat, as he bucks and spasms beneath me.

The table makes it last impossibly long. We shudder and scream, clinging together like two souls lost in the blackness of space, riding the waves of pleasure until we cannot stand it any longer. Too much, too exquisite, too intense, without changing the setting, the pleasure crosses the line into agony and I turn it off.

And I lay, weeping with my face buried in the Wolf's chest, and his strong hands still holding mine in the sudden strange silence of sensation. I can feel the Wolf's thigh muscles quivering beneath me. He has endured the full strength of the table's pain and pleasure, and his body is near the end of its great strength.

I lift my head and look into those impossibly pale blue eyes. The man looks back at me, and his lips twist in the familiar half grin, but it is not a mask this time... the ironic laughter is in his eyes as well.

"Thank you, beautiful Diana, for making my last day my finest."

The tears of joy on my cheeks are joined by more of sorrow. This is his last day. By catching him in my trap, I have condemned him to death. I touch his cheek, tracing the line of it, memorizing the shape and the feel of his skin under my fingers.

Before I can say anything, I feel the subtle shift in the ship's artificial gravity, and the change in tone in the engine's hum. We've dropped out of hyperspace.

I climb down from the table quickly and pull my uniform back on. Quick swipes of the back of my hand erase the tracks of my tears, and a rake of fingers puts my hair back in proper order.

Lt. Ralin will undoubtedly be at the door in moments to inform me unnecessarily that we have arrived, and that it is time to take the Wolf to his death.

I lean against the table with the Wolf's things on it, and the tiny transponder that we cut from his skin catches my eye. It is still functional, a pressure sensitive switch on the side could activate it, but it must be in physical contact with the Wolf in order to send his coordinates. And a ship friendly to the rebel cause must be within transporter range for it to matter.

Lt. Ralin and a small security escort enters, weapons drawn.

"I don't believe that's necessary, Lieutenant. The Wolf is restrained, and in no shape to offer much resistance in any case."

Ralin sneers in my direction, looking exceptionally smug. "Your attempt to block the recording of the interrogation was unsuccessful. As I suspected, you have been compromised by your feelings for this rebel. I am taking command of the ship and the prisoner."

"On whose authority?" I growl, deep hatred instant and hot filling me.

"The High Command gave me the authority to take command whenever you proved your traitorous intentions. And I believe what I just saw proves them without a doubt."

"Traitorous?" I bite out. "How dare you call me a traitor. I have fulfilled my orders. I have successfully caught the Wolf, and done my best to turn him."

"I think it is he who has turned you," Ralin says, eyeing the spot of wetness between my legs where the Wolf's seed has dampened my uniform. "I will be the one to take the Wolf off the ship, and escort him to his execution. We wouldn't want another miraculous escape."

"You want the credit, you little weasel. I've spent two years hunting the Wolf, and you want to be the one to deliver him to Command so you can steal the credit for finally catching him."

Lt. Ralin just smiles that smug smile. "And I'll get it, too. And command of your starship with it."

There is nothing I can say to that. Command will do it. They'll give everything I've worked for to this backstabbing little worm.

"Get him off that machine," Ralin commands me. He doesn't know how the controls operate.

I walk away from the table with the Wolf's equipment on it, and operate the control that tilts the table up until the Wolf's feet are touching the deck. I look at the Wolf now eye to eye with me. I can do nothing for him once Ralin has him.

I put my hand over my mouth to stop the flow of emotions, and conceal my true intentions. I can't let the weasel see anything.

I touch another control and the bands that hold the Wolf's wrists and ankles withdraw into the table, leaving the Wolf standing unsupported.

He crumples slowly, his abused, twitching muscles unable to hold him.

I catch him as he falls, lifting him back up to his feet, letting him lean on me for a moment.

His arms are around me, holding me to keep from falling, and his pale blue eyes look at me with vulnerable open pain, like a puppy that's been kicked. "Diana?" he asks for reassurance that the connection we forged was real and I won't just throw him to the dogs.

I grab his hair and force a deep harsh kiss on him. "Don't fool yourself, rebel. You were an assignment to me, nothing more." I drop him naked and shaking at Ralin's feet.

"I spent years of my life catching this scum. If you lose him, I'll have your head, Ralin."

"Oh, don't worry..." a hesitation, then, "Captain," in the most insulting tone possible. "I'll make certain the Wolf makes it to his execution on time."

"So, he's to be executed naked on galactic broadcast?" I ask with bland curiosity.

Ralin makes an expression of disgust on his pinched face. He goes to the table with the Wolf's things, and finds his pants and gives them to him. "Put those on," he orders.

The Wolf says nothing, not meeting anyone's eyes. He struggles into his pants, with some help from one of the guards. Then his hands are bound behind him with magnisteel cuffs.

They lift him to his feet, facing me, and one last time I see that not-a-care-in-the-world lopsided grin on his face, just before they take him to die.

And it takes a great effort of will to not grin back at him, although I feel my lips twitch just the slightest at the corner.

On the bridge, at what used to be Lt. Ralin's security post, I watch the Galactic news feed broadcasting the public execution of the notorious rebel leader known only as the Wolf. Another screen scans the surrounding space for telltale trace element signatures. There it is…a cloaked rebel ship, without a doubt. It's not enough to lock weapons on them, but it's enough to know they're there.

My communications officer notices it as well. "Captain, it looks like a rebel ship at three o'clock."

I nod. "I see it, Ensign. But I've been relieved of command by Lt. Ralin. Contact him for orders."

"Aye, Captain."

I can hear her trying to contact Ralin. But he refuses to be bothered by such a petty concern during his hour of triumph.

"Let them watch their leader die," I hear his voice say. "Without a transponder on him, they can't do a damn thing about it."

A third screen on my board shows the log video from the interrogation room. There is a little distortion from the jamming device, but Ralin was clever enough to get around it with image enhancement. Still, the image is unclear enough that tampering will be less noticeable. I fast forward to the end, and tweak the image as skillfully and untraceably as my years of experience allow, so it shows Ralin palming the transponder and handing it to the Wolf along with his pants. Then I clumsily delete that image, leaving a trace of it where a good Command investigator will find it, and replace it with a less

than perfectly spliced image of me passing the transponder to the Wolf. To a good savvy investigator, it will look like Ralin deleted the image of himself giving the Wolf a transponder, and replaced it with an image of me giving it to him, an obvious attempt to frame me.

I shift my attention to the first screen as the honor guard lifts laser rifles to shoulders. "Ready," the age-old command rings out across the galactic broadcast.

Command's cameraman, in fine dramatic style, zooms in to a close-up on the Wolf's face. The Wolf has regained enough strength that he stands solid and alone awaiting his fate. My heart twists with passion at the sight of him, and pounds a little faster with fear that something will go wrong and he will truly die in the next few seconds.

"Aim."

The Wolf grins full into the camera. The image of his face becomes slightly sparkly and unfocused.

"Fire!" The command rings out and the laser rifles fire into emptiness. The Wolf is gone, disappearing in the telltale energy sparkles of a transporter beam.

A collective gasp of astonishment is heard from all of my bridge crew.

"Be damned with Ralin's orders," I shout as if I am as shocked as the rest. "I would swear that man wanted the Wolf to escape. Fire up the main engines, pursue that sensor ghost. It's got to be the Wolf's rescue ship!"

"Aye, Captain," my crew responds expertly and loyally. But there isn't a chance in hell of us catching that ship from a flatfooted synchronous orbit when they're already boosting toward hyperspeed.

A flash of energy on my center screen shows the flicker of a hyperspace corridor being opened and closed.

"Too late, Captain. They've jumped," my navigator says.

I throw out a few choice curse words. "That weasel of a lieutenant let the Wolf escape. Plot their most probable course. We can still catch them if we act quickly."

"Captain," my communications officer says. "Lt. Ralin says absolutely under no circumstances are we to leave orbit."

I curse Lt. Ralin's parentage with some truly creative language that it feels marvelously liberating to finally be able to use out loud. "If we don't pursue at once, they will get away, and we won't have a chance in hell of finding them."

"Nevertheless, those are the Lieutenant's orders."

"Fine," I say bitterly. "But I want an official protest logged." I throw up my hands in disgust. "I'll be in my quarters."

From the privacy of my own cabin, I look out my small window. It's a captain's privilege to have such a view of the stars. And a shadow of the Wolf's grin touches my own face. I aim my thoughts to the constellation that looked like a running wolf to my distant ancestors.

The High Command's investigation will show that Ralin is the traitor who set you free, Wolf. Only you and I will ever know that it was that last kiss that gave you the transponder that saved your life.

I chased you until you caught me, in your trap of honor and strength and passion. No matter what Command believes, I became a rebel today.

Run free, Wolf. And someday, maybe, I will run with you.

Sybariote

Diane Kepler

Session 1
00:12:24.98

I pulled open the first door I saw and dragged her inside, out of the sleeting rain. Her dimpled cheeks and cute little nose were already glossy and it slicked the black, reflective surface of her jacket, sliding off in rivulets, like... well, like I'd somehow showered her with come.

She had that needy expression again, the one that made her look so perfectly fuckable. She was also shivering. No wonder —plastic clothes, feet stuffed into those impossibly high heels. Hell, I was shaking, too. A harsh, burning cold needled at the deepest parts of me. It was a change, cause I'd been running hot ever since I'd found her.

It'd been a simple hit on an arcology lab. No clue what kind of research went on. My employers hadn't said and it was bad business to ask. They called the shots; they dispensed the need-to-know. After

all, who were the genehanced demigods and who was the goon from the slums, right?

I didn't waste any time fucking around. After insertion, I had 54 seconds to manually infect the drives. The lab was completely net-locked—that's why they needed a realtime goon to bring it down.

I'd finished nearly all the stations when a cracking sound came from behind me.

I spun just in time to see a big plexisphere break under pressure. Warm, milky fluid sheeted out and hit me. Tried to dodge, but I wasn't fast enough. The stuff was so slick that, suddenly, it was like there was no floor at all. I fell hard.

I couldn't do anything except flail around, trying to find a hand-hold, panicking for a shitload of reasons, not least because of the death squad that was probably on its way up. So when something unseen got hold of my leg, I grabbed my gun and almost fired before realizing this wasn't something I'd want to be shooting at. Not with an impulse weapon, anyway.

She was naked and wet, her blonde hair clinging to a dimpled face that ended in the cutest, tiniest chin I'd ever seen. Wide eyes, perfect tits, and not a single hair on her plump little pussy-mound.

I stared for too long. When I tried to get up she kept hold of my leg and gave me this look like she was scared I'd leave without her. Shit, was she some kind of test subject? What kind of lab was this, anyway?

I grabbed her hands and somehow got enough leverage to pull her into the lift, the one I'd programmed not to know it was mov-ing. I wrapped her in my coat during the 200-storey drop. Asked her name but got nothing more than a blue-eyed blank. She was com-pletely hush and stayed that way through all the different trips we took to lose a possible tail.

Ordinarily, I would've just gone to a bar after the job and shot some toxin. But this was completely off the scale. I had to find out who this fem was besides some hot eyeful I'd love to fuck in all the colors of the rainbow. Got a hotel room so I could think it through. Would the bosses mind that I'd stolen instead of just sabotaged?

Owning up might help. I'd give them the fem and let them decide where she belonged and whether she was important.

But another look at her made me rethink it.

I'd never seen a realtime girl like that. Plenty of sims, sure, but they were mostly digitized anyway. Who did she belong to? It had to be somebody—everything about her said "toy." Maybe I'd keep her around.

"Who made you?" I murmured. She was sitting by the window. Her hair was drying now, fluffing out into a gorgeous cloud.

She cocked her head, like she'd heard the words but couldn't get the meaning. Then she uncurled, padded over, and knelt down to put her head in my lap.

I was floored. I've always, I mean always, wanted a chit to do something like that. It was an intimate kind of thing that you couldn't get from a whore. And the tail-feathers that ran with our crew? Hell, they'd 'cast it and I'd get laughed off the street.

It took me a half-second to harden and only about twice that long take it out. She reared back in surprise, but didn't resist when I guided her—one hand on my cock, another in her sunny curls. The weird thing was, she didn't know what to do once I was inside. That confused me. A pet like her should've been an expert. The idea that she wasn't excited me even more. I wanted to probe every corner of her possibly virgin mouth, to slide down into her throat til she choked. But I held back. No sense in scaring the poor little thing.

Her hot mouth and tight little body were amazing to watch and pretty soon I filled her mouth with glorious jets of sticky-sweet come. She even swallowed. Better yet, she kept right on going, every swirl of her tongue sending thrills straight through me. God, what a lucky break. Most fems wouldn't go for seconds unless they knew there was something extra in it and, lots of times, not even then.

I guided her the second time, showing her what was good. She learned awfully fast. Had to pull her away once she'd gotten me hard again so we could try something new. I spared a sec to worry about rolling on a skin, but decided against that. I'd had the spectrum of shots, just like everybody. Besides, a toy like her would be sterile.

When I started fucking her, she was clueless about how to move. Still, it was an unparalleled screw for a goon who'd had to pay or fight for every lay up 'til now. I kept kissing and rubbing every part of her just to make sure it wasn't a dream. The problems of who she was and why she didn't talk could wait until later. For now, I'd call her Sherri, after my favorite sim queen.

Instead of being wiped out after that lovefest, I was wired. I might even've gone on but the timer on the door was creeping into the red zone, so I wrapped Sherri back up in my coat and got us out of there.

Walking down the causeway was fun, even with the rain coming down. All the other goons stared at my prize and I got a made-man kind of feeling. We passed a niche with some vend-a-wares. I pulled her into the golden circle of light and together we watched the holo-girls parading around in whatever cheap little confections were on sale that day. I got Sherri a pink plastic skirt and a white stretchy tank that would cover but not really hide her firm, high tits. Black reflective jacket to go on over top and sky high heels to match. I collected the plasticized squares and loaded her down with them.

"Just like Christmas, huh?" I asked her.

I wasn't sure if she understood, but her smile made up for that.

Was that all? No, she needed panties, even if it was just so that I could take them off. As a kind of joke, I got the most conservative ones the machine had. My slutty schoolgirl—what a trip!

I hustled her off to the bathroom of a noodle hut to change, then went in after her, mostly to see a reverse striptease, but also because of a nagging feeling that she wouldn't know what to do with the clothes. I was right—she had no clue. So I took back my coat and dressed her myself. Heels first, then panties, and then skirt. It bunched up around her ass and I had to tug the stretchy thing past her ample cheeks. Damn. When was the last time I'd been close to a can like that? The thought made me pause to paint her tits with my tongue and suck those long, pink nipples into full erection.

"You fucking goddess," I breathed. I got her up against the wall, kissed her lips, which were still swollen from our bang at the hotel. It was heaven, except she still didn't know enough to put her

tongue—oh wait, there it was. Yeah, tickling mine as I explored the deepest parts of her mouth. Perfect.

But I wanted more. I got her down on the tiles and pushed my warm, fat, glisteningly ripe cock into her willing mouth. This time, every tug of her lips, every brush of her tongue, every suckling sound was exactly right. I came in minutes and hooted like a fucking monkey. Oh man, this was -

The thought was interrupted by the brown noodle goon, who'd actually come in to the bathroom and was yelling in some language I didn't understand. I stuffed my meat back in my pants dressed Sherri the rest of the way and then hauled out of there. This was crazy. We had to be somewhere private if we were gonna do that kind of shit.

Back on the street, the weather was doing one of those weird, microclimate things, dumping wind and sleet and whatever else the sky didn't want. I pulled open the first door I saw and dragged her inside, out of—

Oh, wait—I already said that, didn't I?

SESSION 2
00:27:15.02

I stepped away from the door and did a quickscan. We were in a convenience store, the kind that sold everything from food to cheap software. It was a cramped space, a lot longer than it was wide, with these old fluorescent lights, one flickering crazily with the rhythm of a trapped bug.

I checked the food rack while keeping an eye on the clerk. He'd spotted Sherri, of course, and was scoping her out. Probably wondering what her pussy was like, or whether she'd deign to suck him off, maybe even right here with her knees on the cold lino and people passing by outside.

The thought got my semi-boner completely hard. I couldn't believe it! Still sticky and even a little sore from the three times, it was there again, yearning for her like some rich kid in a cathouse.

I slid my right hand down to her ass, feeling the heat of it through the pink plastic mini. She shifted closer to me and wiggled her cheeks, heels making little scraping sounds on the dirty floor.

"I want it," her eyes said, and she wet her lips. Then she put her head onto my chest and sighed a cute little sigh.

Over her bent head I could see the clerk gawking at the spot where my hand and her ass connected. I didn't usually display like that. I'd learned young that you could get your ass kicked for showing off. But just then, it seemed right to start massaging, to move that sweetness in easy circles, with my little finger in the crack.

The next time I looked, the clerk was pressed right up against the counter. His shining eyes flicked up to my face. He swallowed, then smiled. It was a hesitant kind of smile. Dreamy.

Softly, Sherri cooed against my chest.

Fuck—I wanted to push her down on the floor and do her right there. But I couldn't. Every sex-starved goon and junkie would be at the window and then through it, wanting a piece of something that was so obviously free. I wondered how many seconds it would take to get her somewhere private and slip into her.

Too many. And every moment I stood there was making it worse.

I grabbed at the bright plastic wrappers on the shelves. Sweet things, quick energy, stuff that would keep me going for hours. Did Sherri like sweets? Could I tie her up and tease her with them? I took my hand off her long enough to get some liquids, too. Juice, beer, gajja... a haphazard pull.

I plunked it all down on the counter. The voyeur in back had a name tag that said "Carl." He was younger than me and had dirty blond hair. He was still smiling in that asslicking way.

"That be all, Sur?"

I fumbled for my cred, panicking when I discovered it wasn't in any of the places I usually keep it. Where was it? Back at the vend-a-wares? Somewhere on the street?

Numb, I looked at Carl, now mirroring his smile. I needed the food that was on the counter between us. Needed it so I could go home and fuck. Right now.

"Lost yer cred, Sur?"

My stupid grin broadened. Better call in, warned a small voice inside my head. If anybody smart found it they could hack my PIN and thumbprint—it wasn't hard. The balance would be zeroed in a matter of hours. But I ignored the voice. There were other, more pressing things.

Carl was also still smiling, his eyes flicking between me and her. You didn't have to have hard cred, said his gaze, if you had so many other assets.

Relaxing, I straightened up and guided Sherri between us.

"Could let you go with it," he drawled.

"Yeah? For what?"

He leaned forward. An agile tongue darted out to wet his lips. "Show me her tits."

Sherri squirmed against me, as if she'd understood and was more than ready. Her movements felt playful, like she didn't really want to get away. Like it was all just an act to get me hotter.

I pressed her right up against the counter, hitching her skirt up so I could press my dick into her little-girl panties. Tenderly, I fondled her jugs through thin plastic of her jacket. "Have you got something to show Carl, baby?"

All it took was a tug on the the main zipper. The blackness parted and Carl got a nice view of her cleavage. Delicate spaghetti straps held everything in, but just barely. I saw his eyes run over the cleft, which deepened when I took a hot melon in each hand and pushed them together.

Sherri started to wriggle more, but it was past obvious that the little slut wanted this. Roughly, I pinned her with my hips, working the bulge of my cock even deeper into her sweet ass-crack. My dick was beyond hard. My balls felt hot and full.

"No, we're not leaving yet, Sweetie. Not 'til Carl here gets his show..." I took the straps of her top in my hands, holding them steady as she writhed. By degrees, the very little that was left to Carl's imagination was coming into view. Pretty soon her pink aureolae

rose up over the top of the halter. I noticed again how luscious they were.

With a last squirm, her nipples came spilling out. I shot a glance at Carl, who was frantically rubbing himself through those ugly gray coveralls he was wearing.

When I cupped her tits and flicked the nipples with my fingers, Sherri made a silky sound. I wanted it to go on forever. But that was it. Our side of the deal was now over.

Carl knew it, too. His hand stopped moving on his cock and his face was blank. I wondered how often he got it, with all the sweet girls locked up in arcologies and the whores so goddamn expensive. I imagined how tired he got of jacking his meat day after weary day. I felt sorry for him then. And kind of protective, like towards a younger guy in my crew.

He licked his lips again and turned around for a second, coming up with one of those glossy porn packages with sim options. It was probably the priciest thing in the store. Of course, it wasn't worth shit next to what I had to trade, but still...

"You wanna give me that?" I asked. His round, hopeful eyes told me yes. The balance of power had shifted.

I glanced behind me at the people passing by outside. "You got a back room in here?"

Carl's face split into a huge grin and he hurried to move a display that was blocking a low doorway. He motioned with his head for us to follow. I ushered Sherri through the flimsy swinging door at the end of the counter and deep inside.

The space was dim and barely tall enough for me to stand up in. The walls were covered with pictures of naked fems in outrageous positions. Glossy ones ripped from damp magazines, crumpled ones from backstreet printers, and one prize: a redheaded hologirl that shifted in the gloom.

Carl sat down on the foam mat that took up most of the floor. I shoved Sherri down beside him and settled onto an unstable three-toed stool in the corner. Carl seemed like he couldn't believe this was

a realtime show. He started to take off her jacket, but then looked at me for permission. I nodded intently from my shadowy corner.

Cautiously, he ran his hands over her smooth, pale arms. She was quivering, even though the temp was lots higher than before. I peeled off my coat too. Only five minutes ago I'd been chilled right through, but now I was actually sweating.

I waited for Carl to do something, but soon realized that situation still wasn't totally clear to him.

"You ever fuck a girl, Carl?"

His Adam's apple bobbed like a gigolo's rump. "Coupl'a times."

"When?"

"Before. When I was workin' for this guy."

"Yeah? He had some women, huh? How many, Carl? How many girls did you fuck?"

His eyes darted from me to her and back again. "Dunno. Not many."

From this I knew that it'd been none. Before Sherri I'd remembered every single lay, because with ghetto boys they were more important than fights, or junk, or the make-work that bought you soycakes. They were your status and your stories. They defined who you were and determined whether people gave you respect, or kicked your ass.

"Well Carl, you're going to remember this time. See, Sherri's real special. She'll do anything you want."

Carl started to get undressed. He'd gotten everything off but his T-shirt before I got impatient and told him to start. His cock was small and limp—to his neverending shame, no doubt. He leaned back against the papery wall and spread his legs, eyes on the doe that was creeping towards him, her tits gently swaying.

She dipped her head and gathered him up. Carl groaned and bunched the yellow sheets in his fists. Sherri was slow and patient, keeping her mouth around the base of him and drawing him up to hardness with her lips and tongue. It didn't take long. Soon he was as hard as he was going to get and stabbing lustily away at her mouth.

"Easy, man," I said, rubbing myself delicately. Every part of me was now cold again, except my nads which were hot and throbbing. I was beyond aroused. Even my lightest strokes was starting to feel uncomfortable. "Easy, Carly. You don't want to come too soon now. Lay back. Let her work on you."

He did so and watched her rosy mouth as it slid slowly up and down. I relaxed, taking in Sherri's actions with half-closed eyes. She was getting into it, that was for sure. It wasn't just her head moving. Her whole body was swaying with that rhythm of sucking him off and my cock was somehow pulsing in time to it, as if it was me she was smoking.

Carl's shoulders were propped up against the wall. Cords in his neck were standing out with the effort of trying not to come. Again, I felt a rush of sympathy. Carl figured a shot in her mouth was all he was gonna get. He wanted to make it last because who knew if he'd ever get another chance like this? Worst of all, his boys wouldn't even believe him when he tried to tell them later. They'd probably pound him for being such a lying little shit.

I was happy with this insight. Carl and me, we were tight. Even though I wanted to grab Sherri off his cock and feed her mine, I also felt like being nice. Kid deserved a break. Besides, watching my lady do him only increased the anticipation.

"Don't want to miss any of his juice, do you baby? Yeah, get every last drop. And when you've got it, you'd better keep on sucking. Get him hard again for me. Maybe then you'll get something in that slick little pussy of yours."

Carl had been watching me with wary eyes. But after he heard that, he focused on her completely. He grabbed her head between his hands and started pumping into her like his brain had been taken over by aliens. It would've been a good show if it'd lasted more than five seconds. But pretty soon he was just holding her and shaking, with his eyes shut and his mouth open wide. When the last spasm came, he groaned and shoved her head right down because in that moment he was God and could do anything.

I smiled. Sherri made me feel like that too.

His hands fell away from her and lay like dead crabs on the mattress. Gently, she continued suckling. The sound of that was just too much. Plus her miniskirt barely hid anything, and her panties were soaked through.

My tackle had gotten to the point where I didn't really want to jack it anymore. Even the lightest touch was starting to register as pain. So I got up and walked a step to where Sherri was trying to bring some life back into Carl's little hose. With a finger I touched the damp spot on her panties. She made a high-pitched moan around his cock, one that I was sure must have gotten him halfway back to stiffness, it sounded so damn erotic. What was it about this girl that she could make you want her so much?

Slowly, deliberately, I hooked a finger around each side of her panties and pulled them down to mid-thigh. Held a cold hand to her sex and felt my middle finger just ease on in inside. The sight of my red boner was enough to make me wince. But I had to get inside, just for a second.

I held it out and— it was weird—once I'd slid in, everything was okay. Her tunnel soothed my dick and warmed up the rest of me. From then on, every thrust was sheer pleasure. I sucked in air through my nose, loving the feel of it.

The cubbyhole was filled with the smell of sex. I could hear Sherri's moans (when had she started that, anyway?) over her tiny slurping sounds. Carl was definitely hard again. He rolled his hips and ran his hands over her neck and shoulders and honey-blonde curls. I pulled out and rubbed my glistening cock in circles over Sherri's ass, making sure Carl got a good eyeful. I spent quite awhile at this, dipping into her to make myself wet and then smearing the juices all over the back of her.

Suddenly, I got an irresistible urge to fuck that ass.

I wetted a finger and opened up her back door. There was resistance, but not the kind that said she minded. The idea of getting my dick in there was so hot it was almost enough to make me blow my wad right then and there.

Through slitted eyes, Carl watched me finger-fuck her with one, then two digits. Watched me brace my rod against her pouting hole and push. Watched me slip off and try again, this time holding my cock up against her and easing forward. But she was too tight. I swore and tried again, stopping only when I was at the point of hurting myself. Incredibly, she was too tight.

I got so furious that I pulled her off Carl's dick and flipped her over, grabbing those luscious tits and invading her bald little twat with something like desperation. Pumped away at her for a few minutes before realizing that it wasn't enough. I'd gotten the thought in my head and now I absolutely had to tap that ass. But we had to stretch it first—did Carl sell butt-plugs in his cramped little store?

Then I lit upon Carl himself, lying on a nest of blankets, pumping his dick so fast I could barely follow the motion. I put one leg outside of Sherri's and did a one-eighty to get her off her back.

"Carly-man, can I pre-vail upon you to do me a little favor?"

He wasted no time. He crawled up behind, yanked her skirt right up to her waist, and fitted his mouth against her crease, grabbing handfuls of Sherri's succulent assflesh. That produced another yummy little squeal and made my honey bite her lip with neat, pearlescent teeth.

"C'mon, man. Use that slim jiver of yours and open her up for me."

"Ah! Okay, okay, just let me... uh, just let me..." and the rest was lost as he licked her ass-terior, tasting the juices I'd put there. Carl explored everything with his tongue, even my balls and the base of my cock, which were slick with her sap. I groaned at the unexpected treat and spread my legs to let him have easier access. I held Sherri by the hips, moving her up and down on my bone while Carl struggled to taste both of us. Obviously, this was the kid's main fetish. I glimpsed him beating off and told him to stick it to her now, while he was still hard.

He slicked everything up and then, sweating, he pushed his way inside. "Oh yeah! Oh, man... it's so tight...."

I could feel him through a membrane that felt paper-thin. Damned if I'd ever been interested in guys before, but his cock rubbing against mine as we both worked away at her was about the sexiest thing on the Causeway. If Sherri was ever uncomfortable, it never showed. With both of us inside her, she began this weird cooing noise. But I was so far gone it hardly registered. I just raised my head so I could tongue her beady nipples, pressing her soft jugs together until I could almost reach both at once.

Carl gasped and, with a flash of disappointment, I realized he'd lost it. He pulled out and I felt his hot cream trickle out of her and coat my sweaty balls. The only thing that stopped me from yelling at him for coming so soon was his agile tongue lapping up every drop of the mess he'd just made. That was nice. So nice that it made me buck and groan and blow my wad, too. But then I realized how tired I was, so I unhooked Sherri and rolled over, letting Carl continue the cleanup on his own.

They went at it some more. I was half asleep, so I didn't hear most of it. But when he started talking, going on about her red pussy hair and how you hardly ever find a real redhead these days, I sat up.

"What do you mean, red?" I snarled at him.

"She's ...I mean, her"

"She's blond and fucking shaved, you virtual little shit! " I was furious with the kid for not telling me that he was using. There were a lot of bacterial toxins around these days and they could creep right on into your system if you shared fluids. It'd be expensive to find out if I'd picked anything up. And if it turned out I had, detoxifying would be hell.

"I never use!" he protested. "I don't have the cred for that."

I wanted to pound the hallucinogen out of him, but settled for dressing Sherri as fast as I could, realizing it was my own damn fault. What moronic impulse had made me start this threesome, anyway?

Sherri wailed and reached for Carl, but she was small and light enough that I could pull her easily out of the shop. Enough of this shit. It was time to be alone.

SESSION 3
00:06:03.71

The hotel was too far away, so I didn't take her back there. Instead, I rented a spot in a shack complex, the kind that cheaper whores used. It had the bare essentials: a foam pad, a towel, and a washstand in the corner. Toilet was common to the hallway, explained the red-faced broad in the cage up front. I made a deal with her: time in a room in exchange for letting her tape whatever we did. This meant she could sell it to whatever porn outlets would buy amateur stuff. I assured her she'd make a good profit, as I was intent on giving one hell of a performance. She probably heard that every day, but this time it was for real.

It was only when we'd gotten to the room that I realized I'd forgotten the food.

Parsing that was like getting a kick to the throat. My stomach had been churning the whole time we'd been in Carl's hideaway and now I was feeling lightheaded. But once I left the building, the contract I'd made with the manager would be over. Would she re-negotiate for the same deal? I didn't want to risk it and be trapped outside with Sherri in here.

No, wait, I wasn't thinking straight. I'd take her with me and use her baby-soft curves to cement all my transactions. But first, I had to get some sleep. That last scene had completely drained me.

I fell onto the bed, bringing her up beside me for warmth and comfort. She hummed quietly to herself, a low sound, deep in the throat. The qualities were odd, but it sounded like she was happy.

I turned on my side and gathered her close. The humming made her entire body vibrate—like a purring cat. My body throbbed in reply. We resonated.

Her ass was warm against my groin and with a start, I realized that I still hadn't had it. Right then, she wiggled it provocatively, causing my dick to uncurl with renewed lust. The little tart! I was dog-tired and there was no question that I needed to sleep. Yet here she was, so warm and soft and—damned if she wasn't reaching back and

cupping me. That was the boldest thing she'd done so far. Usually she just looked sweet and fuckable.

I fumbled with the zipper on her jacket and freed a hot tit.

"You want me to open up that ass a little more, don't you Sherri?" I whispered, wincing at my own sour breath.

She didn't say a word, of course, but crooned in reply.

"Mmm, yeah. Sweet little ass." I rolled the plastic skirt up over damp skin. Her panties had disappeared. Carl was probably sniffing them right now, jerking off to their scent in his narrow store.

I stripped her all the way and then eased my dick out. It was a weird and bothersome red. But under the circumstances the thing was bound to look a little odd. I hadn't fucked so much since... well, never.

I got my baby up on her hands and knees, setting my cock to her slippery cleft and pushing. It was still tight, but soon the head of my cock was lodged in her hole. Sherri let out a provocative little squeal. The sound delighted me. I wanted to plug her with one gigantic thrust, but forced myself to take it slow.

We fucked for I don't know how long.

It was unbelievable. Not only did I not stop plugging her ass, but I didn't stop wanting to. This third and most exciting hole was driving me around the bend. Especially once I'd taught her to clench her muscles in time with my thrusts. It was sheer heaven.

Except, Jesus, I was tired.

Session 4
00:06:42.43

I woke up with bleary eyes and dry, cracked lips. It took a minute to figure out that she was underneath me, sleeping soundly, and that my dick was still firmly lodged in her ass. I blinked incredulously. This was too much.

Gently, so as not to disturb Sherri, I eased my still-swollen cock out of her. Fucking incredible. I had a hard-on that just wouldn't go away.

But the rest of me wasn't doing so good. Every joint ached. Every muscle felt like I'd spent the night on bare plasticrete instead of thick foam. My tongue was dry and swollen—how long since I'd had a drink? And worst of all, the chill had come back. Was it a virus? Shit, that was all I needed. Or maybe it was just that I hadn't eaten in so long. This was crazy. I had to take better care of myself.

I got up and shuffled to the washstand, slurping water out of my cupped hands and then out of the tap when that wasn't fast enough. By rights, I shouldn't've even been drinking tap water. Only people who couldn't afford bottled took that chance. But I wasn't up to putting on clothes and finding a store, not right now. Later, I could get an immunobooster at a drug stand.

Drinking reminded me that my bladder was full, so I emptied it into the sink. Walking to the common can was just too much trouble. Besides, I didn't want to leave Sherri alone for a minute.

When I turned, she was awake and sitting up. God, those eyes! That gorgeously tousled hair! It was like every single centerfold of my beat-off years had come to life and was sitting on that cheap mattress, blinking like an angel.

But there was no question that I needed a rest. Even though I was somehow still hard, I was in no shape for fucking. During the night it'd actually turned kind of purple. It was also sore as hell and seemed to hurt more every moment I stood there.

I got into a flat-backed position on the bed and grinned up at her. "You're something else, Sherri. Just wait 'til the skin shops get a peek at this tape. We'll be famous in every port—air, sea, and space."

Sherri smiled. It seemed like she'd really understood me that time.

I needed sleep in the worst way, but my throbbing cock made that impossible. God, I'd overdone it. Maybe it was time to check into a clinic. But what would I pay with? Doctors took only hard cred. Had to find—

A twitch from below.

It was Sherri, of course. She was kneeling between my legs, her gentle tongue on my knob. Once again, the soreness had faded... but,

no, this was insane! I had to get some rest, food, and even some medical care. So I pushed her away.

She looked at me like I'd slapped her.

Suddenly, for no reason, I burst out crying.

"I'm sorry, baby," I wailed, "I'm sorry. But Daddy's gotta sleep, you know?"

She just kept looking at me, her eyes pleading. I couldn't stand that gaze.

"Shit, I'm sorry. Come here Sherri."

I held open my arms, but she made for my cock instead. I didn't have the energy to fight. And after a few strokes, I stopped caring.

"Mmm... yeah... okay, just let me... lie here."

FINAL SESSION
00:00:54.09

I slept. Drifted. Woke to find her lick/suck/riding me. Sometimes, I had crazy dreams, like the one about pulling her under me and finding she'd opened enough to receive my cock and balls at once. I didn't need to thrust. She just milked me.

Sometimes... oh Jesus, it hurt. But Sherri was so nice. When I asked for water, she turned around and sat on my face. Her juices had gotten sweeter... like eating an apple, or something.

End of audio recording

The computer-generated voice faded, leaving the conference room silent. There were reams of data on the elliptical table, but neither occupant seemed interested. Not in the abstracts, not in the charts, and especially not in the digital images with their sanguine details.

"How is he physically?" Cresge asked as she snapped a loose thread off the sleeve of her blazer.

"Stable," said Davis. "His rehydration is complete, but the trauma of removing the sybariote has left some rather permanent damage."

"How about otherwise?"

Davis blew air through his nostrils, but took care to do it quietly. "Problematic. The narrative you just heard was extracted under hypnosis. Based on what happened to the others, full consciousness was deemed too risky."

"I see," the older woman replied, but Davis doubted that. Cresge hadn't actually seen the sybariote. She didn't understand.

She leaned back in her chair. "Your conclusions?"

"Although we've managed to duplicate the agent that the sybariote uses to arouse its partners, we're not sure whether the hallucinogenic effects can be controlled, or whether the product can be manufactured in quantity."

"When will you be sure?"

"Ma'am, the responses of our subjects depend to a large extent on factors we don't quite understand. We need time to—"

"We doesn't have time," warned the director.

"We're very close." Davis soothed, trying to stay calm. "Look, why don't I arrange a tour of the facilities for you, say, in two weeks? It'll give you a much better idea of how far we've come."

"One week," Cresge snapped. It was statement, not a question.

"If that would be more convenient, of course." Davis put on what he hoped was a polite smile, even as he raged inside.

When the ritual of leave-taking was over, he turned and began tidying the conference table, gathering up the data. But his hands shook. His nerves, jacked up by a month of anti-sleep patches, felt like they were about to snap.

How could she possibly think of cutting the funding now? Ignorant bitch and her stupid, fucking consortium! They were pressing R&D beyond its capabilities. And for what? Not to study the sybariote for itself, oh no! Not to learn something about the first completely alien lifeform ever known. The multinational, under Cresge's leadership, was just trying to see if they could create a weapon or, failing that, the ultimate fucking marital aid!

Davis seized the nearest chair and with a strangled noise, threw it against an impassive gray wall. Nothing was damaged, of course, not with these rubbery new materials. Everything remained intact.

Except his health, he fumed, and his career. His sanity!

He turned and stalked out of the chamber. The logical portion of Davis' mind warned him that he was behaving irrationally. He knew full well that even with massive doses of neurotransmitters, a person could only stay awake for so long.

The penthouse lab was dark and quiet, monitors and drives humming softly. Hayes was there, but she was slumped over her control panel, snoring. Ordinarily, he would have reprimanded her, but just then her nap was convenient. He wanted some time alone with their prisoner.

The sybariote, now separated it from its most recent host, was back in its containment sphere. Deprived of company, the creature had resumed its amorphous form. The fluid was pale. Pearlescent.

But he could change that.

Davis put out a hand and touched the supposedly impermeable barrier between himself and the creature. He watched as the fluid darkened, coalesced, and then solidified into the clean-limbed, Asian boy that had been surfacing in his most private fantasies ever since the war.

"Yesss," he breathed, slipping the other hand under his lab coat to fondle a cock grown diamond-hard. "You're learning, aren't you baby?"

The boy smiled in reply.

Davis made a snap decision just then.

"How about we get you someone else to play with, hmm?"

The details of the "unfortunate containment failure" came to him instantly. But then, how to ensure that the project would keep its funding while the arcologies fought over which would lead? And how to make certain that the Cresge's successor understood how vital all of this was?

The boy beckoned to him.

Never mind. He'd figure something out.

Acknowledgments

The publishers would like to extend a special thanks to THE CIRCLET 100 whose contributions helped make this book possible:

Anne Vesprey, Ashley MacDonald, Bev Picazo, Bryt Bradley, Cos, Daniel Robichaud, Daniëlle Suurlant, David Weavr, DL King, Douglas Henwood, Fibrowitch/Jan Dumas, Gavin Atlas, Georgina White, Ginger Vaughan, HPStrangelove, Jeff Mach, Jennifer Thorne, JJ Pionke, J.M.C, Joe Nobel, Kendra Tornheim, Kip O'Connor, Lady Badger, Larry "LordInyc" Nelson, Louisa Bacio, Lucy Felthouse, Mad the Safety Ranger, Marilyn Jae Lewis, Me-ya-ri, Monique Poirier, Morloki's jewel, M. Svairini, Peg Duthie, Phaedra Meyer, Rachel Silber, Rae Lewis, Reina Delacroix, Sacchi Green, Sarah Sloane, Tance, The Society of Bastet Halifax Nova Scotia, t'Sade, and Velma deSelby-Bowen.

Contributors

Allison Lonsdale (www.allisonlonsdale.com) makes a living as a technical editor and makes the living worth while by singing her original songs about sex, science, and the supernatural in coffee-houses. In her spare time she invents new genders and rehabilitates domesticated memes for release into the wild. Her fiction has appeared at Cleansheets.com and ScarletLetters.com, and in the anthologies *Best Transgender Erotica, Blood Surrender,* and *From Porn to Poetry.*

Vylar Kaftan writes speculative fiction of all genres, including science fiction, fantasy, horror, and slipstream. Her stories have appeared in places such as *Realms of Fantasy, Strange Horizons,* and *Clarkesworld.* Her work has been reprinted in *Horror: The Best of the Year.* A graduate of Clarion West, she's volunteered for that group as well as the Little Owls mentoring program for young writers. She's a member of SFWA, Codex, Broad Universe, and the Carl Brandon Society. She lives with her husband Shannon in northern California. Her hobbies include modern-day temple dancing and preparing for a major earthquake. Her favorite color is all of them. She prefers the term "differently sane." She blogs at www.vylarkaftan.net.

Jason Rubis lives in the Washington, DC area with his wife and dog. His fiction has appeared in the Circlet anthologies *Erotic Fantastic*, *Best Fantastic Erotica*, *Like A Wisp of Steam*, *Like A Sword*, and *Like Crimson Droplets*. He blogs at http://jason-rubis.livejournal.com.

Pete Peters is a writer of erotic fiction who lives on a farm in central Canada. He specializes in organic root vegetables of various shapes and sizes. By lantern light he's working on sequel stories to Double Check. He blogs at http://PetePeters.blogspot.com.

Deb Atwood is a wife, mother, systems administrator, gamer, and writer (sleep is optional). She lives in upstate NY with her husband, two children, and a cat who moved in and took over the household remotes."Metamorphosis" is her fourth published short story, and her second with Circlet Press.

Connie Wilkins has published speculative fiction in venues from *Strange Horizons* to Circlet's 2007 *Best Fantastic Erotica*, and is editor of *Time Well Bent: Queer Alternative History* (Lethe Press). Her alter ego Sacchi Green is way ahead of her, placing short fiction in dozens of erotica venues including seven volumes of *Best Lesbian Erotica*, and editing or co-editing six anthologies, *Rode Hard*, *Put Away Wet*, *Lipstick on Her Collar*, *Hard Road*, *Easy Riding*, and *Lesbian Cowboys* (all with co-editor Rakelle Valencia) as well as *Girl Crazy*, *Coming Out Erotica* and *Lesbian Lust* (the last three from Cleis Press).

Helen E. H. Madden is a writer and artist who quit her lucrative day job years ago to tell dirty stories for fun and profit. Her published works have appeared in various anthologies, including *Cream:The Best of the Erotica Readers and Writers Association*, *Nerdvana*, and the *Coming Together* charity anthologies. Helen also writes and produces the Heat Flash podcast, a free online audio program of erotic speculative fiction. In her spare time, she draws *The Adventures of Cynical Woman*, a web comic about her life as a stay-at-home mom and erotica writer. When she's not working, Helen thinks about sex. A lot. Website: http://www.cynicalwoman.com The Heat Flash Erotica Podcast: http://www.heatflash.libsyn.com

Grant Carrington has had about 40 stories published in sf, literary, and men's magazines and 5 plays produced in Baltimore, as well as articles, book & record reviews, and even a short-lived column. (We will not speak in polite company of his poetry.) His sf novel *Time's Fool* was published in 1981. He has worked with the Champlain Shakespeare Festival, Fells Point Theatre, and The American Light Opera Company among many theatre groups, as actor and lighting tech. Currently he performs as a solo singer in the mid-Atlantic area. His CD, Songs Without Wisdom, is available at CDBaby.com/cd/Carrington. The title of "Younger Than Springtime" comes from a song in South Pacific.

Bryn Allen is the pseudonym of a not-famous-at-all author from the rural mid-west. A writer of horror, science fiction and fantasy, Bryn taps out stories amidst the chaos of a busy spouse, multiple small children, and the furry tumbleweeds of two ghost cats.

Kal Cobalt's human iteration is a Circlet Press regular, with tales in numerous anthologies including *Best Fantastic Erotica* and *Queerpunk*, "10 Things You Always Wanted To Know About Robot Sex" on circlet.com, and an e-book collection, *Robotica*, all over the web. K.C. is a columnist on sex, kink, and tech for Sexis Magazine and has penned fiction for *Best Gay Romance*, *Country Boys*, *Hot Gay Erotica*, *Boys in Heat*, and numerous webzines. Grab more Kal (metaphorically) at conferences across the Pacific Northwest, or hit up kalcobalt.com for free stuff and general mayhem.

Jean Roberta teaches English in a Canadian prairie university and writes in several genres. Her story "Smoke" is in *Best Fantastic Erotica* and "The Way to a Man's Heart" is in *Like a Sword* (both from Circlet). Over 80 of her stories (mostly erotic) have appeared in print anthologies, not including magazines and websites. Her own diverse erotic collection, *Obsession*, is available in various formats from Eternal Press. Her column, "Sex Is All Metaphors," appears monthly on the site of the Erotic Readers and Writers Association (www.erotica-readers.com) and her reviews appear on www.eroticarevealed.com (erotic site), www.kissed-

byvenus.ca (lesbian site), and other sites. More at www.JeanRoberta.com

Beth Bernobich is a writer, reader, mother, and geek. Her short stories *have appeared in Asimov's, Interzone, the Mammoth Book of Best New Erotica, and Sex in the System*, among other places. Her first collection, *A Handful of Pearls & Other Stories*, recently appeared from Lethe Press, and her first full-length novel, *Passion Play*, is forthcoming from Tor Books in October 2010.

Maya Kaathryn Bohnhoff is the author of six fantasy novels and a collection of short fiction (*I Loved Thy Creation*), and is a founding member of the Book View Café online publishing co-op. Her short works have been published in *Analog, Amazing Stories, Interzone*, and *Jim Baen's Universe*, and have been finalists for the Nebula, Sidewise and British Science Fiction awards. She is also a musician/singer/songwriter and performs and records original and filk/parody music with husband Jeff. Their latest release, "Jeff and Maya Bohnhoff: Grated Hits." Maya is currently working on a new Star Wars novel with Michael Reaves. Websites: www.mysticfig.com, www.bookviewcafe.com

Eric Del Carlo's fiction had appeared over the years in Strange Horizons, Futurismic, Talebones, Brain Harvest, various Circlet Press and Ravenous Romance anthologies and many other publications. His book-length work has been published by Ace Books, Loose Id and DarkStar Books. See ericdelcarlo.com for more information. Eric currently lives in California.

D.L. Keith is a Canadian writer who has had around 40 short stories published in various magazines and webzines, under other by-lines and aliases—mainly in the genres of science fiction and fantasy. He has also written reviews and essays for various sites. This is his first (published) effort in the field of out-and-out "erotica"—though he has been known to skirt its edges occasionally with a few of his other stories.

Paige E. Roberts loves to write sexy stories that dance on the edge of reality, and frequently fall off. She has published short stories in the US

and UK in a variety of genres, including paranormal and urban fantasy, science fiction, romance, and erotica. Vampire, shape-shifter, and super-hero romance and adventure are her specialty with powerful female protagonists her signature. She lives in Austin, TX with her husband, two kids, three cats, a dog and a very small dragon.

Diane Kepler has been thinking of ways to pervert sci-fi ever since first holding a novel of that genre in her hot little hands. Her other Circlet publications include "Venus Rising" in *Best Fantastic Erotica* and "Nectar" in *Wired Hard* 4. She also maintains a blog on LiveJournal and a list of publications and recommendations at www.dianekepler.net

About the Publisher

Circlet Press was founded in 1992 as a place where the erotic and the fantastic could be combined in fiction. At the time, erotica publishers shied away from anything paranormal or science fictional, and science fiction publishers shied away from anything involving pleasurable sex. Circlet welcomed the mix, trying to prove to the literary world that chocolate and peanut butter really could be mixed with delicious results, and hoping to also open the minds of many readers not just to new realms of erotic fantasy, but of possible erotic realities that could possibly exist even in our own world, if only we'd let them.

Now almost two decades later, having seen the rise of paranormal erotic romance and the opening of the sf genre to adult concepts, Circlet is still at the vanguard of this movement, In addition to books like this one, Circlet also has a very active digital publishing program, producing dozens of ebooks per year and also publishing web serials and microfictions that are free to read online. In 2010 the program expanded to include erotic sf/f MP3s as well.

C+ Circlet Press: Erotic Fantasy and Science Fiction
Digital books and print editions
www.circlet.com

BEST FANTASTIC EROTICA
$9.99 ebook ▪ $19.95 trade paperback

The winning stories from Circlet's 2006-2007 contest to find the very best of erotic fantasy and erotic science fiction short stories. Over 600 entries were considered and 18 were chosen. The winners span the genres of fantasy and science fiction to create erotic scenarios, unique plots, and explore sexuality.

EROTIC FANTASTIC: The Best of Circlet Press
$9.99 ebook ▪ $19.95 trade paperback

The best selections from ten years of publishing erotic science fiction and fantasy. Between 1992 and 2002, Circlet Press published dozens of anthologies, and culled the top 20 stories for this volume.

Circlet Press's print volumes are available from fine booksellers everywhere. If you don't see our titles on the shelf, please ask your friendly book retailer to get them for you, or order directly from our web site at www.circlet.com.

Circlet's digital books, ebooks, and MP3s, are available for direct download from circlet.com and our ebooks from many online retailers including the Kindle Store, Fictionwise, BN.com, All Romance eBooks, Rainbow Ebooks, Trapezium Books, Smashwords, Scribd, Kobo, and more which are popping up all the time.

We also publish many stories and serialized novels for free reading on our website at www.circlet.com. Please drop by to enjoy the stories and sample chapters.

Circlet Press: Erotic Fantasy and Science Fiction
The leaders in Erotic Steampunk
www.circlet.com

LIKE A WISP OF STEAM: Steampunk Erotica edited by J. Blackmore
$6.99 ebook

All the trappings of steampunk society—corsets, airships, and 'leaping technologie'—meet the simmering undertone of sexuality so well-hidden by Victorian morality.

LIKE CLOCKWORK: Steampunk Erotica
$7.99 ebook

Seven stories of erotic steampunk, exploring worlds of clockwork people and their relationship to their creators. If a mad, or not-so-mad, scientist of the steam age were to create his or her own being, what desires would be reflected there?

LIKE A CORSET UNDONE: Steampunk Erotica
$6.99 ebook

Enter a Victorian age that never was. By turns kinky and romantic, these stories explore all the reasons to unlace, whether to rebel, or for more intimate purposes.

THE INNOCENT'S PROGRESS by Peter Tupper
$6.99

Return to the alternate Victorian world of Peter Tupper, whose stories in LIKE A WISP OF STEAM and other volumes explore the fascinating theatrical world of the Commedia, and the tightly controlled erotic roleplay liaisons that patrons of the theatre indulge in after each public performance.